GEORGIA O'KEEFFE

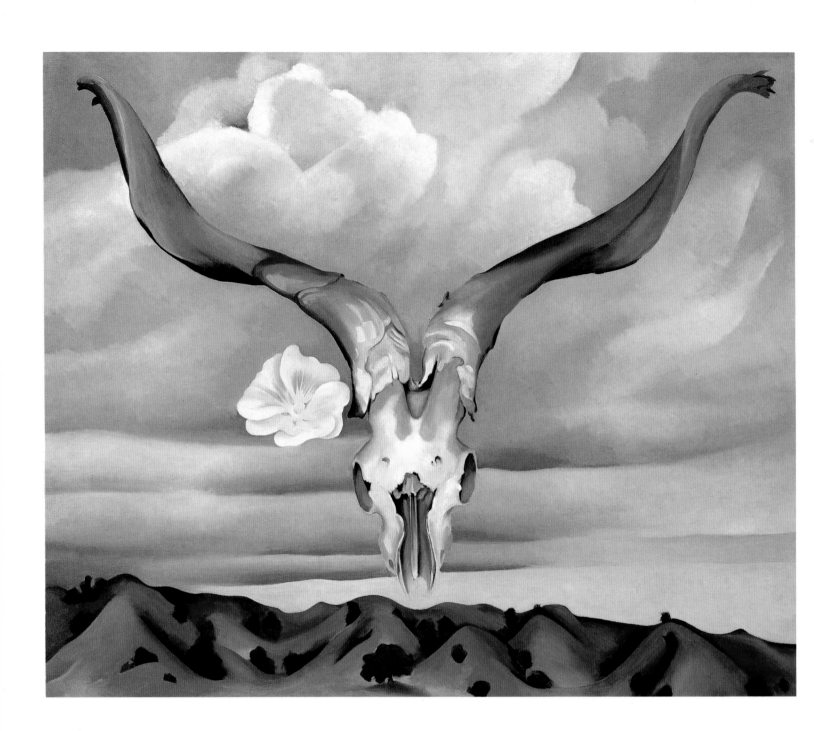

Georgia O'Keeffe

CHARLES C. ELDREDGE

Harry N. Abrams, Inc., Publishers, New York

IN ASSOCIATION WITH

The National Museum of American Art, Smithsonian Institution

For Jane

Series Director: Margaret L. Kaplan
Editor: Eric Himmel
Designer: Ellen Nygaard Ford
Photo Research: Neil Ryder Hoos

Paintings by Georgia O'Keeffe in this book are published with the permission of the Georgia O'Keeffe Foundation insofar as such permission is required. Rights owned by the Georgia O'Keeffe Foundation are reserved by the Foundation.

Excerpts from Alfred Stieglitz and Georgia O'Keeffe letters in the Collection of American Literature, Beinecke Rare Book and Manuscript Library, Yale University. Copyright Georgia O'Keeffe Foundation.

The author and publisher would like to thank Juan Hamilton for permission to use quotations by Georgia O'Keeffe originally published in the following books: *Georgia O'Keeffe: A Portrait by Alfred Stieglitz* (New York: The Metropolitan Museum of Art, 1978), Copyright © 1987 Juan Hamilton; and Georgia O'Keeffe, *Georgia O'Keeffe* (New York: Viking Press, 1977), Copyright © 1987 Juan Hamilton.

Library of Congress Cataloging-in-Publication Data

Eldredge, Charles C. .
 Georgia O'Keeffe/Charles C. Eldredge.
 p. cm.—(The Library of American art)
 Includes bibliographical references and index.
 ISBN 0–8109–3657–7
 1. O'Keeffe, Georgia, 1887–1986—Criticism and interpretation.
 I. Title. II. Series: Library of American art (Harry N. Abrams, Inc.)
ND237.05E43 1991 90–48459
759.13—dc20 CIP

Frontispiece: *Ram's Head with Hollyhock*
 1935. Oil on canvas, 30 x 36"
 Collection of Edith A. and Milton Lowenthal
 For commentary, see page 127.

Text copyright © 1991 Charles C. Eldredge
Illustrations copyright © 1991 Harry N. Abrams, Inc.

Published in 1991 by Harry N. Abrams, Incorporated, New York

A Times Mirror Company

Contents

Acknowledgments

The present study of Georgia O'Keeffe's art had its genesis in the early 1960s; in the years since, I have benefited enormously from the assistance of many friends and colleagues to whom I am indebted for their generous cooperation and helpful insights. Given the book's long gestation, it is hazardous to single out individuals, yet there are several without whose timely interest and support this publication could never have been realized.

First and foremost, I am forever appreciative to the artist herself. Early in 1970, while in the midst of preparations for her retrospective at the Whitney Museum of American Art in New York, she took time from pressing business to welcome an importunate graduate student to her home and to share, with engaging candor and wisdom, observations on her art and life. Her kindness remains one of my fondest memories, and recollections of that first visit to Abiquiu have ever since sustained my interest in her work and belief in its significance.

A generation ago—when a proposed dissertation on a living, American, woman artist could raise academic eyebrows three times over—the late Professor Donald Torbert of the University of Minnesota provided crucial support and guidance. For that, I continue to be grateful.

The Abrams Library of American Art series evolved in collaboration with the National Museum of American Art while I had the privilege of serving as the museum's director. I thank Abrams' president Paul Gottlieb and senior vice president Margaret L. Kaplan for their inspiration and for the invitation to prepare this volume. At the National Museum of American Art, I enjoyed the assistance of many talented colleagues; for their valuable efforts, I am particularly thankful to Karol Ann Lawson and my successor, Elizabeth Broun.

Since returning to the University of Kansas, I have been further aided by numerous colleagues and graduate students; for contributions to my education on music, botany, and urban design I especially thank Cynda Benson, Sharyn Katzman, and Dixie Webb. At the Georgia O'Keeffe Foundation, Elizabeth Glassman, president, and Judy Lopez have been most cooperative; I thank as well the Foundation's directors—Richard Brettell, Juan Hamilton, Raymond Krueger, and June O'Keeffe Sebring—for their interest in this project.

Sarah Greenough of the National Gallery of Art provided generous counsel on the work of both Stieglitz and O'Keeffe, in which she is expert. In Santa Fe, Gerald P. Peters and his associate Katie Flanagan responded to my numerous requests with prompt and invaluable assistance.

Every writer hopes for a deft editor; in that respect I have been unusually fortunate to have the assistance of Eric Himmel. Also at Abrams, Neil Hoos has

Bell/Cross, Ranchos Church

1930. Oil on canvas, 30 x 16"
Private Collection.
Photo courtesy Gerald Peters Gallery,
Santa Fe, New Mexico

For commentary, see page 106.

6

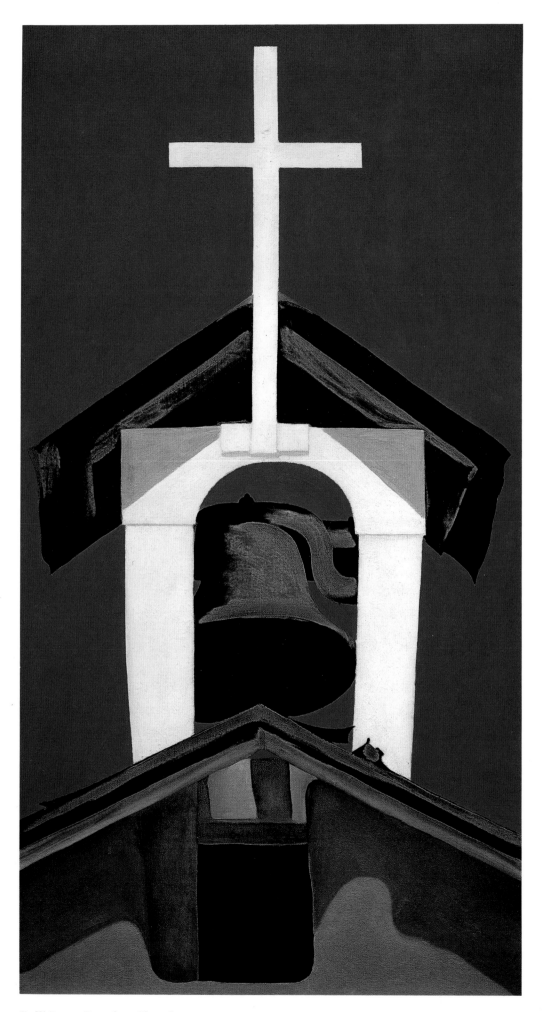

Bell/Cross, Ranchos Church

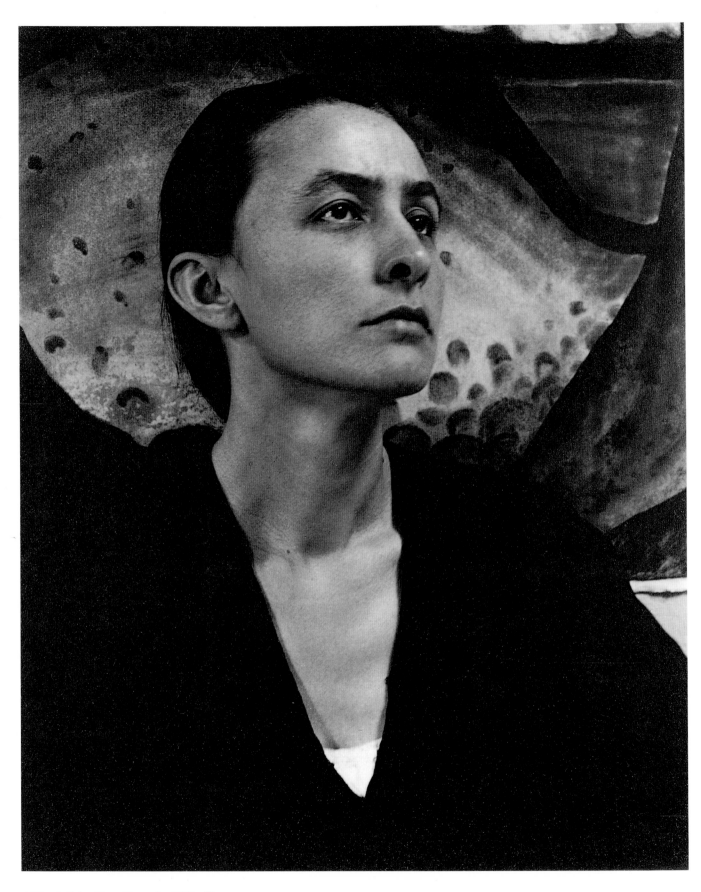

Alfred Stieglitz, *Georgia O'Keeffe*

been indefatigable in locating photographs of O'Keeffe's paintings, a number of them reproduced here for the first time, and designer Ellen Nygaard-Ford has skillfully combined word and image in this publication.

Last, but surely not least, I owe a special debt to my wife who, for twenty-five years, has suffered this "other woman" in our lives. Her patient support has eased this task and her keen insights have added immeasurably to my understanding. Finally, her assistance is beyond recompense. I can only put her name at the beginning, trusting that she will know what it means.

<div align="right">

CHARLES C. ELDREDGE
Lawrence, Kansas

</div>

<div align="right">

Alfred Stieglitz, *Georgia O'Keeffe*

1918. Palladium print, 9¾ x 7¾"
The Metropolitan Museum of Art, New York.
Gift of David A. Schulte, 1928

</div>

My Autumn

I. Life and Legend

AUTUMN HAD ALWAYS BEEN HER FAVORITE SEASON. At Lake George in the 1920s, she often tarried long after family and summer vacationers had returned to their urban haunts, delighting in her solitude amidst the foliage that emblazoned the mountains surrounding the blue-black water. From those painting seasons resulted memorable images of fiery trees and large, tinted leaves with which she captivated New York in her winter shows. Later, in New Mexico, she would linger if she could into October, after the eastern visitors had vacated the desert country. Then, as the aspen groves in the Sangre de Cristo mountains turned to gold and the night chill in the high desert brought tidings of the harsh winter ahead, she revitalized herself in the autumn still, that pause between seasonal extremes, before returning to the busy winter season in New York. In later years, she would linger at her Ghost Ranch home well into the fall, before the winds drove her down the winter road to her Abiquiu house, nearby, yet, in the gentle Chama River valley, sheltered from the northern blasts.

For Georgia O'Keeffe, however, October of 1970 was different. Autumn that year found the artist back in the Manhattan she had abandoned more than two decades earlier, far from the desert landscape she had made familiar to generations of American art lovers; from the still-warm noons so good for walking and painting the hills and arroyos; from the crisp, starry evenings spent with pleasurable books, music, or friends. Instead, the eighty-two-year-old painter found herself on Madison Avenue, spending long hours in the galleries of the Whitney Museum of American Art, overseeing and rearranging the installation of a major retrospective exhibition, her first in New York since 1946.

Much had changed since that earlier show, both in O'Keeffe's life and in the art world at large. The 1946 retrospective—the first one-woman show ever presented by the Museum of Modern Art—had marked the culmination of three decades' work, during which her reputation had been secured by her stylish abstractions; distinctive enlargements of flowers, leaves, and shells; landscapes of Lake George and New Mexico complemented by New York cityscapes; and memorable skeletal compositions derived from the desert's detritus. It was during the Modern's exhibition, in July 1946, that Alfred Stieglitz had died, depriving O'Keeffe of her primary champion, who was also her collaborator, her frequent inspiration, and, for nearly twenty-two years, her husband. The settlement of his complicated estate occupied O'Keeffe for most of the ensuing three years, but by 1949, she was free at last to leave Manhattan to settle in her beloved Southwest.

My Autumn

1929. Oil on canvas, 40 x 30"
Private Collection.
Photo courtesy Gerald Peters Gallery,
Santa Fe, New Mexico

At the time of her leave-taking, the young masters of the "New York School" were very much in the ascendant, claiming the attention of press and gallery-goers with large, gestural canvases, expressive abstractions so different from her own. The acclaim they eventually won for their "triumph of American painting" eclipsed, at least momentarily, the singular contributions made by a pioneering generation, triumphs in which the artists of Alfred Stieglitz's coterie figured prominently, including Georgia O'Keeffe. The boisterous bonhomie of the new school had little in common with the rarefied discourse of the older artists; their camaraderie was alien to the private existence O'Keeffe preferred in the environs of Spartan elegance she had created for herself in New Mexico. "I don't mind the exile," she once admitted, "—I'm not really a mixer."

Working in the relative isolation of New Mexico for two decades, O'Keeffe had been far removed from New York's critics and artists, to whose attention and judgment she now returned. Yet she remained apparently undeterred by this period of critical neglect, and if she was at all uneasy about the reception of the Whitney show, she betrayed not a bit of it.

From the 1920s onward, at the various New York galleries operated by photographer and modern art impresario Alfred Stieglitz, O'Keeffe had customarily arranged the annual exhibitions of her own work as well as those of other painters. Her installations generally earned the respect of artists and the acclamation of visitors, and it was little surprise that she sought the same control in exhibitions on other premises. "Dealing with Georgia is very easy," reported one museum director, "provided you do exactly what she wants." In the Whitney Museum's spacious galleries, O'Keeffe claimed her customary privilege, reorganizing the preliminary layout arranged by exhibition curator Lloyd Goodrich. Finally, her exacting standards met, the Whitney exhibition—121 paintings covering a fifty-five-year period—was ready for an uncertain reception by press and preview guests.

One guest at the opening later described the scene about the redoubtable octogenarian: "She was at the Whitney looking strong and tough and diminutive, like an Indian woman. Witch? Shaman? Power." Even a seasoned New York reviewer confessed that "meeting Miss O'Keeffe, one of America's best-known cultural landmarks, is a little unsettling." Clearly, the artist's legendary status, carefully developed and honed over the preceding decades, continued undiminished despite the years away from the public eye. The reputation may even have been increased by her remoteness and her passion for privacy. However, it was not only, nor even primarily, as a living landmark that she had planned this return to the scene of her early triumphs and glory. At an age when most of her contemporaries were well into the winters of their lives, or had become part of history, O'Keeffe reappeared as a creator still in her prime, with an unexpected body of new work.

By 1970, the painter's position as one of our modern pioneers was secure; she was often acknowledged, with bold condescension, as our "leading woman artist." But, to a generation reared on the gestural canvases of the Abstract Expressionists, the work of O'Keeffe and her fellow innovators in the early decades

of the century might have seemed at best historical, at worst, irrelevant. In an art scene which seasonally accommodated Pop, Op, minimal, and other inventions, the images from Abiquiu were seldom considered. Even to admirers who recalled her exhibitions at Stieglitz's galleries, her Museum of Modern Art retrospective, or her occasional exposures at New York's Downtown Gallery in the 1950s, O'Keeffe's continued productivity—or her very survival—came as a surprise. For all, the Whitney show proved a revelation.

O'Keeffe's work had, from her earliest days as a professional artist, elicited comments like "revelation." When Alfred Stieglitz first encountered her abstract drawings in 1916, he responded immediately to their power. As recalled by one witness to the moment, "They were a revelation to him. He had long hoped that someday drawings with such feeling and candor would be put on paper by a woman. In O'Keeffe's work he saw a new expression of things felt, a new beauty." Prominent critics were similarly struck by O'Keeffe's works when they were shown at Stieglitz's gallery later that year and again in 1917. William Fisher, for instance, praised the "mystic and musical drawings," which he likened to religious "revelations" in their "cosmic grandeur."

It was a heady entry into Manhattan for the hitherto unknown twenty-nine-year-old school teacher from Sun Prairie, Wisconsin, a well-trained graduate of fine schools of art in Chicago and New York who yet remained uncertain about the public exposure of her private and innovative creations. The early acclamation by America's leading proponents of the avant-garde anticipated the response which her Whitney Museum retrospective elicited more than a half-century later.

In a New York still marked by generally conservative tastes and attitudes, the creative group—artists, writers, collectors, and critics—that circled around Alfred Stieglitz and his "291" gallery (so called for its Fifth Avenue address) in the years before World War I was remarkable for its advanced aesthetic and intellectual interests. The discourse of the Stieglitz circle offered a pronounced contrast to that in the small (and small-minded) college communities in South Carolina and Texas where O'Keeffe had spent the preceding years. By temperament she might have seemed ill suited to the esoteric discussion and the lofty debate that characterized the habitués at 291, and particularly their garrulous doyen, Alfred Stieglitz; she habitually preferred to maintain her quiet privacy and, in her work, she eschewed intellectual theory, trusting instead in her intuition. Yet Stieglitz's initial, enthusiastic response to her art shortly turned to a committed advocacy which in 1918 drew the artist herself to New York; there, at his side, she enjoyed a special position in his avant-garde coterie.

In their early years together, O'Keeffe was more often an observer than a participant in the intellectual debates at 291; but, from Stieglitz and his associates she drew support and inspiration, and she reflected their adventuresome spirit in abstractions that earned their respect. Arthur Dove, perhaps the most sophisticated painter in the group, once exclaimed in admiration tinged with envy, "This girl is doing naturally what many of us fellows are trying to do, and failing."

The support that Stieglitz offered quickly grew from financial and professional to a more personal sort. The two artists might have seemed at first an unlikely pair: he, the Hoboken-born son of an affluent German-Jewish family, nearly twenty-four years her senior, married and a father, worldly and gregarious; she, the product of the midwestern prairie, daughter of a large and struggling farm family of mixed Irish-Hungarian-Dutch Catholic ancestry, an introverted schoolteacher who, at thirty years of age, might have been considered a spinster by the standards of the day. Yet, despite—or perhaps, proverbially, because of—the apparent differences in their backgrounds and temperaments, the attraction between the two artists was immediate and profound.

While their differences periodically caused professional and personal strains between them, the relationship also afforded important inspiration to each partner. To O'Keeffe, Stieglitz provided nurture and security at a crucial moment in her life, as well as entry into an artistic ambience which might otherwise have remained elusive; conversely, he drew inspiration from her interest in nature, a product of her rural Wisconsin upbringing, and from her pictorial imagination which relied upon intuition unfettered by foreign theory. Despite his own European roots and training, he believed in and struggled for a culture distinctive to this native soil, for an "America without that damned French flavor!"—and in O'Keeffe he found it. "That's why I'm really fighting for Georgia," he admitted in 1923. "She *is* American."

Stieglitz was inspired artistically as well as romantically, and from their first meeting in 1917, he began to photograph his new Muse, over the next two decades producing an extended "composite portrait" of O'Keeffe. Beyond the familiar facial portrait, he discovered in intimate studies of her expressive hands, torso, and other parts of the body a reflection of her various "selves." The photographs had an unmistakable erotic charge which occasioned predictably excited discussion when Stieglitz exhibited them in 1921 and again in 1923. He was surprised when several men asked him to photograph their wives or girlfriends in a similar fashion, and years later O'Keeffe recalled his amusement at the request. "If they had known what a close relationship he would have needed to have to photograph [them] the way he photographed me—I think they wouldn't have been interested." At the time, however, her reaction to the hubbub was more complex.

Early in her career she had pronounced ambivalence about showing her own work, about revealing her personal responses to the world. "I always have a curious sort of feeling about some of my things—," she confessed in 1915. "I hate to show them—I am perfectly inconsistent about it—I am afraid people wont [sic] understand—and hope they wont—and am afraid they will." Eight years later, when Stieglitz presented one hundred of her new pictures in a major show, this reaction was further complicated by the attention generated by his intimate photographs, works in whose creation O'Keeffe had been a willing collaborator. O'Keeffe's dual exposure as artist and model elicited feverish critical speculation about her private life and its reflection in her (public) art, sexual

interpretations that the artist found invasive and for which she had little patience. "If they write about me like that," she once complained, "I shall quit being an artist. I can't bear to have such things said of me." More than with any previous showing, the publicity surrounding her exhibition in 1923, and that of Stieglitz's portraits a few weeks later—as well, of course, as the works themselves—vaulted O'Keeffe into the ranks of celebrity.

The bond with Stieglitz was formalized in marriage in December 1924, shortly after his divorce from his first wife, and the couple enjoyed a prominent position in the ebullient art world of New York throughout the 1920s. Stieglitz turned to his own art with new energy, producing notable photographs of natural forms and his famous cloud studies ("Equivalents"), as well as additions to the ongoing O'Keeffe portrait. Freed of routine gallery obligations after the closing of 291 in 1917, he nevertheless remained loyal to "his" artists. In addition to O'Keeffe's shows, he also organized special exhibitions for others of the 291 circle at various venues before reestablishing a regular base at his new Intimate Gallery in December 1925; that in turn was succeeded by another Stieglitz operation, An American Place, in 1929. In these settings he regularly presented O'Keeffe's new work, introducing audiences to her large floral pictures, her paintings of Manhattan, and, later, her views of the Southwest, each year's work garnering acclaim and new enthusiasts among collectors. In 1928, reports of a record-breaking sale of her calla lily paintings to a private collector won headlines—"$25,000 for Six O'Keeffes"—and further fueled the interest in the artist. By the end of the decade, one frustrated reviewer lamented that "Georgia O'Keeffe has become so much an institution . . . that it is difficult to find a point of departure for criticism."

In a commentary of 1928, critic Helen Read had resorted to a familiar point of departure, raising anew the issue of gender. She wrote sympathetically that "Georgia O'Keeffe . . . is regarded by many critics and art lovers and hosts of romantically minded young people as the high priestess of woman's expression in the arts." (The romantic hosts were the ancestors of the young audiences who, in 1970, led the applause and "rediscovery" of O'Keeffe at her Whitney retrospective.) As "high priestess," O'Keeffe was sympathetic to the aspirations of other women in modern society, in the arts and elsewhere. While late in life she disclaimed a role as Founding Mother for a renascent feminist movement, in earlier years her efforts were newsworthy. In 1927, for instance, she served on the jury for the Opportunity Gallery in New York City, a showcase for "emergent" artists who lacked adequate exhibition facilities, and her selections were notable for the representation of women who amounted to two-thirds of those chosen.

In other arenas her feminist sympathies were also evident. While in politics, as in painting, she was often reserved in her public utterances, opinion was nevertheless firmly held. O'Keeffe had joined the National Woman's Party about 1914, at the urging of her friend Anita Pollitzer, to whom she was shortly reporting enthusiastically on suffrage meetings she attended in South Carolina. She retained membership in the party throughout her life and contributed her ef-

forts to its campaign for an equal rights amendment; she even lobbied Eleanor Roosevelt on the subject, noting that the amendment "could very much change the girl child's idea of her place in the world. I would like each child to feel...that no door for any activity that they may choose is closed on account of sex." In 1926—again at Pollitzer's prodding—she addressed a party convention in Washington, D.C., urging her large audience of women to develop their individual talents and end their dependency on men. Stieglitz could not have missed the irony of his wife's speech at the Washington convention, which was reported in the *New York Times* and elsewhere. He took pride in his role in her development, even remarking to one interviewer, "I've given the world a woman." Her call for women's independence from men might have struck him as ingratitude for his Pygmalion service, a possible symptom of stresses in their relationship. Late in her life, O'Keeffe alluded to the strains between such strong individuals, when she acknowledged that "for me he was much more wonderful in his work than as a human being. I believe it was the work that kept me with him—though I loved him as a human being.... I put up with what seemed to me a good deal of contradictory nonsense," she concluded, "because of what seemed clear and bright and beautiful."

O'Keeffe's journey to the National Woman's Party convention left Stieglitz alone in New York for the first time in their union; the brief separation presaged other breaks, longer and more painful, as she sought relief apart from the "contradictory nonsense." Her most significant deviation from their parallel orbits began in 1929 when she traveled to New Mexico to spend a summer painting in the Southwest, initiating a seasonal cycle which had a life-long consequence. In the dramatic desert country she discovered the inspiration for series of paintings which sustained her over the balance of her long career, and which regularly captivated audiences in her winter shows at Stieglitz's gallery. Her paintings of New Mexico—especially the famous Black Crosses and pictures of desert bones—became O'Keeffe's new signature images, as familiar as the large flowers of the 1920s had been. Collectively the Southwestern subjects bespoke the artist's mature authority—and her independence. They figured prominently in her major retrospective at the Museum of Modern Art in 1946. The exhibition drew enthusiastic responses through the summer, which she again spent in New Mexico. It was there, on July 10, that she received a telegram informing her of Stieglitz's stroke, and she immediately flew back to New York. She was at his side when he died three days later.

Life after Stieglitz differed dramatically for O'Keeffe. In the 1950s, for the first time, she—whom Stieglitz had always prized as the embodiment of America—began to travel widely and often. Without an eastern anchor, she spent most of her working time in New Mexico. Absent from New York for long stretches, her name was infrequently in the news, and though this might have seemed a retreat from the high profile Stieglitz and she had jointly managed over many years, it suited the artist who was content in the seasonal rhythms of life in the desert. Although her art was less often before the public in the two decades following her husband's death, she remained active, and her work con-

tinued to attract support from a circle of devoted collectors. But they—and perhaps even O'Keeffe—could scarcely have anticipated the intense and enduring interest in the artist and her work, which was first stimulated by her 1966 show at Fort Worth's Amon Carter Museum, and then burgeoned after the triumphant Whitney exhibition in 1970.

Now, twenty years later, the phenomenon of Georgia O'Keeffe shows no sign of abating; since her death on March 6, 1986, at the age of ninety-eight, this legendary life has become the stuff of best-selling biographies and of the cinema and the stage. Indeed, the popular reputation at times threatens to overwhelm and obscure the art to which she was primarily dedicated, a fact which would have troubled the artist.

Perhaps sensing this, O'Keeffe demurred in advance: "Where I was born and where and how I have lived is unimportant. It is what I have done with where I have been that should be of interest." Accordingly, this book is organized by the themes of her art more than the events of her life. The chapters that follow are devoted to significant subjects that she treated, generally in series, over a long and prolific—and, yes, remarkable—career. While she moved from one series to another over time, a fact which gives the text a loosely chronological structure, this study should not be considered a biography of the artist. Rather, it is a series of ruminations on what she did with where she had been, for only through understanding its subjects can we ultimately appreciate her art and its significance.

Series I, No. 12

II. Abstraction

THE ABSTRACTIONS WITH WHICH O'KEEFFE made her professional debut in 1916 were among the most astonishing work by any American artist of her generation. Their novel strength was immediately recognized by reviewers of her first New York exhibition; even many years later, in her large centennial exhibition organized by the National Gallery of Art in 1987, they continued to surprise and delight critics and the public who flocked to the show in unprecedented numbers during its nationwide tour. These early drawings and watercolors displayed a brilliant inventiveness and contained the germ of a formal language upon which O'Keeffe long relied, in designs both abstract and representational.

The abstract designs were created in the years around World War I, a period of turmoil both aesthetic and social during which O'Keeffe was teaching in Columbia, South Carolina, and Canyon, Texas, precincts remote from the American capitals of art and politics. Working in private, she was able to put to the test what she had learned from her various mentors, from exposure to avant-garde exhibitions in New York, and from her extensive readings in modern art criticism. The results of that experimentation drew astonished reactions when unveiled at Alfred Stieglitz's 291 gallery.

The tale of how these pioneering works on paper came to be shown has been often told and is by now a familiar part of O'Keeffe's legend. Late in 1915, to go to the origins of the legend, Anita Pollitzer received a roll of charcoal drawings from her friend in South Carolina. The two had first met in New York while students of Professor Arthur Wesley Dow at Columbia Teachers College. The friendship that blossomed between Dow's two prize students continued after O'Keeffe left to teach art at a small college in South Carolina in the fall of 1915. To O'Keeffe, Pollitzer sent newsy letters, filled with personal encouragement and candid observations on developments in the American art capital. She rhapsodized about the heady atmosphere of Stieglitz's gallery, the crucible in which the American modernist revolution was born and a stimulating destination for O'Keeffe, Pollitzer, and other art students in New York.

In return, O'Keeffe shared with Pollitzer rambling letters filled with her personal thoughts and evolving artistic notions. To her confidante she also sent occasional parcels of new work, not only as examples of her rapidly changing imagery, but also as a nonverbal form of communication. This exchange, both verbal and visual, was purely personal. "I am writing only to you," O'Keeffe warned, "you know—anything I say about anyone is the same as if it wasn't said isn't it."

Series I, No. 12

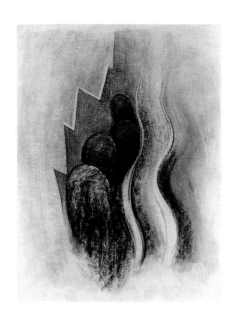

Special No. 13

1915. Charcoal on paper, 29½ x 19″
The Metropolitan Museum of Art, New York.
The Alfred Stieglitz Collection, 1949

O'Keeffe's early charcoals were the product of intuition rather than aesthetic theory, the outpouring of "things in my head that are not like what anyone had taught me."

The "message" of the drawings was equally private. The abstract drawings sent by the twenty-eight-year-old artist in December 1915 were the result of a period of feverish creativity, and O'Keeffe worried, "I wonder if I am a raving lunatic for trying to make these things." The works were freighted with significance of a highly personal yet inchoate nature; they conveyed a private meaning that O'Keeffe was unable to verbalize. "Maybe the fault is with what I am trying to say," she apologized; "I don't seem to be able to find words for it—."

Pollitzer, struck by the novelty of the black-and-white drawings, disobeyed her correspondent's admonitions and on New Year's Day 1916 hastened to 291 where she shared them with the admired Stieglitz. The impresario reacted enthusiastically—"At last, a woman on paper!" was his legendary (but probably apocryphal) response—and retained Pollitzer's parcel, determined to share the drawings with a larger public. O'Keeffe reacted ambivalently to her friend's actions, upset by the betrayal of confidence yet thrilled to have earned the approval of a discerning judge whose opinion she already valued above all others. Her reaction to his unauthorized showing of the works a few months later was more straightforward; the artist, who was back in New York for another term with Professor Dow, angrily descended upon 291 and demanded the show's dismantling. The persuasive Stieglitz prevailed, however, and the exhibition launched the fruitful association between the two that continued for the next three decades.

The images with which O'Keeffe made her 291 debut in 1916 marked the genesis of the artist's mature vision. In the preceding decade, the artist had come into contact with a wide range of novel and stimulating concepts and images. She had studied with some of the leading instructors of the period, beginning with John Vanderpoel at the Art Institute of Chicago in 1905, and subsequently with the dashing William Merritt Chase at the Art Students League in New York (1907–08). She had encountered the Orientalizing principles of Arthur Wesley Dow as enunciated by his disciple Alon Bement, with whom she worked during summers at the University of Virginia; and finally she had studied with Dow himself at Columbia Teachers College. Outside of formal instruction, she had tested her eye and intellect on the sophisticated aesthetic theory of Wassily Kandinsky, whose influential treatise *Concerning the Spiritual in Art* she was by 1915 reading for the *second* time, and on other important critics, ranging from Clive Bell to Willard Huntington Wright to Arthur Jerome Eddy. And, in what retrospectively might have been the most crucial inspiration, she had been stimulated by Stieglitz's exhibitions of contemporary art, European and American, and by his provocative publications, particularly the avant-garde journal *Camera Work*. By her own admission, however, "It was some time before I really began to use the ideas. I didn't start until I was down in Carolina—alone—thinking things out for myself."

Late in 1915, O'Keeffe arrayed her works around her small room in South Carolina for what amounted to a private retrospective. In that self-critique, she recognized the influences that had shaped her work and, in a pivotal decision, she determined to purge the mannerisms acquired over her long tutelage. Rath-

er than try to fulfill the expectations of others, she would "think things out for myself." She began by drawing the "things in my head that are not like what anyone has taught me—shapes and ideas so near to me—so natural to my way of being and thinking that it hasn't occurred to me to put them down." These unexpected, abstract forms she drew in charcoal, for the moment banishing color as well as recognizable subject matter from her repertoire.

While suggestions of the figure, of natural forms, and other aspects of the perceived world can be found in some of the drawings, it was their tendency toward simplified abstraction that was most pronounced. To his students and to readers of his treatise on *Composition*, one of the most widely distributed art texts of the early twentieth century, Arthur Wesley Dow had emphasized the importance of the Oriental aesthetic, especially the Japanese concept of *notan*, or composition using balanced values of darks and lights. It was this Orientalizing, decorative approach that led to O'Keeffe's life-long interest in "filling a space in a beautiful way," as first evinced in the drawings whose particular importance she emphasized with the series title Special.

Special No. 13 (1915) provides good evidence of the innovative character of O'Keeffe's work. Its combination of rhythmically rounded forms and jagged angular shapes reveals a dichotomy in O'Keeffe's vision between the geometric and the organic. This dualism first appeared in these monochromatic drawings and persisted throughout much of O'Keeffe's long career. The hard angularity of the lightning bolt–like form recurs in later drawings, like *Abstraction* (1919; Addison Gallery of American Art, Andover, Massachusetts), in which the collision of hard bars and rounded form emits splinters of black. These combinations of the geometric and the organic were also echoed in oils, such as the little-known *Series I, No. 7*, also of 1919.

In short order, these designs provided the basis for some of O'Keeffe's most hermetic abstract paintings, in which the swollen orbs were reduced or eliminated and the patterns of intersecting arcs or lines bear little apparent reference to the world. Her deft control of the oil medium is apparent in these works, such as *Series I, No. 12* (1920; page 18), whose pastel hues are modulated with extreme subtlety to suggest the overlapping of torn and tinted planes in a very shallow space, without any allusion to natural inspiration. The geometric abstractions that O'Keeffe painted in the late 1910s and early 1920s are among the most sophisticated produced by any American artist of her generation. They represent the fullest expression of one aspect of her vision first developed in the Special drawings, an interest in angular geometric patterns that was to resurface in later years. They were, however, but one part of the complicated formal vocabulary that the artist invented in those crucial drawings.

Among the works shared with Pollitzer and shown by Stieglitz were others of a very different character, organic patterns based upon swelling, undulant forms that provide the morphological counterpoint to O'Keeffe's geometric designs. The pastel *Special No. 32* (1914; overleaf) exemplifies that other aspect of her formal invention. In design and overall conception, the drawing departs from hard-edged geometries and instead relates to the flowing patterns of Art

Series I, No. 7

1919. Oil on canvas, 20 x 16"
Private Collection.
Copyright © The Georgia O'Keeffe Foundation

The intersecting lines of the oil painting are similar to those used contemporaneously by Charles Demuth, who was soon to become O'Keeffe's close friend in the Stieglitz circle, suggesting their aesthetic kinship.

Special No. 32

Nouveau, to which O'Keeffe, as a child of the turn of the century, was attracted. Parallels might be drawn with the decorative shapes employed by John Twachtman in his *Snowbound* scenes of the 1880s; her flowing curves and countercurves could also reflect the sinuous forms found in American poster design, which flourished in the 1890s, or even in the architectural decoration of Louis Sullivan, whose Chicago-based influence was reflected in buildings of southern Wisconsin, O'Keeffe's childhood home. In fact, Art Nouveau's formal vocabulary was nearly ubiquitous in American art and design at the century's turn and provides an obvious foundation for O'Keeffe's organic inventions.

Special No. 32 evokes affinities across cultures as well as time. Its dynamic rhythms suggest the organic vitality possible in abstractions from nature, such as the innovative vegetal designs of Henri van de Velde, master of the Belgian fin de siècle. Alternatively, O'Keeffe's diagonal descent of flowing curves is curiously reminiscent of Southern Sung landscape painting, such as Ma Yuan's river views, a model which her teacher Dow would likely have endorsed. As with the geometric abstractions, her organic shapes of the mid-1910s are pivotal, looking Janus-like to the Art Nouveau past or more distant sources while simultaneously containing the germ of her future innovation.

The flow of line and color in the 1914 pastel anticipates the wavelike patterns of many later works treating subjects as diverse as coastal views of Maine, where she spent several holidays in the 1920s, or the flow of water across desert landscape. Such views were at once decorative and documentary—formally inventive depictions of specific locales, often of personal import—and they suggest that her designs—representative as well as abstract, organic as well as geometric—might have a significance beyond the merely formal. This was early intimated by the importance that O'Keeffe placed upon the privacy of her pictorial correspondence with Pollitzer and her angry reaction to Stieglitz's public display of the images. When considerations of subject join those of design, when the drawings are viewed in terms both formal and metaphoric, O'Keeffe's early works take on a new interest and import.

Such is the case with *Drawing No. 8*, another of the innovative 1915 charcoal compositions. This drawing of a great spiral wave curving inward upon itself bears the imprint of Dow's tutelage and echoes such Japanese prints as Hokusai's famous *Great Wave off Kanagawa*; the drawing also bears a strong resemblance to another Dow student's work reproduced in his book, *Composition*—an illustration of a pirate ship in heavy seas—suggesting that O'Keeffe's *Drawing No. 8* might be her particularly inventive response to one of the professor's standard assignments. O'Keeffe is also invoking the Romantic image of the deep vortex, familiar, for instance, in the work of J.M.W. Turner.

Drawing No. 8 invites all such formal comparisons—and then something more. In 1918, shortly after her arrival in New York as his newest protégée, O'Keeffe was photographed by Stieglitz before a similar charcoal spiral; the dramatic pose suggests that Stieglitz equated the vitality of the drawing with that of its maker, as if O'Keeffe herself was a force of nature. Illustrations in nineteenth-century treatises on nature and science provide other provocative

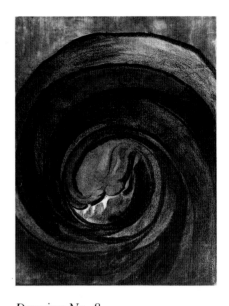

Drawing No. 8

1915. Charcoal on paper mounted on cardboard, 24¼ x 18⅞"
Whitney Museum of American Art, New York. Purchased with funds from the Mr. and Mrs. Arthur G. Altschul Purchase Fund

The power of O'Keeffe's early abstractions surprised even their maker. "I wonder if I am a raving lunatic for trying to make these things?" she asked in 1915.

Special No. 32

1914. Pastel on paper, 14 x 19½"
Private Collection.
Copyright © The Georgia O'Keeffe Foundation

Line and color flowing organically across the sheet suggest parallels with Art Nouveau style.

parallels to O'Keeffe's design. The publications of astronomer Angelo Secchi, for instance, were embellished with graphic representations of the cosmos; one of these, *A Solar Cyclone, May 5, 1857*, was later reproduced in *The Principles of Light and Color* (1878) by Edwin D. Babbitt, his classic study of the healing power of color. The swirling design offers a formal prototype for O'Keeffe's drawing.

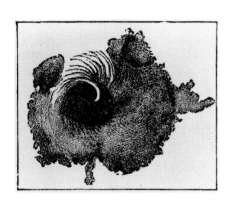

A Solar Cyclone, May 5, 1857

From Edward D. Babbitt,
The Principles of Light and Color, 1878

Although we cannot be certain that she knew Secchi's work or, more likely, Babbitt's, the enduring popularity of the latter, the general familiarity of the uranic spiral design, and O'Keeffe's own predilection for solar imagery all suggest the possibility of more cosmic readings of her abstraction. The great spiral—the Ur-form, or Uroboros—was widely understood by metaphysicians as the symbol of primordial matter, before it evolved into separate male and female principles. Such a reading suggests that both the illustration of the sun, a life-giving force, and O'Keeffe's modern abstraction share a common concern with the generative principle, with Creation made manifest. This interest in genera-tion, in the vitalist impulse, in origins of the most primal sort—in what one of the Stieglitz circle's favorite philosophers, Henri Bergson, called élan vital—found expression in O'Keeffe's charcoals of 1915 as well as in her watercolors of 1916–17, for which the drawings often seemed to be black-and-white rehearsals.

After a period of rigorous invention in black-and-white, color returned to O'Keeffe's palette late in the spring of 1916. Initially, and perhaps somewhat tentatively, she opted for monochromes, generally selecting strongly evocative hues, colors with symbolic connotations. From her reading of Kandinsky, she was mindful of the special significance he attached to color. Beyond its purely physical effect on the retina, Kandinsky claimed that "color directly influences the soul" and that its psychological effect can, in a "more sensitive soul …produce a correspondent spiritual vibration." In yellow, for instance, he found "a disturbing influence" with an "irresponsible appeal"; comparing colors to states of mind, he likened yellow to "the manic aspect of madness." Red, by contrast, was "determined and powerful. It glows in itself, maturely." For Kan-dinsky, blue was restful, the "typical heavenly color." In it he felt "a call to the infinite, a desire for purity and transcendence." In their varied intensities, colors could evoke different responses. In its lighter tones, blue grows "indifferent and affects us in a remote and neutral fashion, like a high cerulean sky," ultimately reaching complete quiescence in white. In the darker range, however, a very different effect results. "When it sinks almost to black," Kandinsky noted, "it echoes a grief that is hardly human. It becomes an infinite engrossment in sol-emn moods."

Kandinsky's treatise, including his theory of the psychology of color, re-flected interests shared by many artists in the early years of the century in this country and abroad, O'Keeffe among them. When she felt the need for color again, her initial choice was blue, likely inspired by the special significance Kan-dinsky assigned to it. She used that color in a series of four watercolor abstrac-tions, entitled *Blue I–IV* (Brooklyn Museum), created in 1916, which continued her interest in the Ur-form. The hue remained a consistent favorite and was used in a number of her monochrome designs in the year that followed.

A B S T R A C T I O N

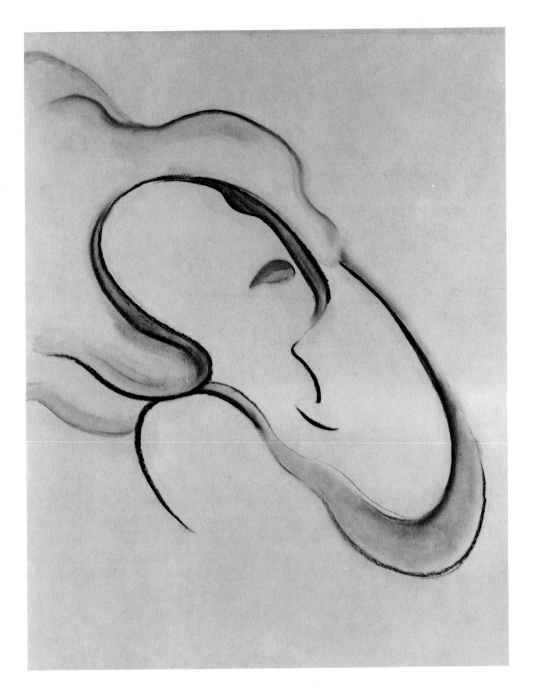

Abstraction IX

1916. Charcoal on paper, 24¼ x 18¾"
The Metropolitan Museum of Art, New York.
The Alfred Stieglitz Collection, 1949

After the restrictive experiments in abstraction in 1915, representation made a tentative reappearance early in the following year.

Along with color, representation also returned in 1916. The emergence of the figure had been presaged in one of O'Keeffe's charcoal designs, *Abstraction IX* (1916). Its decorative arabesque of curving lines comports with the organic abstractions of the Specials and related drawings; in this case, however, the lines also vaguely describe the rounded forms of a head and shoulder, but only the full lips in an otherwise featureless face betray the figurative source of the design. O'Keeffe returned to the figure in earnest later that year, beginning a series of more than a dozen watercolors of the female nude. This suite was remarkably independent of any tradition of figuration she might have acquired in her academic training, suggesting that her abstract experiments in charcoal had had a cathartic and liberating effect on her imagination. The nudes were free in their execution, their forms not dependent upon preliminary drawing

Leah

1917. Watercolor on paper, 15 x 11″
Whereabouts Unknown

In this rare "portrait," O'Keeffe's model was her friend Leah Harris, who taught home economics at West Texas State Normal College. The watercolor is a miracle of abbreviation, its awkward stooped pose, incomplete figure, and loose strokes all reminiscent of Auguste Rodin's radically simplified nudes, which O'Keeffe greatly admired in Stieglitz's exhibitions and collection.

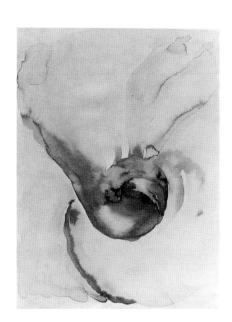

Cerise and Green

1917. Watercolor on paper, 11¾ x 8¾″
Private Collection

but instead directly brushed in loose washes upon the paper. Some were painted in monochrome, for example, the blue *Leah* (1917), atypically identified by its subject (Leah Harris, a colleague in Texas). Other watercolor nudes were varicolored but equally summary. *Nude No. IV* (1917), for example, is viewed frontally, the rosy silhouette of body defined by a crisp border of white against a generalized background plane; facial details are largely lost in a dark wash of shadow that descends to define the contour of the right breast. The roundness of the breasts is emphasized by semicircular strokes beneath each, and that form is echoed in the navel and nipples as well. Arms and legs are suggested by attenuated bleeds of color which taper into nothingness.

In this simplification of anatomy is found the figurative inspiration for contemporaneous abstractions such as *Cerise and Green* (1917). Its pendulous, dark, circular form, whose extensions pale into amorphous washes, recalls the shad-

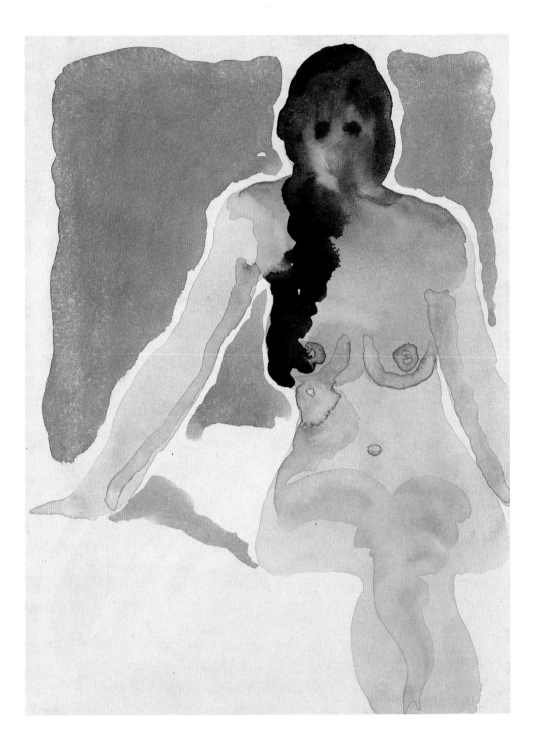

Nude No. IV

1917. Watercolor on paper, 12 x 9″
Private Collection

*Although not primarily known as a paint-
er of the figure, O'Keeffe did concentrate
on the female nude in a series of watercol-
ors produced between 1916 and 1918,
while in Texas. In later decades, she also
produced occasional portrait drawings of
friends and family.*

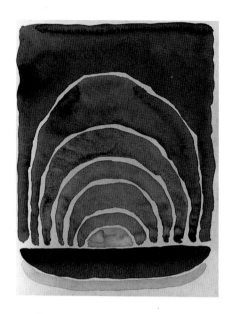

Light Coming on the Plains I

1917. Watercolor on paper, 12 x 9"
Courtesy Amon Carter Museum of Western Art,
Fort Worth

The wide skies of Texas provided special inspiration during O'Keeffe's years teaching in Amarillo and Canyon.

owed right breast of *Nude No. IV*, suggesting the proximity of O'Keeffe's realistic and abstract visions and the influence of each mode upon the other. Although the figures remained exceptional in her career, other representational motifs of 1916–17 are similarly indebted to the crucial abstractions of the year immediately preceding.

The watercolor nudes were completed in Canyon, Texas, where O'Keeffe began her new assignment as head (and sole member) of the art department at West Texas State Normal College in September 1916. In that isolated setting, just as she had previously in South Carolina, she was able to work as she pleased, and the privacy proved stimulating and liberating. In Canyon, "I was alone and free—*so very free,*" she later recalled, somewhat wistfully. There O'Keeffe was newly inspired by the landscape and other natural subjects, which provided motifs to supplement the shapes she saw only in her mind. The artist, who had been raised in the gently rolling country of southern Wisconsin and the wooded hills of Virginia, was enthralled by the vastness of the north Texas plains. To her friend Pollitzer, back in the bustling metropolis of Manhattan, she exclaimed: "It is absurd the way I love this country.... I am loving the plains more than ever it seems—and the SKY—Anita you have never seen SKY—it is wonderful—."

The shift of focus outward, to the world observed around her, prompted such notable images as the series Light Coming on the Plains of 1917, inspired by the experience of a memorable sunrise over the empty land. In *Light Coming on the Plains I,* concentric arches of blue above the flat and empty horizon repeat the basic configuration of the preceding year's *Blue* abstractions, but now with subject, nature's phenomena, given new primacy.

In the Panhandle's vacant precincts, sunrises and sunsets were daily dramas not to be missed, eliciting from O'Keeffe an increasingly colorful range. She painted the brilliant effects at daybreak and day's end using the full spectrum, from warm yellow-oranges to cool blue-blacks, and in many cases gave her colors greater emphasis by carefully separating the heavy washes of watercolor with unpainted margins of white paper, accentuating each hue. This technique had been earlier used in both abstract and figurative compositions, but reached its most intense effect in her 1917 series, Evening Star (overleaf). In celestial motifs such as the Evening Star watercolors, O'Keeffe discovered the perfect wedding of formal language with a natural subject that inspired her profoundly.

The Texas landscape also prompted watercolor treatments which accentuated its colorful patterns, sometimes in relatively straightforward views, at other times distilling from the subject nearly abstract designs. O'Keeffe remarked upon the allure of the colorful plains in autumn "like green gold and yellow gold and red gold—in patches—and the distance blue and pink and lavender strips and spots." Those forms and tones coalesced in harmonious evocations of place, such as *Abstraction, Red and Green* (c. 1917; overleaf), that were allusive yet scarcely topographical.

Among the most notable sights in the Panhandle country was the Palo Duro Canyon, about twenty miles east of the town of Canyon. O'Keeffe quickly discovered the place and sought to capture its peculiar forms and colors in her work.

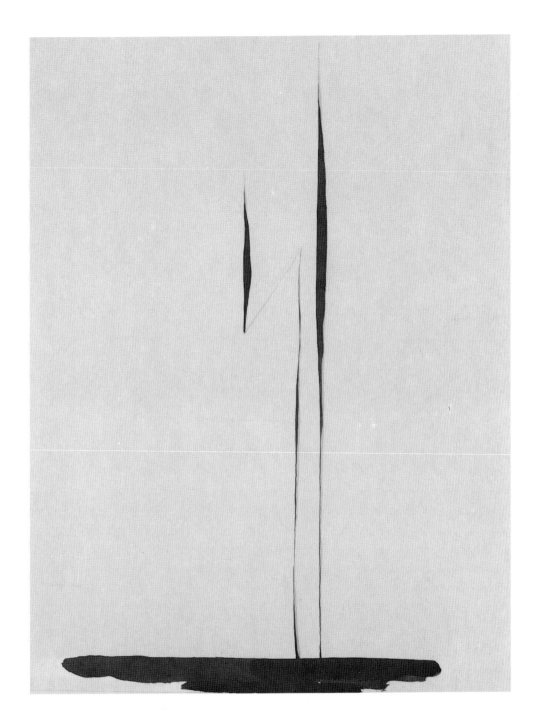

Blue Lines No. 10

1916. Watercolor on paper, 24¹⁵/₁₆ x 18¹⁵/₁₆″
The Metropolitan Museum of Art, New York.
The Alfred Stieglitz Collection, 1949

The ultimate in a series of linear abstractions, Blue Lines No. 10 was included in the artist's first solo exhibition in 1917. There it attracted the attention of critic Henry Tyrell, who praised it as "a sort of allegory in sensitized line," a tracing of two lives, male and female, "distinct yet invisibly joined together by mutual attraction."

To Stieglitz, with whom she was in frequent correspondence, she described the "curious slit in the plains" with its "wonderful color—darker and deeper with the night [when] imagination makes you see all sorts of things." The perspective from deep within the canyon's steep recess was dramatic and memorable; years later, O'Keeffe recalled that "the weather seemed to go over it. It was quiet down in the canyon. We saw the wind and snow blow across the plains as if the slit didn't exist." Within weeks of her arrival, she was tackling the motif; she reminded Anita Pollitzer that "my landscapes are always funny and these are not exceptions—Slits in nothingness are not very easy to paint—but its great to try."

One of O'Keeffe's most familiar early watercolors, *Blue Lines No. 10* was painted in 1916 and may have its origin in those "slits into nothingness." The

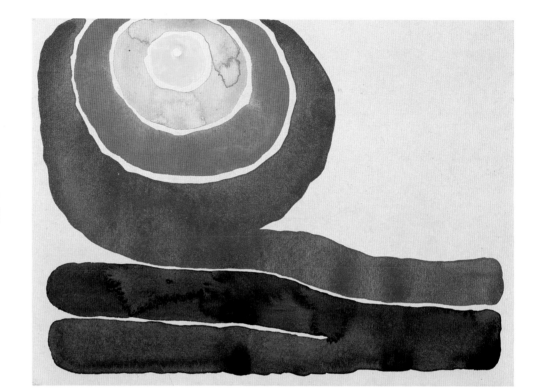

Evening Star III

1917. Watercolor on paper, 9 x 11⅞"
Collection, The Museum of Modern Art, New York.
Mr. and Mrs. Donald B. Straus Fund

Captivated by the glowing orb over the empty land, O'Keeffe first treated it with pale washes which bled amorphously into each other; in subsequent sheets, the colors were both heightened and varied and given greater intensity by their white borders, as ribbons of yellow, orange, and red unfurl over blue and green stripes of horizon. The series of ten watercolors which she made she called Evening Star.

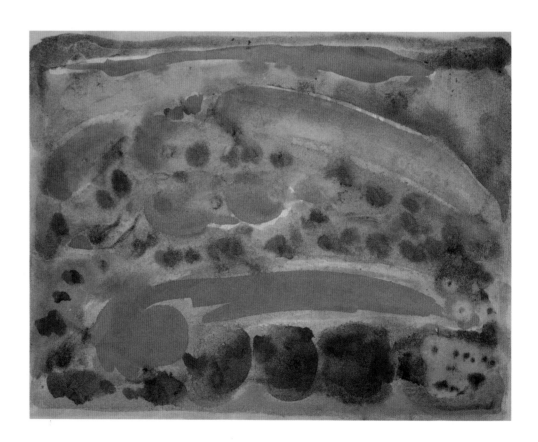

Abstraction, Red and Green

c. 1917. Watercolor on paper, 9½ x 12½"
Gerald Peters Gallery, Santa Fe

One of a recently discovered cache of watercolors from her Canyon years, this design creates a colorful abstract pattern from the tints of autumn on the Texas plains.

ABSTRACTION

precise circumstances of its creation are difficult to determine. Whatever its inspiration—Panhandle topography or shapes in her mind—O'Keeffe's *Blue Lines No. 10* has, more than any other early work, been subject to varied interpretations. Stieglitz often referred to it as the tracing of male and female principles, arising from the same ground and pursuing parallel but independent courses. F.S.C. Northrop, one of the most prominent of mid-century philosophers, also saw in the image a metaphor for polarities, but cultural or philosophical rather than sexual; he used the watercolor as the frontispiece for his major study *The Meeting of East and West* (1946). Yet others have seen the provocative piece as pure design, the ultimate expression of Dow's principles. The susceptibility of O'Keeffe's abstractions to such varied readings suggests again the potency of her formal inventions and their capacity to convey significance independent of representation, even as they evolved from depictions of the world observed.

The Canyon interlude had provided the painter with essential new inspiration. Though distant from New York, O'Keeffe had kept abreast of developments there and elsewhere through her correspondence with Pollitzer and more particularly with Stieglitz and by reading *Camera Work* and other avant-garde publications sent to her by friends. Her painting, particularly in watercolors, had shown rapid progress as she absorbed the various possibilities of modernism and applied them to her new subjects, most notably landscape and the phenomena of nature. But the isolation and small size of the community in Canyon, the very factors that seemingly fueled her own private inventions, also bred a less attractive small-mindedness among some of her neighbors and colleagues. She had previously chafed at the narrow outlook of her colleagues, particularly administrators who sought to dictate a conventional curriculum and prized traditional teachers—which O'Keeffe decidedly was not. With the United States' entry into World War I in April 1917 a zealous militarism infected Canyon, adding to the discomforts of the pacifist O'Keeffe. At least one of her associates questioned the art instructor's loyalties, leading to her angry retort: "But what has patriotism to do with seeing a thing as green when it is green or red when it is red?" By February 1918, the situation had grown intolerable, and O'Keeffe abandoned both her teaching role and her beloved Canyon countryside for a period of rest and recuperation at the South Texas ranch of her friend Leah Harris.

In New York, Alfred Stieglitz, who shared and perhaps even inspired O'Keeffe's pacifist sentiments, grew concerned about the condition of the young artist to whose work and development he had shown such commitment. Miles Standish–like, he dispatched a young colleague, photographer Paul Strand, to Texas to retrieve O'Keeffe from the provinces. Despite the immediate affinity that developed between the two artists in Texas, Strand eschewed the John Alden role and obediently delivered O'Keeffe to Stieglitz's benevolent protection and support in June 1918, initiating a new chapter in this artistic and domestic drama.

The Stieglitz who greeted O'Keeffe upon her return to New York was in some respects a different man from the one she had admired while a student in

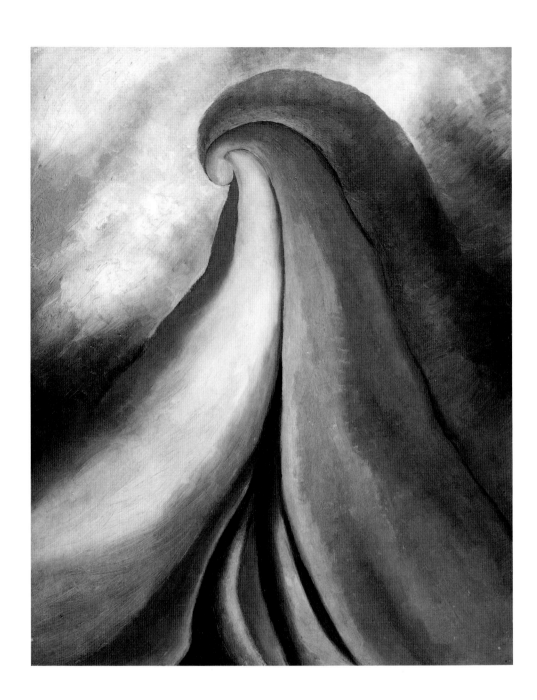

Series I, No. 4

New York or in correspondence from Texas. In 1918 he was fifty-four years old and for the first time in many years without a gallery as forum and focus for his prodigious advocacy. The solo O'Keeffe show he presented in April 1917 had been the finale for 291, and the June 1917 issue of *Camera Work*, which promised extensive coverage of the newly discovered O'Keeffe in the next issue, proved to be the journal's last. Recently separated from his dour wife Emmeline, Stieglitz was homeless as well as gallery-less, temporarily installed in the residence of his married brother.

Yet, despite the turmoil in his life, his allegiance to his favored artists remained undiminished, and in none did he have greater faith than the new arrival from Texas. In answer to his query as to what she wanted above all else,

O'Keeffe answered simply, "I would like a year to paint." To this he generously responded, just as he had previously done in assisting John Marin, Marsden Hartley, Arthur Dove, and others whose innovations he early appreciated and who today are acclaimed as pioneers in the emergence of modern American art. With his support came a new intimacy and inspiration for both artists.

Of their early time together, O'Keeffe recalled that "I had a kind of belief in Alfred that made those days especially fine. I had a need of him that I had never seemed to feel for anyone else before. His feeling for music, concerts, books and the outdoors was wonderful. He would notice shapes and colors different from those I had seen and so delicate that I began to notice more."

Early evidence of O'Keeffe's flourishing can be seen in the abstractions in oil, which continued the forms of her Specials and Texas watercolors. Some emphasized the hard shapes and angles that had appeared in her works on paper; much more frequent were the organic shapes that had evolved from her close study of nature. As with the watercolors, she explored these forms over several canvases. *Series I, No. 4* (1918) suggests the upward thrust of a seedling plant; the vitalist image continues the forms of the earlier monochromes, but here with unprecedented chromatic freedom. A few years earlier, while working in charcoal, O'Keeffe had worried to Pollitzer that "the colors I seem to want to use absolutely nauseate me"—a concern from which she had clearly recovered by 1918. O'Keeffe was uncommonly gifted in her ability to harmonize strident contrasts, such as the orange and green bands of *Series I, No. 4*. In her decorative compositions, she made striking use of clean, forceful hues—cherry reds warming to oranges and acid yellows, blues ranging from cold whites to inky blacks, and a gamut of greens surpassing nature's own palette—tones not found in the drabber paintings of her contemporaries. Viewers reacted with astonished delight to this novel sensibility; the painter Charles Demuth exclaimed memorably that in O'Keeffe's paintings "each color almost regains the fun it must have felt within itself on forming the first rainbow."

The colorful abstractions culminated in a group of grand oils in 1919, a remarkably fruitful year made possible by Stieglitz's encouragement and support. *Red and Orange Streak* (overleaf) evokes the dark emptiness of night on the plains, with only the scarlet line of daybreak suggesting the distant, flat horizon. Across this nocturnal landscape streaks a jagged arc of orange, an abstract form inspired by the sounds of the cattle country, where the lowing of animals was always in the air. O'Keeffe later explained that the distinctive motif was inspired by the sounds of the Panhandle. Her interest in representing one sensation (sound) translated to another (sight)—the phenomenon known as synaesthesia, a legacy of the fin de siècle—was shared by many early modernists in this country and abroad. Although O'Keeffe's synaesthetic evocation of place was distinctive—and her bovine inspiration surely unique—several among the Stieglitz coterie, including Marsden Hartley, Max Weber, and Arthur Dove, had dealt with this general concern in musical themes.

O'Keeffe's painted song of the cattle was accompanied by other more generalized musical abstractions, including two versions of *Music—Pink and Blue*

Red and Orange Streak

1919. Oil on canvas, 27 x 23″
Philadelphia Museum of Art.
The Alfred Stieglitz Collection,
Bequest of Georgia O'Keeffe

Although she was far removed from Texas, reminiscence of the wide plains country continued to inspire O'Keeffe's imagery during her initial years with Stieglitz in New York.

(Collections of Emily Fisher Landau and Barney A. Ebsworth). These canvases, composed about central blue apertures surrounded by pale organic folds, provide the painted corollary to the artist's wish: "I want real things— . . . Music that makes holes in the sky." *Blue and Green Music* (1919), the mate to the pink-and-blue paintings of the same year, echoes the synaesthetic inspiration but reverts to the morphology of certain charcoal drawings from four years earlier, combining flamelike swirls of flickering whites and rhymed pale waves with hard, dark diagonals intersecting in an angular V-shape. The wavy pattern, here used to convey the harmonic pulsations of music or sound waves, had first appeared in one of O'Keeffe's abstract drawings of 1915. In its initial appearance, however, this formal invention had carried the suggestion not of sound waves but of landscape—a furrowed field, or perhaps a flowing stream—showing the variety of inventive uses to which O'Keeffe's formal language could be applied.

Blue and Green Music

1919. Oil on canvas, 23 x 19"
The Art Institute of Chicago.
Gift of Georgia O'Keeffe to
The Alfred Stieglitz Collection

The equation of musical and visual arts was stressed by many painters and critics early in this century. O'Keeffe's keen interest in the subject led to a group of three "music paintings" in 1919.

The distinctive wave motif, like other inventions of the 1910s, provided the foundation for decorative compositions in the coming decades. The pattern reappeared, for instance, in O'Keeffe's acclaimed designs based upon close study of flowers. As she dove beelike into her subjects, their forms became increasingly abstract as blossoms were reduced to decorative pattern; yet the art's genesis in nature is recalled in the pulsing wavy lines, implying the organic vitality of the original floral inspiration.

In macrocosmic views as well as microcosmic, these forms proved useful. The vibrating patterns appearing in flowers, landscapes, and musical abstractions were also employed for more "cosmic" motifs, such as the cloud-and-sky design with which the artist paid homage to her favored brother Alexis in 1928. Like Stieglitz, who made his Equivalents, his most metaphysical and challenging statements, during the same period, O'Keeffe, in *Abstraction—Alexis* (overleaf),

turned her attention to the heavens above. The undulant horizon line is echoed in the flat lobes of cloud, rendered with a nearly Oriental delicacy, that continue the vibratory pattern throughout the composition. The peculiar persistence of this patterning through so many subjects left its impress upon O'Keeffe's contemporaries as well as later generations of artists, from the New Mexican painter Agnes Pelton, whose canvases of the 1930s mimic the design, to such recent feminist iconographers as Hannah Wilke and Judy Chicago, who have appropriated O'Keeffe's motif and by isolating it endowed it with special emblematic status.

But O'Keeffe's early abstract device possesses a significance that transcends the decoratively gynocentric—an assertion given credence by its appearance in the works of other pioneering modernists of O'Keeffe's era. Similar designs were employed by Wassily Kandinsky, Robert Delaunay, the British Vorticists, and even the experimental photographer Alvin Langdon Coburn, who jarred his tripod to achieve vibratory effects in his "Vortographs" of the mid-1910s. Fantasy figures painted by the Czech innovator František Kupka before 1910 are energized by a similar harmonic rhythm—like O'Keeffe's horizon, flower petals, and cumulus. The vibratory pattern recalls the synaesthetic equation proposed by the influential Kandinsky. "Words, musical tones and colors," he wrote, "possess the psychical power of calling forth soul vibrations . . . they create identical vibrations, ultimately bringing about the attainment of knowledge. . . . In Theosophy," he continued, "vibration is the formative agent behind all material shapes, which is but the manifestation of life concealed by matter."

Kandinsky's or Kupka's "manifestations of life" through vibration or other mystically derived patterns is akin to O'Keeffe's quest for the essence of life or nature. Although the American's approach was neither narrowly Theosophical nor doctrinaire, her reliance upon repeated patterns suggests comparable concerns for getting at rhythms beyond the visible.

The mystic reading of O'Keeffe's abstractions admittedly remains speculative, but no more so than Stieglitz's interpretation of the *Blue Lines No. 10* as an embodiment of sexual principles. The metaphoric potential of such designs fascinated O'Keeffe and lent her abstractions of the late 1910s their unique and compelling power. In these crucial and monumental abstractions, she took as her subject the cosmos, discovering in global subjects and universal themes sources of inspiration. To describe such, she had to invent a new pictorial language for that which she was unable to address verbally. As she explained, "It is lines and colors put together so that they may say something. For me, that is the very basis of painting. The abstraction is often the most definite form for the intangible thing in myself that I can only clarify in paint."

Abstraction—Alexis

1928. Oil on canvas, 36 x 30"
Private Collection

American modernists were often preoccupied with capturing a particular personality through abstract means, an interest that was especially pronounced among members of Alfred Stieglitz's circle. This abstract portrait honors O'Keeffe's favorite brother, who was poisoned by a noxious gas cloud during World War I.

ABSTRACTION

Abstraction—Alexis

Lake George—Abstraction

III. Lake George

THE APARTMENT OF STIEGLITZ'S NIECE into which O'Keeffe moved upon arriving in New York in 1918 was a dramatic change from her prior circumstances in the Texas Panhandle. It was in the city, in those cramped and borrowed quarters, that she produced her abstractions of skies over the plains and empty Texas spaces, poignant recollections of that which she had forsaken in order to join Stieglitz in Manhattan. But Alfred Stieglitz, like many urbanites then and now, also had a rural base, at Lake George in upstate New York, and every year he joined other members of the large family at his mother's summer home there. In August 1918, he was accompanied by O'Keeffe, who was warmly received by the *mater familias* and the sundry siblings, in-laws, and offspring of the Stieglitz tribe.

The verdant Lake George country was in its way as different from the wide Texas plains as had been the urban canyons of Manhattan. Its fertile fields and wooded hills, although more rugged than Wisconsin's, were reminiscent of the rural Midwest where O'Keeffe was born and spent her early childhood, or of the Virginia Piedmont where she passed her high-school years. Such landscapes, particularly the rich countryside around Sun Prairie, Wisconsin, left their impress upon the young girl, fostering a love of the land and a sense of nature's wonders which persisted throughout her lifetime.

Late in life, looking back with startling clarity over nearly nine decades, O'Keeffe described her earliest memory of patterns of sunlight and shadow on her baby quilt, an infantile impression of light and the outdoors that presaged the inspirations of her adulthood. Were one inclined to speculate on environment and the formative process, Sun Prairie would be a good place to begin the examination of O'Keeffe's landscape sensibility. The painter believed that herself, explaining that "what's important about painters is what part of the country they grow up in," and she always was proud of her roots in the Middle West, that "normal healthy part of America [which] had a great deal to do with my development as an artist."

Another of Wisconsin's famous offspring, Frank Lloyd Wright, often spoke of the deep impact that land had on him. The young Wright was particularly moved by the beauty of meadows in blossom, the sort of experience that provided O'Keeffe with inspiration and subjects for her early schoolgirl drawings. Wright proclaimed that "from sunrise to sunset there can be nothing so surpassingly beautiful in any cultivated garden as these wild Wisconsin pastures." The rural Wisconsin experience was also at the root of Wright's revulsion from Chi-

Lake George—Abstraction

1918. Oil on canvas, 19¼ x 14″
Whereabouts Unknown

O'Keeffe first visited Lake George in 1908, on a scholarship won for her work at the Art Students League. In 1918 she returned with Stieglitz, beginning the pattern of seasonal visits to his family home which persisted for more than a decade.

cago's urban architecture when he began his practice there. He later recalled that, in contrast to the Wisconsin farm where he "learn[ed] how really to work...all this I saw around me [in the city] seems affectation, nonsense, or profanity. The first feeling was hunger for reality and sincerity, a desire for simplicity." Similar in kind and intensity was O'Keeffe's ultimate reaction against the prevailing tastes in her field of painting, and against the urban environs where she was destined to spend much of her early career. The simplicity and reduction that are so often remarked upon in her work seem, at least in part, due to a Wright-like reverence for the basics, inspired by nature's teachings and strengthened by memories of her early years.

John Marin, another member of the Stieglitz group, upon first visiting the spacious country of the American West, exclaimed that by contrast "the East looks screened in." O'Keeffe had responded similarly, admitting that when she first discovered the Southwest, "I felt that Virginia was tired in comparison." However, O'Keeffe initially reacted to Lake George's leafy screen not as something tiresome, but inspiring. It was especially so after the family and visitors had departed, leaving her with Stieglitz, at peace in a northwoods autumn. One September she wrote enthusiastically to her friend Sherwood Anderson, exclaiming over "a wonderful morning...most summer people gone home....I wish you could see the place here—there is something so perfect about the mountains and the lake and the trees...it is really lovely." Autumn, O'Keeffe's favorite season, was also often her most fruitful. At Lake George, she responded to the unfamiliar crimson hillsides with colorful patterns, such as *Lake George— Abstraction* (1918; page 38); that "landscape" plays off an abstract swirl of red-orange and leafy forms of dark green against the blueness of the lake and sky in a design whose forms and colors parallel those of her contemporaneous abstractions. Subsequent paintings, such as *Maple and Cedar (Red)* (1923), focused upon the stylized mounds of red maple and dark pine silhouetted against the sky or accentuated the writhing rhythms of bending trees and swirling clouds in arabesques of flowerlike delicacy. In each case, the hues were the same as autumn painters had used, from Jasper Francis Cropsey's day onward, but O'Keeffe's simplified organic shapes, derived from the close observation of nature, resulted in landscapes of strikingly modern design.

Other seasons prompted comparably stylized designs, such as *Spring* (1922; overleaf). Its composition echoes the abstract patterns of the late 1910s; for example, the curious dark bar bisecting the design from the upper left recalls *Blue and Green Music*. *Spring*'s landscape forms also approximate the autumnal motifs of a few years earlier, including the conical cedars of the Lake George country; however, in lieu of her familiar October palette, fresh greens and acid yellows, combined with touches of cherry red and pinks, suggest the flowering of the new year. At the left of the painting, a large green shape sweeps upward to embrace a fruitlike form, suggesting an inverted bud and new growth.

During these early years at the lake O'Keeffe began to isolate the forms of trees in individual arboreal "portraits." Initially, the subjects were immersed in the greenness, such as the *Tree with Cut Limb* (c. 1920; Private Collection), which

Maple and Cedar (Red)

1923. Oil on canvas, 25 x 20"
Mr. and Mrs. Gerald P. Peters, Santa Fe.
Copyright © The Georgia O'Keeffe Foundation

The fiery tints of the Catskills in autumn inspired a series of colorful landscapes and leaf studies during the 1920s at Lake George.

Maple and Cedar (Red)

Spring

1922. Oil on canvas, 35½ x 30⅜″
Collection, Vassar College Art Gallery,
Poughkeepsie, New York.
Bequest of Mrs. Arthur Schwab (Edna Bryner '07)

recorded the appearance of a wounded sapling, probably in the orchard that
O'Keeffe helped to prune, a task at which Stieglitz photographed her and his
brother in the same year. Another local specimen, gnarled and grizzled, pro-
vided the inspiration for *The Old Maple, Lake George* (1926; Mississippi Museum
of Art, Jackson), whose shaft is animated by patterned bark and dark cavities,
suggesting the ravages of time and age and providing the tree a sense of individ-
ual personality. O'Keeffe here examines a detail section of the tree, and by re-
ducing the foliage and relegating it to the margins emphasizes the cruciform
design of trunk and limbs.

The crosslike pattern was even more pronounced in *Chestnut Tree—Red*,
whose bare limbs against a twilit sky O'Keeffe painted twice in the summer of
1924. The chestnut was the first of her Big Trees, large simplified renditions
which remained a recurrent preoccupation through much of her subsequent

work. The cruciform design, which anticipated her famed New Mexican crosses by several years, seems here unusually freighted with symbolic import.

The giant chestnut was one of Stieglitz's favorite landmarks on the family property; he spoke of it as "dignified" and grieved when it showed signs of blight. Reflecting on the death of his mother the preceding year, he lamented in 1923 that "our estate is going to pieces. . . . all about me disintegration—slow but sure: dying chestnut trees . . . the pines doomed too—diseased . . . the world in a great mess." The following summer, he photographed the dead chestnut boughs silhouetted against the sky, a memorial image to the beloved tree, and possibly to his mother as well. Stieglitz's attention to the chestnut coincided with O'Keeffe's turn to the same subject, and the somber palette and mood of her paintings seemed to echo his melancholy. In nature's forms and phenomena, both artists found analogues for personal states of mind, suggesting the subjective content that informed even their most representational works.

The smooth bareness of tree trunks and limbs continued to fascinate O'Keeffe. In the mid-1920s, she produced a series of tree studies emphasizing the tubular forms of trunks, details excerpted from the Lake George woodlands. Her interest paralleled that of Stieglitz, whose photograph *Dancing Trees* (1921) similarly focused upon the smooth trunks of fruit trees, here gracefully entwined at the crotch. His subject and handling are reminiscent of the nearly abstract designs based upon tree limbs that Charles Demuth had produced in the mid-1910s, works that Stieglitz admired. Stieglitz and Demuth first met in 1921, and Stieglitz quickly recognized a kindred spirit, leading to his inclusion of Demuth in exhibitions he organized over the next decade.

The suggestion of nature's vitality—the trees "dancing"—was found as well in O'Keeffe's paintings of silvery birch limbs, often embraced by boughs of dark pine. As with the chestnut, O'Keeffe used some of these natural motifs to express her thoughts and feelings. In at least one instance an arboreal subject became a surrogate portrait of a close friend. She told the writer Jean Toomer, who had visited Lake George in 1925, that "there is a painting I made from something of you the first time you were here," probably an allusion to her *Birch and Pine Trees—Pink* (1925; overleaf), one of a group of the paired trees she painted that year.

If the embrace of pale birch and dark pine alluded to O'Keeffe's friendship for the black author, other designs of branches and foliage seem more straightforward celebrations of the colorful effects of Lake George in October. In the Birches in Autumn series, also dating from 1925, the tree is centered in the canvas, immersed in autumnal yellows and oranges that fill the composition, obliterating any recession into space. In some of these works, strokes of pigment describe, somewhat impressionistically, individual leaves in profile; in others, a more general feathery blur of gold suggests the mass of foliage. In both cases, however, the smooth volumes of trunks and colorful blaze of foliage adhere insistently to the flat surface of the canvas. O'Keeffe, like many modernist painters, exploited the flatness of the canvas and did not seek to impose on it an illusion of depth.

Chestnut Tree—Red

1924. Oil on canvas, 36 x 30"
Private Collection.
Photo courtesy Gerald Peters Gallery,
Santa Fe, New Mexico
Copyright © The Georgia O'Keeffe Foundation

The old chestnut, Stieglitz's favorite tree on the family property, died in the winter of 1923–24, inspiring a group of mournful photographic studies by Stieglitz and two "memorial portraits" by O'Keeffe.

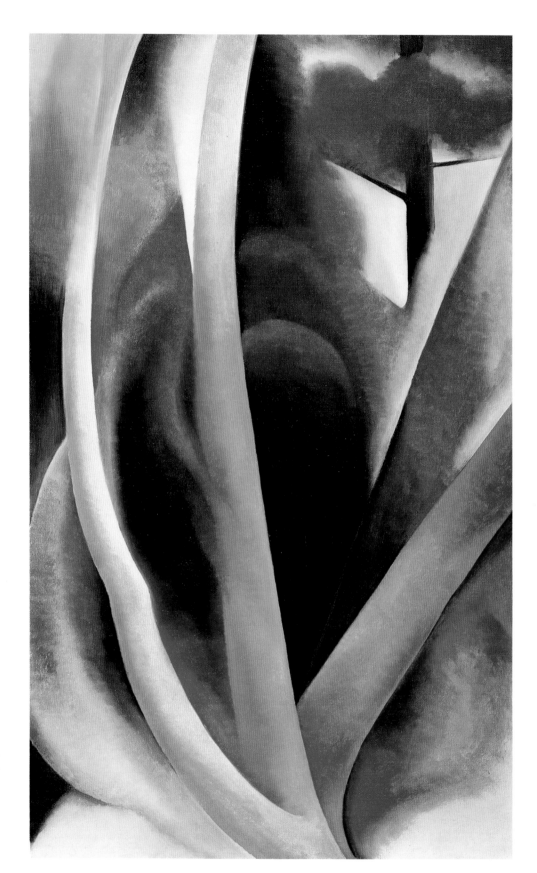

Birch and Pine Trees—Pink

1925. Oil on canvas, 36 x 22"
Collection of Paula and M. Anthony Fisher

In plants and other objects, O'Keeffe discovered a surrogate for portraiture; in this case, she "portrays" her friend, the novelist Jean Toomer, who had been a guest at Lake George in 1925.

44

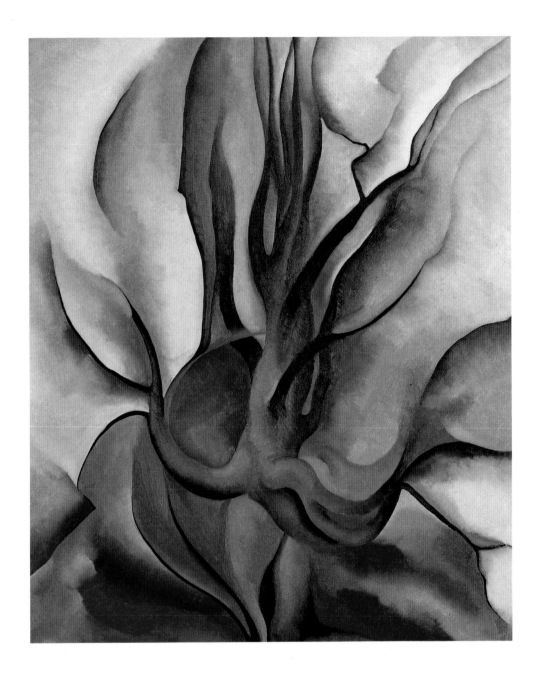

Autumn Trees—The Maple

1924. Oil on canvas, 36 x 30″
Mr. and Mrs. Gerald P. Peters, Santa Fe

Autumn Trees—The Maple (1924), painted with an unusual palette of cool blue-grays and liver reds similar to those of *Chestnut Tree—Red*, seems ultimately inspired by a different concern. Instead of being a memorial portrait, the painting provides a pretext for the exploration of a complex pattern, as the sinuous gray limbs of the maple taper into ambiguous planes of color. The painting is strikingly similar to the earlier tree designs of the Dutch modernist Piet Mondrian. The artful pattern of intersecting arcs across the flat plane of O'Keeffe's canvas parallels that of Mondrian's apple trees of about 1911; others of his early trees share her picture's range of reds and blues. Tantalizing though the similarities might be, any direct tie to the Dutch works is only speculative, as O'Keeffe had not traveled to Europe, and Mondrian's early work remained relatively unfamiliar in this country at that date. A more likely source of inspiration was

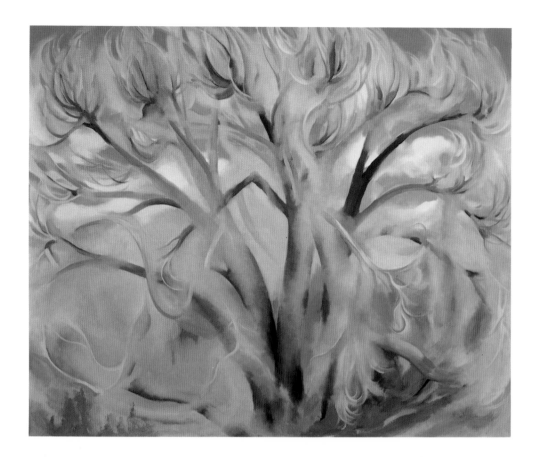

Cottonwood No. 1

1944. Oil on canvas, 30 x 36″
Gerald Peters Gallery, Santa Fe.
Copyright © The Georgia O'Keeffe Foundation

From the Lake No. 3

1924. Oil on canvas, 36 x 30″
Philadelphia Museum of Art.
The Alfred Stieglitz Collection,
Bequest of Georgia O'Keeffe

In the close observation of nature's phe-nomena, O'Keeffe continually discovered the motivation for colorful designs which often approached the abstract.

available closer to home, however, in Demuth's watercolors of entwined trees or the photographic studies by Stieglitz. Whatever their sources, the painted trees of O'Keeffe present distinctive solutions to the pictorial problems posed by the subjects. These were problems to which she would return in her series of New Mexican cottonwoods, begun in the mid-1940s.

In the 1920s, O'Keeffe also began to paint the lake and the surrounding countryside. As was often her wont, she studied the water and hillsides from different prospects, extracting from the motifs designs variously topographic or abstract. Her distinctive ability as a colorist reappeared in the stylized patterns of *Lake George with Crows* (1921; overleaf). The spatially ambiguous form of the blue lake is encircled by a simplified landscape, loosely brushed with inventive secondary hues—mauves, pinks, and grays—a palette reminiscent of some of Stanton Macdonald-Wright's work. The co-founder with Morgan Russell in 1913 of the Synchromist movement, the major American contribution to Parisian modernism in the years immediately preceding World War I, Macdonald-Wright's paintings were featured in the penultimate exhibition at 291 in 1917, immediately preceding O'Keeffe's finale. She had responded well to his "Synchromist things that are wonderful—Theory plus feeling—They are really great." The artist himself made rather a different impression; as she described him, he "looks glum diseased—physically and mentally—Id like to give him an airing in the country—green grass—blue sky and water—clean flowers—and clean simple folks." Ironically, when she turned to a country subject in *Lake George with*

From the Lake No. 3

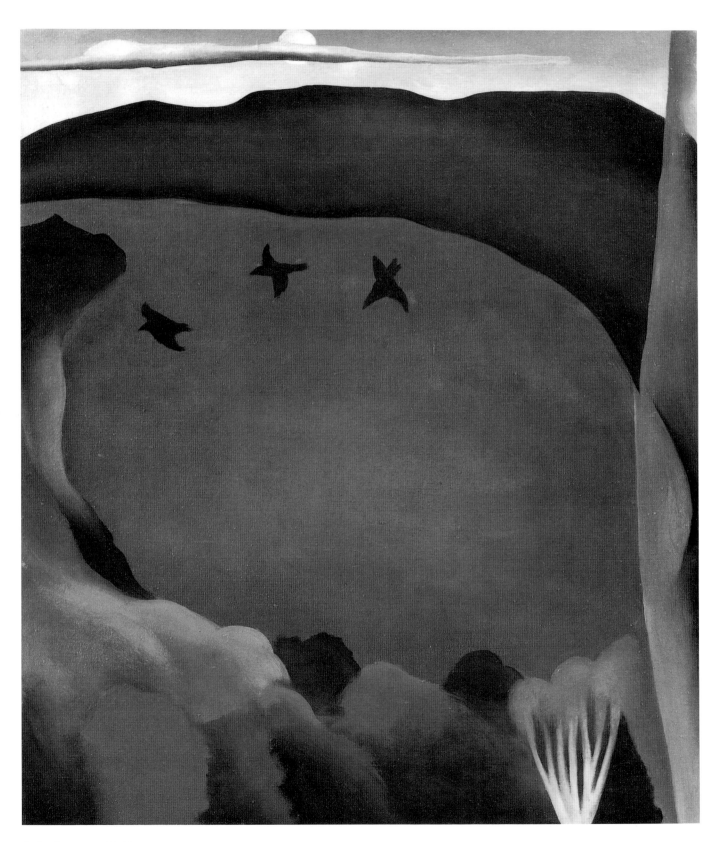

Lake George with Crows

Crows, it was rendered with his unnatural tints, rather than the grass greens and clean colors she had earlier commended.

The vertiginous prospect in *Lake George with Crows* brings to mind certain paintings by Thomas Hart Benton from his Synchromist period. During his brief excursion into modernist landscapes about 1920, Benton often painted the cliffs and inlets of Martha's Vineyard from an overhead perspective, resulting in stylized patterns pulsing with energy similar to O'Keeffe's Lake George vista. In both painters' landscapes, the blue lobe of lake or bay is viewed from overhead, which tilts the watery plane upward to align with the flat canvas; their similar experiments may have had less to do with influence between contemporaries than with their independent efforts to come to terms with the radical change in landscape practice effected in the early years of this century.

On other occasions O'Keeffe took imaginative flight over the waters to capture the many moods of Lake George. "The weather up here has gone absolutely mad," reported Stieglitz in late September 1919. "I have never seen such skies—Lightning changes of infinite variety—as the last three days here. We are having summer, autumn, spring & winter within a few hours.... Great to brace one up." O'Keeffe was likewise "braced up" by the lake country and the dramas overhead. In 1922, she recorded the awesome force of electrical storms above the dark waters in a pair of pastels which progress from an initial impression of lightning over the lake's reflective surface to a more stylized yet simplified design. This movement from representation toward abstraction, exemplifying the distillation of form and force, was shared by other nature-inspired artists of the Stieglitz circle, most notably Arthur Dove, whose earlier study of thunderstorms may have provided an inspiration for her experiments. Reflections on the water's still surface provided inspiration for other abstract patterns initially inspired by close observation, such as *Pink Moon and Blue Lines* (1923; Janet and Robert Kardon Collection), in which the horizon has been unexpectedly upended to effect a symmetrical vertical design. Equally disorienting is the effect of a "detail" of the lake, such as the curvilinear pattern that O'Keeffe abstracted from an overhead view of the gray waters against green and tan land in *From the Lake No. 3* (1924; page 47).

O'Keeffe's love of the land and of nature was contagious. One of the Stieglitz family retainers who knew him well admitted that "Mr. Alfred would never have been the photographer he later was if he hadn't got with Georgia.... He did wonderful street scenes, portraits, railroad tracks and all that before Georgia came. But after Georgia came, he made the clouds, the moon, he even made lightning. He never photographed things like that before." In 1922, Stieglitz turned his attention skyward, beginning the series of cloud studies that ultimately yielded his Equivalents, the most abstract and expressive of all his photographs. The limitless expanse of sky, the domain of lightning, played a crucial role in his work of the 1920s and in her paintings over a lifetime. She once explained the inspiration of New Mexico as in part deriving from having "more sky than earth in one's world," but even in the embrace of Lake George's verdant hills, the heavens often figured prominently.

Alfred Stieglitz, *Equivalent, Mountains and Sky, Lake George*

1924. Photograph, 9½ x 7½"
Philadelphia Museum of Art.
From the Carl Zingrosser Collection

Lake George with Crows

1921. Oil on canvas, 28½ x 25"
Private Collection.
Copyright © The Georgia O'Keeffe Foundation

A Celebration

The elongated view of clouds joyously cavorting overhead evokes parallels with the cloud subjects of Stieglitz's Equivalents and the format of Oriental scroll paintings, both highly prized by O'Keeffe.

Lake George

1926. Oil on canvas, 6 x 8″
The Regis Collection, Minneapolis.
Photo courtesy Gerald Peters Gallery,
Santa Fe, New Mexico

This small study was likely produced on the spot, as O'Keeffe enjoyed the effects of moonlight and darkness over the landscape.

A *Celebration*, O'Keeffe's jubilant cloudscape of 1924, echoes the subjects and the focus of Stieglitz's photographs. The long narrow canvas approximated the proportions of some of his works, and the blue and white colors echo those of cyanotypes, a kind of photographic print common at the time. The vertical format also echoes that of Oriental scrolls, a type which O'Keeffe had long admired and whose decorative effects are approximated in her unusual canvas.

Inspiration from overhead was also apparent in nocturnes, to which O'Keeffe, like many of her generation, was often drawn. One of the couple's favorite pastimes was rowing on the lake at night, escaping the crowded family homestead for private moments alone in the darkness. A study, *Lake George* (c. 1926), was probably inspired by such an evening; the dark, tiny canvas—six by eight inches, small enough to have been painted in the stern of a rowboat—belies the large scale of the landscape composition. In subject and mood, it is redolent of moody motifs from the turn of the century, for instance the moonlit marines of the vastly admired Albert Pinkham Ryder, subjects and attitudes to which O'Keeffe was logically an heir. In her study, however, Romantic reverie is complemented by the dramatically expressive jawlike intersection of dark cloud and hill which establishes a bold diagonal rhythm through simple landscape forms. This energized landscape composition became the basis for an extended series of nocturnes, some of which, like *Storm Cloud, Lake George* (1923; overleaf), emphasize the more turbulent aspects of nature's power. The bleak palette and somber mood of O'Keeffe's nocturne (as well as its curiously elongated format) suggest affinities with Marsden Hartley's brooding paintings of New Mexico, canvases that the artist was dispatching to his protector Stieglitz in 1922 and 1923 and that O'Keeffe would surely have known; yet her image is less tortured

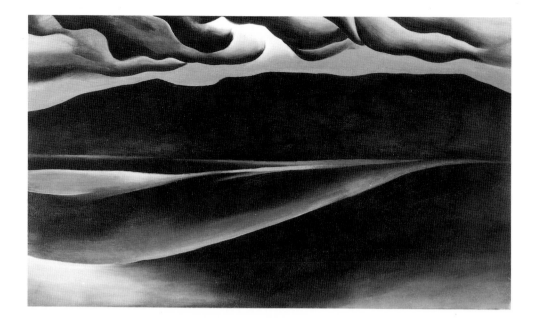

Storm Cloud, Lake George

1923. Oil on canvas, 18 x 30"
Private Collection.
Photo courtesy Gerald Peters Gallery,
Santa Fe, New Mexico

than any of Hartley's, moving not toward his expressionist extremes but instead toward suavely patterned abstractions, such as *From the Lake No. 1* (1924). Here she pushes the landscape into abstraction, celebrating the rhythms and colors of the stormy Lake George country in a design that grows simultaneously from her more representational views and from her abstractions.

The dynamic arrangement of forms suggests the search for an abstract equivalent for the forces of nature that motivated O'Keeffe's pictorial imagination. Like Arthur Dove, her artistic soul mate, she tended to simplify natural forms, seeking to distill their essence over extended treatments of a motif. His early pastel *Nature Symbolized* (1911; Art Institute of Chicago) was inspired by the experience of wind on a hillside, its movement over land and vegetation reduced to spiky arcs and comma shapes; with similarly elongated forms, O'Keeffe distilled the essence of storm sweeping over Lake George.

On other occasions, the organic vitality of nature prompted even more abstract designs. In *Dark Abstraction* (1924; St. Louis Museum of Art), she repeats the odd colors found in her *Storm Cloud, Lake George*, but now without any overt reference to specifics of the locale. The forms of blue-black and liver red collide in a pattern of geological suggestion, an abstract anticipation of plate tectonics yet absent particular topographical reference. In *Abstraction VI* (1928; overleaf) rhymed verticals of similar hue flicker upward in a design suggestive of vegetal tropism and vertical aspiration yet depictive of no particular plant. From such natural inspirations, grand or small, she derived the basis for her distinctive designs, compositions which mark the continuation of her abstract vision in the 1920s, even as she concurrently moved toward more representational views of the world around her.

O'Keeffe also found subjects that appealed to her interest in geometric form at Lake George. Surrounded by the verdant luxury of the landscape, she periodically turned for variety to the weathered barns on the Stieglitz family

From the Lake No. 1

1924. Oil on canvas, 37⅛ x 31"
Des Moines Art Center. Purchased with funds
from the Coffin Fine Arts Trust, Nathan Emory
Coffin Collection of the Des Moines Art Center

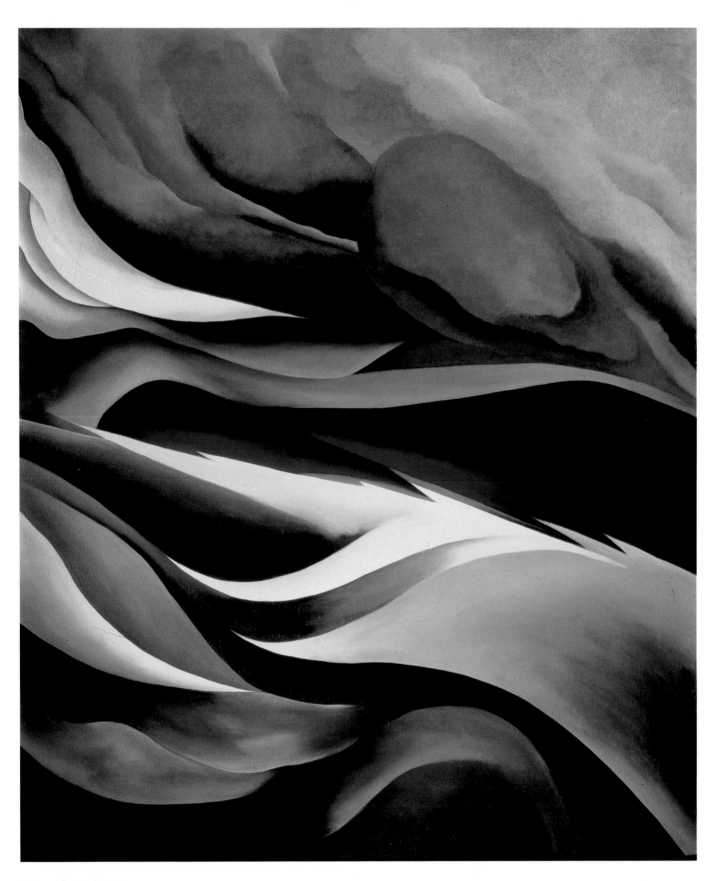

From the Lake No. 1

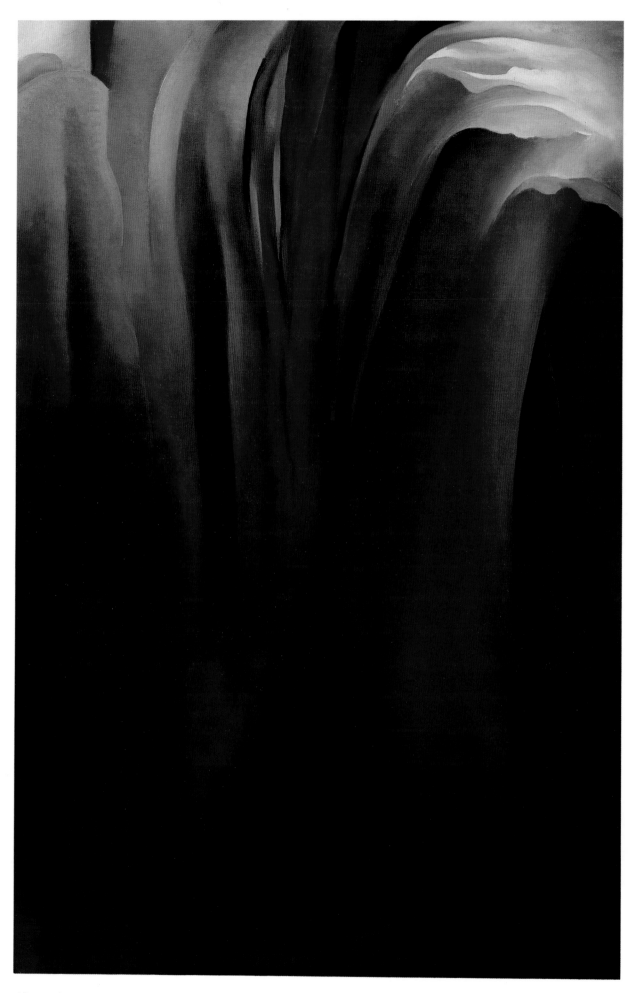

Abstraction VI

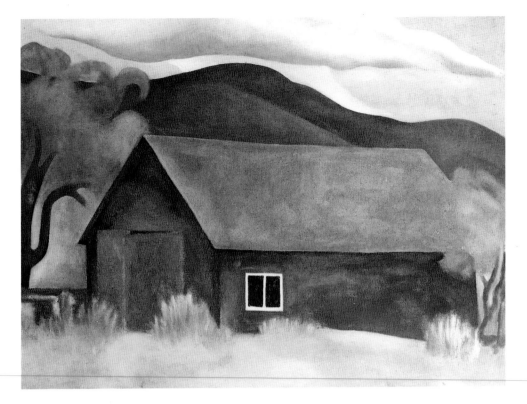

In 1920, during her third season at Lake George, O'Keeffe repaired a small, tumbledown shed, uphill from the main family house, to use as her painting studio. The "shanty" provided a place for her to work in private (as was her lifelong wont) and a welcomed refuge from the large Stieglitz clan.

property. Initially she posed these simple structures head on, silhouetting the gable against the sky to simplify its characteristic profile. Subsequent treatments of the subject grew more complicated as, for instance, she abutted the structures and established angular rhythms with their rhymed peaks. O'Keeffe's various approaches to the Lake George barns parallel those of others in the same period, as numerous artists turned to vernacular subjects with new interest. Charles Sheeler, for example, in the late 1910s and early 1920s depicted the simple farm structures of rural Pennsylvania in an extended series of drawings, paintings, and photographs which are notable for their clarity and geometric precision. At Lake George, Stieglitz also was drawn to the weathered structures whose form and textures he examined in photographs. However, O'Keeffe's attraction to comparable subjects seems ultimately to have arisen from more personal associations, different from either of theirs.

The Shanty (1922) depicts a small, derelict building beyond the farmhouse at Lake George that had been refurbished on the interior to provide a workplace for O'Keeffe, a rustic studio and a retreat from the talkative crowd of family and visitors that congregated seasonally at the Stieglitz home. Amidst the ripe greenness of the countryside, the building's weathered exterior—"shabby . . . brown burned wood"—one day caught her eye, providing a striking contrast to "the clean, clear colors [that] were in my head," and in her paintings. The glimpse of the building against the hillside inspired the thought that "I can paint one of those dismal-colored paintings like the men. I think just for fun I will try—all low-toned and dreary." The odd tertiary colors O'Keeffe employed echo the dark palette Marsden Hartley used at the time—tones which one critic described as "dully empurple[d]"—and resulted in "my only low-toned, dismal-

Abstraction VI

colored painting." The choice of the weathered shanty as the subject for her canvas seems then more than serendipitous, however; in addition to being a chromatic experiment influenced by Hartley, the motif was also one of symbolic consequence to the artist, a portrait of her private refuge.

Although O'Keeffe's shanty did not appear in subsequent canvases, the fascination with weathered Lake George barns persisted through the decade, their reappearance again suggesting an emotional attachment to the motif. Ultimately, the subject seems more about the artist than the architecture. Such structures had been a familiar part of O'Keeffe's world from her earliest memories of life on her father's Wisconsin dairy farm, and her gravitation to the subject in the 1920s suggests it had a claim on her imagination beyond the period's general interest in Americana and "native ground." Even in old age, recollections of her Wisconsin childhood brought pleasure to her: "I can still see the enormous loads of hay coming into the barns in the evening," she told one interviewer, "I've never seen loads of hay like that anywhere else." In 1929 she admitted to a friend that "the barn is a very healthy part of me—. . . It is something that I know . . . it is my childhood."

The specific barn she referred to on that occasion appeared in a painting made during the summer of 1928 in Portage, Wisconsin, where, during a stressful period in her career and her personal life, O'Keeffe had temporarily escaped for a visit with family in her childhood home. Unlike the weathered Lake George structures that sometimes slumped wearily into the gray-green landscape, as in *Lake George Barns* (1926), she depicted the Wisconsin barn standing proudly erect, its bright red gable crowding the upper margin of the canvas. The subject clearly recalls the vanished happiness of her childhood. O'Keeffe rejoiced in the physical environs of the Middle West during her restorative visit and spoke especially of the barns, including one her father had built in Sun Prairie. While the Portage barn she depicted was not the one built by her father, the subject inescapably evokes memories of Francis O'Keeffe, who had died in 1918 after a fall from a steep roof on which he was working; a decade later, memories of this tragedy may have inspired his daughter's nearly abstract painting *Wisconsin Barn* (1928), which isolates the sharp triangle of gable against the sky, perhaps an homage to her father.

Speaking of the barns that were "a very healthy part of me," O'Keeffe lamented somewhat cryptically that "there should be more of it." It is significant that she returned to the subject at moments of personal distress, as during a 1932 trip to Canada's rugged Gaspé country—another of her periodic escapes from the tensions of life with Stieglitz at Lake George—where her attention was captured by the "hideous houses and beautiful barns. The barns looked old, as if they belonged to the land, while the houses looked like bad accidents," and not surprisingly it was the barns that she featured in her Canadian paintings. A final reprise on the subject dates from 1934, as O'Keeffe emerged from the most trying period of her life; instead of the greenery of summer or the brown tints of autumn, in which she had previously situated her barns, she blanketed her motif with winter's snow, significantly bringing the cycle to seasonal closure.

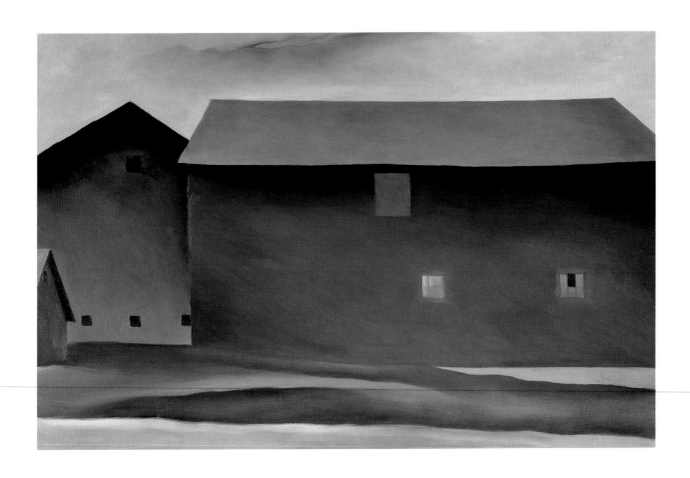

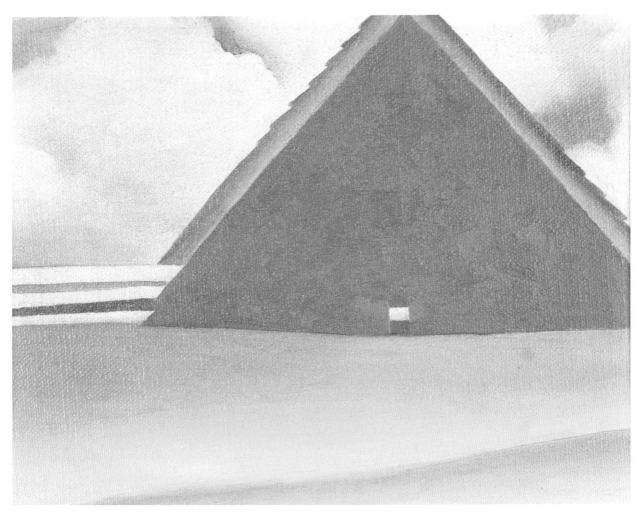

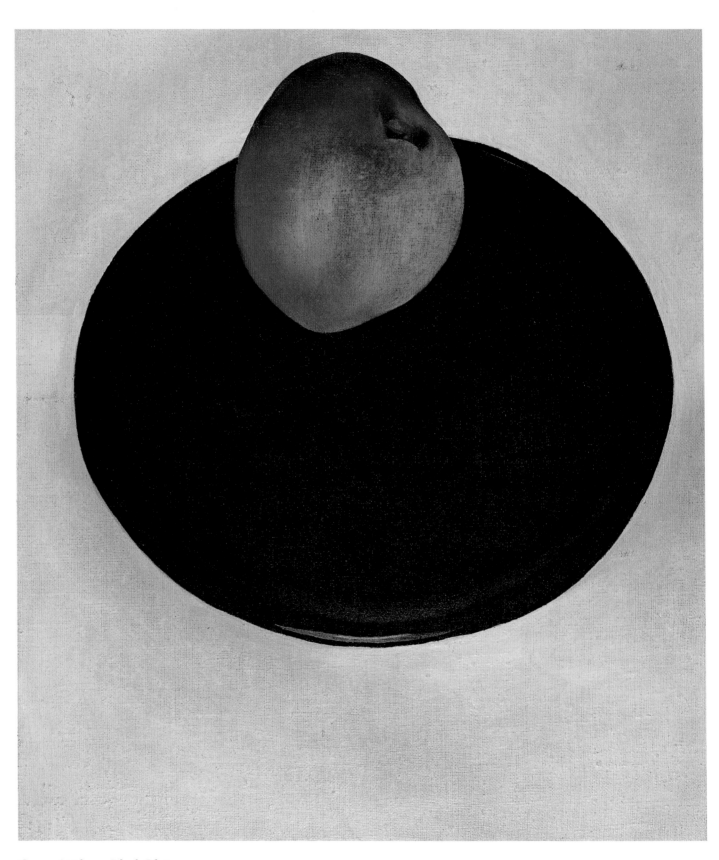

Green Apple on Black Plate

IV. Fruit and Leaf

LATE IN HER LIFE, O'KEEFFE RECALLED WITH PLEASURE William Merritt Chase's still-life classes at the Art Students League in New York, where she studied in 1907-08. The influential painter and teacher was one of the few American Impressionists to create a significant body of still-life compositions. In the early years of the new century, he made a specialty of glistening fish subjects, often in combination with metal vessels, all painted with a warm, shadowy palette very different from his earlier and more colorful outdoor scenes. It was the still life, and dashing brushwork shot through with silvery highlights of white, that he pressed upon his students. In Chase's classes, the sensibility of a still-life painter was nurtured, and it remained with O'Keeffe throughout her career. Even when her interest digressed into landscape and abstraction, the sense of stilled forms closely studied persisted, giving her work its distinctive unity of effect.

O'Keeffe and her classmates were expected to produce a new still life daily in preparation for the master's weekly critique, a demanding regimen which she found inspirational. "There was something fresh and energetic and fierce and exacting about him that made him fun." That such adjectives might also have been applied to the legendary persona O'Keeffe cultivated for herself suggests the depth and endurance of Chase's impact on his student. Similarly influential was his evident enjoyment of the artist's life; many years afterward, O'Keeffe could still remember clearly his appearance, down to such details as the carnation in his lapel. Ultimately more important than questions of personality or dress, however, was Chase's impact as a painter. His technique was memorable. "His love of style—color—paint as paint—was lively," she recalled. To capture the revered teacher's eye, students tried to charge their daily canvases with "a kind of dash and 'go' that kept us looking for something lively, kept us pretty well keyed up."

Chase's bravura brushwork differed markedly from the restrained manner that O'Keeffe eventually developed; her mature images are certainly not the products of "dash and go," looking instead, as one critic wrote, like they had been "wished upon the canvas." Yet, in fundamental ways Chase's impact remained crucial for O'Keeffe. In her productive periods she often kept to the painting-per-day habit he had inculcated in his students, and sometimes even surpassed that pace; more consequential than speed, however, was the seriousness of purpose that Chase invested in his work and which O'Keeffe shared. She once explained to an interviewer her reasons for painting: "One works I sup-

Green Apple on Black Plate

c. 1921. Oil on canvas, 14 x 12½"
Collection of the Birmingham Art Museum,
Alabama.
Museum Purchase with funds from the 1983
Beaux-Arts Committee, Advisory Committee,
Museum Store, donors, and matching funds from
Mr. and Mrs. Jack McSpadden

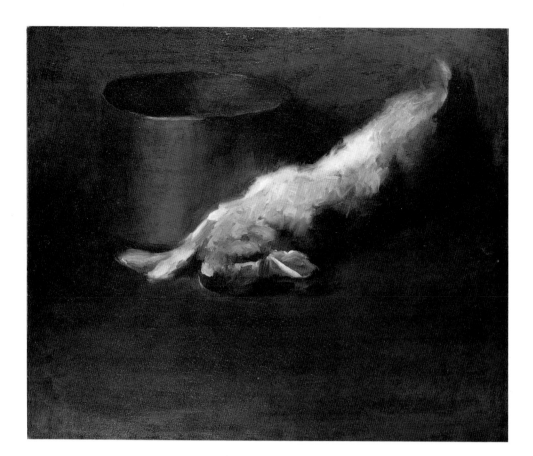

Dead Rabbit and Copper Pot

1908. Oil on canvas, 19 x 23½"
The Art Students League, New York

This painting was made while O'Keeffe was studying with William Merritt Chase at the Art Students League; it won the artist a first prize in still life and a summer fellowship to the league's school at Lake George.

pose because it is the most interesting thing one knows to do. The days one works are the best days. On the other days one is hurrying through the other things one imagines one has to do to keep one's life going. You get the garden planted. You get the roof fixed. You take the dog to the vet. You spend the day with a friend. . . . But always you are hurrying through these things with a certain amount of aggravation so that you can get at the painting again because that is the high spot—in a way what you do all the other things for. Why it is that way I do not know. I have no theories to offer. The painting is like a thread that runs through all the reasons for all the other things that make one's life." William Merritt Chase would have understood and applauded his student's diligence.

Chase early recognized O'Keeffe's talents, in 1908 awarding her a prize for still life and a scholarship to the league's summer program at Lake George. The canvas that won her this acclaim was *Dead Rabbit and Copper Pot*, a competent (if uninspired) imitation of Chase's motifs whose interest resides in the rendering of surface effects. In retrospect, it might be tempting to see in the dead rabbit a precedent for the deceased animals whose skeletons she painted in the 1930s— but this is surely coincidental. More than any sentiments or associations which the dead rabbit might arouse, it was the formal challenge of the assignment that motivated O'Keeffe. "I loved the color in the brass and copper pots and pans, peppers, onions and other things we painted for him."

The tenebrous tones of the canvas with rabbit and pot were not at all typical of the clear hues that O'Keeffe favored in later years. From the metallic tones of pots and pans she soon moved to a brighter, clearer range of color, as suggested

FRUIT AND LEAF

in the surprising still life *Horse—Red* (c. 1914; overleaf). The combination of red clay horse and yellow plate against blue wall provides an early indication of O'Keeffe's bold chromatic abilities, which were encouraged in her studies with Arthur Wesley Dow during the early 1910s, from which period the painting dates. In lieu of the loaded brushes employed in Chase's still-life classes, O'Keeffe in this design used the pointillist touch, suggesting both her experimental manner and a familiarity with developments in French art around the turn of the century. The brushwork called attention to the surface of the painting, announcing a new concern for compositional pattern; the skewed perspective on the upturned plate reinforces the flatness of the design.

Despite—or perhaps because of—the imposing precedent of still lifes by Cézanne, Picasso, Braque, and other Parisian innovators, modernist painters in this country were slow to turn to the mute and humble objects of the household, field, or garden. Photographers were quicker to exploit such subjects, their medium being less burdened by artistic traditions and hierarchical values. The camera's capacity for depicting closely focused details yielded surprisingly abstract patterns when, for instance, Paul Strand examined ordinary vessels in his famous *Abstraction, Bowls* (1915), a work which Stieglitz exhibited at 291 and reproduced in *Camera Work*. The stylish design of the bowls' arcs and shadows at once disguised the ordinariness of the subject and freed it from traditional domestic connotations. The interlocking pattern of hemispheres reads very differently from O'Keeffe's student work.

At their first meeting in 1917, O'Keeffe had been greatly impressed by Strand and his art, which included landscape and figurative work as well as still-life arrangements. She later confided to the photographer the impact he had made upon her: "I believe Ive been looking at things and seeing them as I thought you might photograph them—Isn't that funny—making Strand photographs for myself in my head."

The results of this internalized vision became apparent soon enough in her painting. About 1920, after an intensive period of experimentation with abstract design, she rediscovered her interest in still-life compositions, but with results strikingly different from the conventional arrangements she had produced under Chase's tutelage. *Green Apple on Black Plate* (c. 1921; page 58) releases the fruit and container from the confines of the tabletop to examine their form and clean outline against the ambiguous space of the white ground. The striking silhouette of the paired subjects, the fruit so rotund on the uptilted plane of the plate, defies both gravity and tradition. By isolating the motif and emphasizing its clean, hard contours O'Keeffe has given primacy to design over subject, just as Strand had done with his bowl abstraction.

The simple form of fruit and plate, an intensification of the design essayed in her still life with the red horse, is strikingly similar to other photographic still lifes of the period, such as Strand's closely studied apples and round pans or Edward Steichen's studies of fruit, the latter a possible inspiration for her painted version. The photographers were, of course, limited to the range of silvery grays afforded by their medium, whereas O'Keeffe, even in this relatively early

Horse—Red

The intense colors and distinctive strokes of this still life show O'Keeffe's new interest in European modernism, examples of which she could have seen while studying in New York.

Alligator Pears in Basket No. 2

exercise, has shown her penchant for striking chromatic combination, playing the stark blacks and whites off against the intense acid green of the fruit. Paradoxically, the black-and-white work of Strand and other innovative photographers at 291 had released this sensitivity to color in the painter. "I think you people [at 291] have made me see—or should I say feel new colors—I cannot say them to you but I think Im going to make them," a forecast of 1917 which was borne out in her abstractions of the late 1910s and in her still lifes of the following decade.

Sometimes the simple compositions of fruit were treated in the near monochromes of a photographic palette, as in her black and silvery pastel *Single Alligator Pear* (1922; location unknown), which exploits the pure, clean form of the fruit isolated on a smooth, white cloth. In its stark simplicity, the single avocado departs from the formula of what O'Keeffe jokingly called her "alligator-pears-in-a-large-dark-basket period." In *Alligator Pears in Basket No. 2* (1923) the highlighted spheres of the fruit are painted with rich black-greens and bordered by zones of brilliant hue; the pigments are applied with a palette knife—an unusual technique for O'Keeffe—as if she wished to stress the surface of the painting.

Alligator Pears in Basket No. 2

Alfred Stieglitz, *Georgia O'Keeffe: A Portrait—with Apple Branch*

1921. Gelatin silver print, 4⁹⁄₁₆ x 3⅝"
Philadelphia Museum of Art.
The Alfred Stieglitz Collection

She sustained her interest in her distinctive approach to still-life compositions over a number of years, even as the men of the Stieglitz circle "were all discussing Cézanne with long involved remarks about the 'plastic quality' of his form and color," aesthetic debates which failed to engage O'Keeffe. In an early discussion of her paintings, Strand was characteristic of "the men," combining considerations of Cézanne and Freud to acclaim her work as "the most personal and subtle perceptions of woman [which] are embodied for the first time in plastic terms." In her recollections of those heady years, however, she retained an almost defiant pride that "I was an outsider. My color and form were not acceptable. It had nothing to do with Cézanne or anyone else. I didn't understand what they were talking about—why one color was better than another." She added, coyly: "I never did understand what they meant by 'plastic.'"

The "plastic" qualities of Cézanne's cylinders, spheres, and cones, compositional elements that were the foundation of his still lifes as well as his landscapes and figurative compositions, had provided the basis for the modernist revolution that in time came to hold many American painters in thrall. In the years immediately following World War I, several of Stieglitz's intimates committed to this formal exploration. Marsden Hartley in 1917 returned to still lifes of fruit and flowers he had begun a few years earlier, and over the next several years restlessly explored their pictorial possibilities in modes variously indebted to Cézanne, Braque, and Matisse. His arrangements were highly structured, paradoxically combining a sense of classical composition with dark, expressive brushwork. In a passage as notable for its Freudianism as its aesthetic insight, the prominent critic Paul Rosenfeld, long a partisan of the Stieglitz circle, observed that with Hartley, "a cold and ferocious sensuality seeks to satisfy itself in the still-lives, with their heavy stiff golden bananas, their dark luscious figs, their erectile pears and enormous breast-like peaches."

Inspired by the enthusiasms of his friend Hartley, Charles Demuth at the same time began to crystallize his watercolor style. The late watercolors of Cézanne, with their delicate washes and flickering forms, prompted a new assuredness in Demuth, who began by applying Cubist fracture to architectural and nautical forms and proceeded to fruits and flowers which he treated with sparkling effects.

O'Keeffe's return to still-life motifs paralleled those of her admired contemporaries, although with different effect. Her compositions rely less upon Cézanne's classical structure and crisp forms; instead, they are activated by organic rhythms and a pulsing vitality such as was simultaneously manifest in her abstractions and landscapes. A series of apple compositions which O'Keeffe called Apple Family emphasize not the faceted color and "modern" flatness of Demuth's watercolors, but instead the ripe roundness of the fruit, which energizes the composition.

The Apple Family paintings compressed their subjects into small canvases, thereby exaggerating the fullness of their forms. The close focus on the still life again suggests analogies to photographic practice, isolating the orbs in an indefinite space much as Steichen did in his 1919 studies of the fruit; but, with the

FRUIT AND LEAF

Because of its frequent appearance in Paul Cézanne's still lifes, the apple became emblematic of avant-garde style and attitudes. It also had long been used by American artists to represent the richness of the native land and harvest. In the early 1920s, both Stieglitz and O'Keeffe often depicted the fruit, which abounded in the orchards around Lake George.

advantage of her striking palette, O'Keeffe was able to enliven her composition with chromatic energy unavailable to the photographer. Critics and other artists waxed rhapsodic over her sense of color, evident in the still lifes as well as in her abstractions. In *Apple Family III* (1921) the daring juxtaposition of acid green and yellow with hot reds is characteristic of the "oblique, close, tart harmonies" that Paul Rosenfeld discovered throughout her work, and to which he attributed "much of its curious, biting, pungent savor."

That vital "savor" was expressed differently in photographs of apples that Stieglitz made about the same time. In 1921, he photographed O'Keeffe holding a bough heavy with fruit; posed with classical stability against the empyrean, the subject evokes recollections of a Bellini Madonna—and of Eve. The following year, he again focused on the subject, in his *Apple and Gable, Lake George*, coupling the laden bough not with a figure but with the family homestead. As he explained that summer, "When I go at something, *all* of me is in the centre of that thing digging into that centre's centre." With the apple-and-gable subject, as with the O'Keeffe portrait and other Lake George motifs from that period, Stieglitz was striving to represent not the thing itself but the larger import hidden beneath surface appearance, to dig at the center's center. It was that larger significance that moved his friend Hart Crane to exclaim before Stieglitz's apple image: "That is it. You have captured life."

In her paintings of the period, O'Keeffe similarly strove to capture more than the surfaces of her subjects. In the Apple Family series, she animates her subjects, seemingly endowing the fruits with sentience, creating surrogates for human figures. The effect is duplicated in *Pear and Fig* (1921); the dark fig

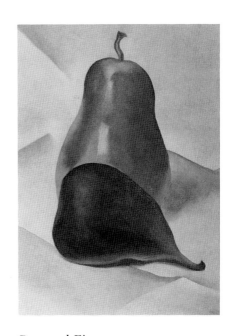

Pear and Fig

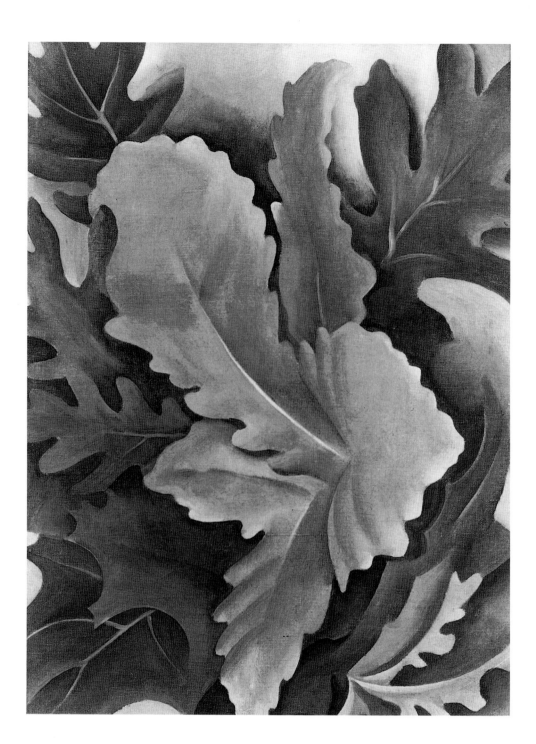

Green Oak Leaves

c. 1923. Oil on canvas mounted on wood, 12 x 9″
Collection of The Newark Museum, New Jersey.
Cora Louise Hartschorn Bequest, 1958

reclines in the foreground while its red mate stands behind, the duo presented
with the air of a double portrait. While her style is at variance with Hartley's
expressive brushwork, O'Keeffe's swelling fruits provide a sensual equivalent to
his "dark luscious figs" and "erectile pears."

The sense of pulsing vitality increased in subsequent still lifes where the
dark fruits recline in undulant folds of white. In comparison with the simple
design of *Green Apple on Black Plate*, almost Oriental in its grace, these paired
fruits of the mid-1920s with their swelling rhythms advancing and receding
appear nearly baroque.

Similar rhythms can be found in O'Keeffe's studies of tree leaves. Initially,

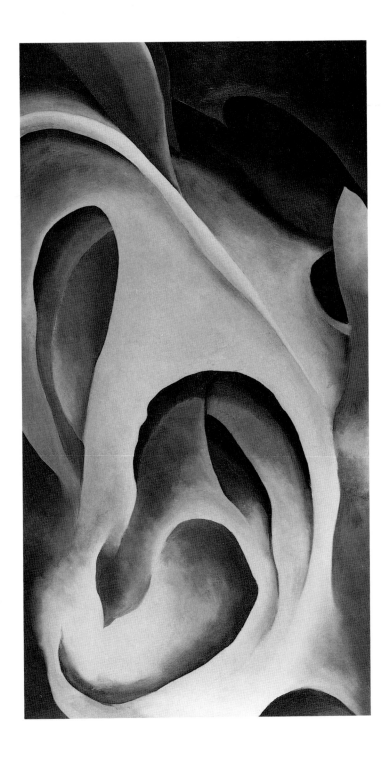

Leaf Motif No. 2

1924. Oil on canvas, 35 x 18″
Marion Koogler McNay Art Museum,
San Antonio, Texas.
The Mary and Sylvan Lang Collection

In 1924, O'Keeffe initiated the series of leaf and floral forms, closely viewed and greatly magnified, that became a "signature image" for the balance of her career.

these leaf designs seemed to be excerpted from her early Lake George panoramic views of forest and foliage, fragments of verdure that represented the larger environ. Eventually she began to zero in on clusters of green or autumnal russet, enlarging the subjects to fill the confines of the canvas, but still clearly relating them to their natural setting and living source. In a small canvas called *Green Oak Leaves* (c. 1923) equivalent in size to the small paintings of fruit, she studied a pattern of oak leaves which move in and out of space in a fashion similar to the folded drapery in her fruit pictures of the same date.

The sweeping diagonals and complex, ornate dynamics of such compositions culminated in *Leaf Motif No. 2*, one of a pair of 1924 paintings in which the

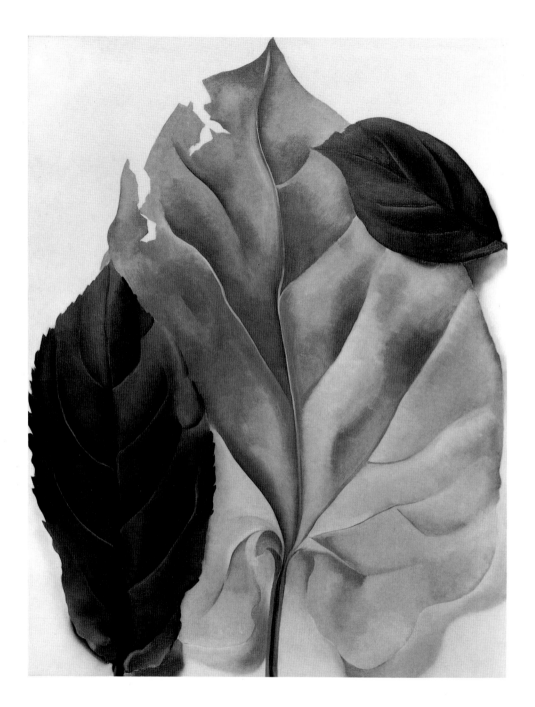

Brown and Tan Leaves

1928. Oil on canvas, 40 x 30″
Mr. and Mrs. Gerald P. Peters, Santa Fe

Dark and Lavender Leaf

1931. Oil on canvas, 20 x 17″
Private Collection.
Copyright © The Georgia O'Keeffe Foundation

subjects were suddenly and dramatically enlarged to fill the thirty-six-inch canvas. No longer viewed "in nature," these sere leaves twist and curl in a nearly abstract design. The leaves, fallen or plucked, suggest the subjects of O'Keeffe's subsequent still lifes; their increased size and scale are harbingers of new directions.

Over time, the convulsive arrangements yielded to frontal depictions of single or overlapping leaves, flatter and more static in design, while the greenery of her early clusters also succumbed to a more autumnal range of color. *Pattern of Leaves* (Phillips Collection, Washington, D.C.), probably dating from the fall of 1923, announced the new mood in her work; its design of three maple leaves

FRUIT AND LEAF

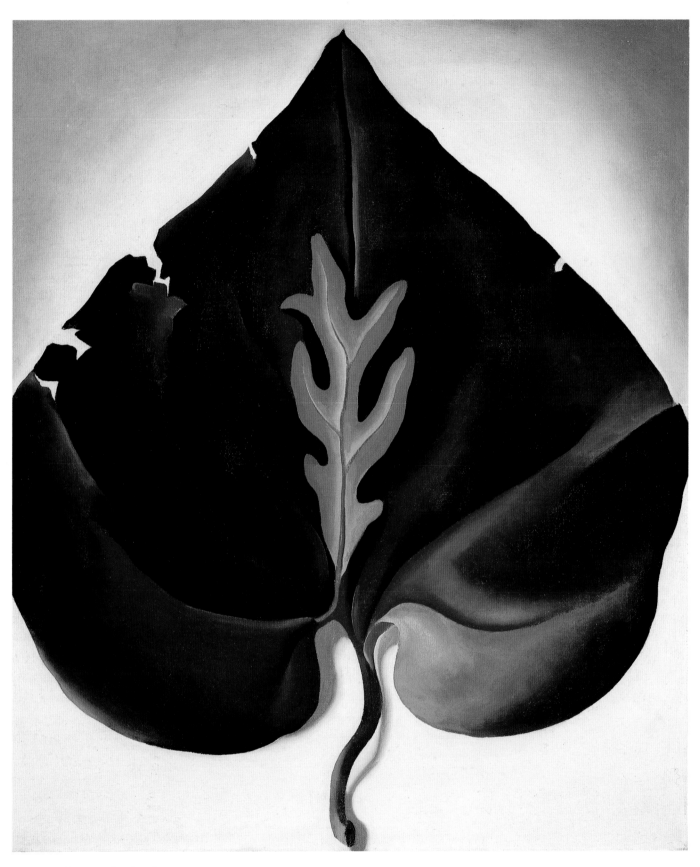

Dark and Lavender Leaf

layered flatly on a white plane recalled the continuing influence of O'Keeffe's mentor, Arthur Dow. In stressing design based upon natural forms, he made various assignments "in the arrangement of color and shape, dark and light, smooth and rough, and so forth," she explained. "One of his exercises was to take a maple leaf and fit it into a seven-inch square in various ways." Although larger than seven inches, O'Keeffe's early Lake George leaf compositions were still relatively small. The simple calm of her layered forms—sometimes specifically laid on snow, often depicted on a white or pale ground—increased after 1924, along with the dimensions of her canvases, culminating in the grand *Brown and Tan Leaves* of 1928 (page 68). In that large canvas, the three magnified leaves are disposed on the undefined background with an artful asymmetry reminiscent of Dow's Orientalizing precepts. The somber tones suggest a personal valedictory to Lake George, the summer verdure and even the October glories that had by late in the decade loosed their grip on the artist.

In 1929, O'Keeffe broke the seasonal pattern of family holidays at Lake George and traveled instead to New Mexico, where she discovered new inspiration and independence. This journey was undertaken over Stieglitz's objections, and his ambivalence continued over the next two summers when she returned to the Southwest. The summer of 1931 was a good one for the painter as she revelled in her new surroundings; in July she wrote from Alcalde, New Mexico, to her friend Henry McBride, critic for the *New York Sun*, exclaiming joyously that "the days here are very good. They are mostly days alone—out of doors all day—I hate being under a roof." Stimulated by the landscape, she regretted only that "the things I like here seem so far away from what I vaguely remember of New York." O'Keeffe was well embarked upon another productive season, but could not escape the nagging thoughts of other obligations. "Cant leave that man alone too long," she confessed to her correspondent. Finally, torn between her love of the desert and her allegiance to Stieglitz, she abbreviated her summer stay and hastened to Lake George.

With the return to New York in late July, O'Keeffe's spirits quickly changed. Her mood showed in her correspondence with a confidant, the New Mexican painter Russell Vernon Hunter, to whom she complained that in Lake George, "I feel smothered with green. . . . Everything is so soft here—I do not work. . . . I walk much and endure the green." She was oppressed not only by the landscape, but by the annual influx of the Stieglitz clan as well, which brought its usual stresses. After so many summers of their unwelcome company, however, O'Keeffe was adept at dealing with this familiar problem. She confided to another friend that "family life . . . at present is a bit thick," but she knew that "nothing disarms them like laughing at them."

More than the green and the clan, the root of O'Keeffe's discontent lay in the relationship with her husband, which was showing signs of strain that could not be laughed away. She had cut short her work in New Mexico thinking that he needed her assistance and company, but upon arriving in Lake George confessed to "feeling a bit disgruntled that I thought I had to come East." Her admission was a remarkably understated reaction to his apparent liaison with

Dorothy Norman, the young photographer and society matron who had become a fixed presence at Stieglitz's gallery. During O'Keeffe's absence, his dependence upon Mrs. Norman's talents had blossomed, and O'Keeffe was distraught to discover that he had made visits to the Normans' Cape Cod summer home. With exquisite insensitivity, he repeated this atypical break in his New York City–Lake George orbit even after his wife had returned from New Mexico.

When she was stirred to paint again that autumn, she made a reprise of the foliate motif. The painting of *Dark and Lavender Leaf* (page 69) is an anomaly, dating from 1931, several years after her abandonment of the subject. The haunting image was never exhibited nor reproduced, and the artist retained it throughout her life, suggesting that the design was exceptional both in its inspiration and its personal meaning. O'Keeffe conceived the design of two unequal but related forms during a period of great emotional stress, and the painting is endowed with a mood different from its predecessors, more somber, even tragic. The pale, fragile oak seems cradled in the dark embrace of the larger and more weathered leaf, at once sheltered by its mate yet overshadowed as well, smothered with dark.

The silhouette of dark leaf laid on a light ground reads like an ace of spades, evoking memories of the ancient gypsy sign of death. (O'Keeffe and Stieglitz, both music lovers, would likely have been familiar with that sign's significant symbolism, as, for instance, in the fortune-telling scene from Bizet's perenially popular opera, *Carmen*.) If the canvas is inverted—as O'Keeffe often did in trying out her designs—the ace of spades becomes a heart, provoking another cluster of associations. From her Catholic upbringing and attendance at the Sacred Heart Academy, O'Keeffe would have been familiar with Mariology's cardiac symbolism. But, for the rebuffed artist-and-wife, the dark form implies a meaning less religious and more personal; it appears to be a cinder heart. The slender form of the oak leaf, when inverted, looks like blood flowing from a gash in the dark, evoking a bleeding heart. (It may not be coincidental that the 1931 leaf picture shortly preceded O'Keeffe's series of Bleeding Heart floral studies, initiated the following spring.)

The lavender leaf is apparently from a pin oak, whose name elicits lancelike images which convey the notion of suffering. The botanical specifics of the larger, older, darker leaf are less precise; its deeply notched, lobed form seems to belong to the type associated with basswood or catalpa, both native to the Catskill region. The heart shape and large size are also characteristic of the genus *Cercis*, or redbud, a tree less common in the Lake George region but certainly familiar to midwesterners, including those from Sun Prairie; if O'Keeffe was here remembering the redbud's distinctive leaf, she might also have been mindful of its popular name, the "Judas tree." Such a connotation would make especially apt its inclusion in this painting, which seems one of symbolic import. With the *Dark and Lavender Leaf*, O'Keeffe transformed her traditional still-life subject into a leafy memorial portrait, inventing a surrogate depiction of the artist and her husband at the nadir of their relationship.

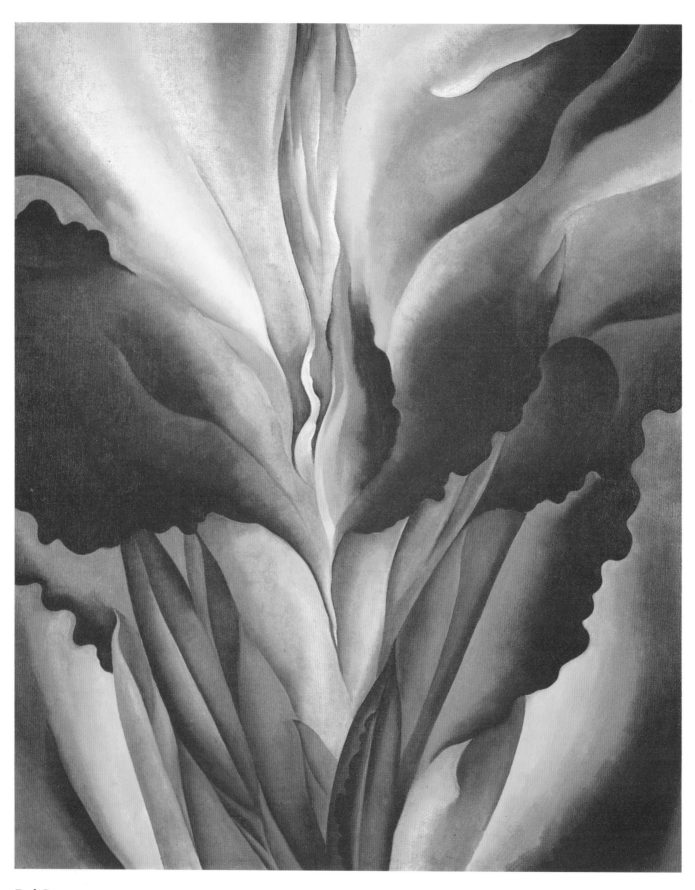

Red Canna

V. Flower

I N SEPTEMBER 1916, GEORGIA O'KEEFE SPENT AN EVENING on the Texas plains, enjoying the beauty of the Palo Duro Canyon at night and the spectacle of moonrise over the black and empty land. In her wanderings that evening, as was her lifetime habit, she picked up "specimens" along the way and returned to her boarder's room with these found objects from nature. So exhilarated by the nocturnal drama that sleep eluded her, she passed the hours until dawn working on a design inspired by some of the souvenirs of the land.

The next day she described the experience in a letter to Anita Pollitzer: "I came home—not sleepy so I made a pattern of some flowers I had picked— They were like water lilies—white ones—with the quality of smoothness gone." The aquatic blossoms might seem like an odd memento of the arid Panhandle country, but perhaps no more so than the fossilized shells she later collected in the New Mexican desert or the barrels of bleached bones that she shipped to New York after her Southwestern summers. She arranged a trio of blooms and stems in a shallow black tray and drew their subtle tones of rose, green, and white in pastels, a dry medium appropriate to the flowers with "smoothness gone." Viewing the simple still life from overhead, O'Keeffe composed a graceful design of curves and countercurves against an indefinite greenish blue background. Among her abstractions and landscapes of the period, the floral still life was somewhat anomalous, sufficiently so to occasion her remarking upon it in her correspondence. Yet, in subject and carefully balanced design *Pond Lilies* (c. 1916; overleaf) continued earlier interests and presaged future productions.

The education of young women at the turn of the century often included the study of art. O'Keeffe's experiences in Wisconsin schools and at the Chatham Episcopal Institute in Virginia were no exception. In the Chatham course catalogue for 1903-04 (the year of O'Keeffe's matriculation), the art department explained that "Industrial Drawing is now acknowledged to be of great value to all classes of people, and several lessons per week in this branch are given, without charge, to all students." In addition, the young ladies had the opportunity to pursue study in drawing and painting, in which the "pupil is led to create pictures from the objects seen" and encouraged to "analyze nature, making true and artistic sketches from leaves, flowers, and easy nature studies." O'Keeffe's work in these classes suggests the traditional approach of her instruction; a watercolor like *Pansies* (1904; overleaf) anticipates the subjects that followed, but not the bold scale of the floral compositions with which she captured New York's attention two decades later. Yet her success in these early works was sufficient to

Red Canna

c. 1924. Oil on canvas mounted on Masonite, 36 x 29⅞" University of Arizona Museum of Art, Tucson. Gift of Oliver James

The gargantuan cross section of the canna's folds and recesses is distilled to a flat pattern of overlapping lobed lines, the frilly petals arrayed in a V-shaped design similar to those O'Keeffe had exploited in her earlier abstractions.

Pond Lilies

c. 1916. Pastel on paper, 19 x 16"
Canajoharie Library and Art Gallery, New York

win the respect of her teacher Charlotte Willis, whom O'Keeffe remembered
fondly years afterward, for it was Willis who recognized her talent and ambition
and encouraged further study at the Art Institute of Chicago, where O'Keeffe
enrolled in the fall of 1905.

Two years later, O'Keeffe's training continued at the Art Students League
in New York. It was there that she was inspired by William Merritt Chase's vir-
tuoso manner and excelled in his still-life class. As a still-life painter, however,
Chase generally avoided floral subjects, a practice he urged upon his students as
well. "There is nothing more difficult than flowers," he cautioned. "Avoid any-
thing as complicated as that."

It was not until she encountered Arthur Wesley Dow that O'Keeffe realized
new possibilities in still-life design, and especially in floral subjects. Dow stressed

Pansies

March 17, 1904. Watercolor on paper, 11 x 13"
Private Collection

Floral still lifes, painstakingly copied in pencil or watercolor, were a frequent assignment in the schooling of young girls early in the century. This painting was produced while O'Keeffe was a student at the Chatham Episcopal Institute in Virginia.

not the time-honored principle of instruction through careful drawing of the subject, which he viewed as "gathering knowledge of facts but acquiring little power to use them." Instead of imitative drawing, he emphasized design as the foundation of art, noting that "good drawing results from trained judgment, not from the making of fac-similes or maps." In his treatise, *Composition,* he recommended flowers as valuable and convenient subjects for composition, advising the student to seek "not a picture of a flower...—that can be left to the botanist—but rather an irregular pattern of lines and spaces, something far beyond the mere drawing of a flower from nature." Something, perhaps, like O'Keeffe's design of water lilies on a dark tray.

For O'Keeffe, this approach to art was liberating, resulting initially in her striking abstract designs, and subsequently in powerful designs of landscape and still-life forms. During her first summer with Stieglitz at Lake George in 1918, she produced several works inspired by the detailed study of flowers. In some of them, she forsook botanical accuracy to portray a generic blossom, a colorful pattern of curving forms, seemingly following Dow's advice that, in such compositions, "all the lines and areas must be related one to another by connections and placing, so as to form a beautiful whole." In other examples from that Lake George summer, such as *Series I, No. 2* (overleaf), whose palette and forms echo other designs from that early group of canvases comprised mainly of abstractions, the image was even more drastically simplified. These two works represent the stylized extremes to which she could push her floral designs and anticipate her innovations of the mid-1920s.

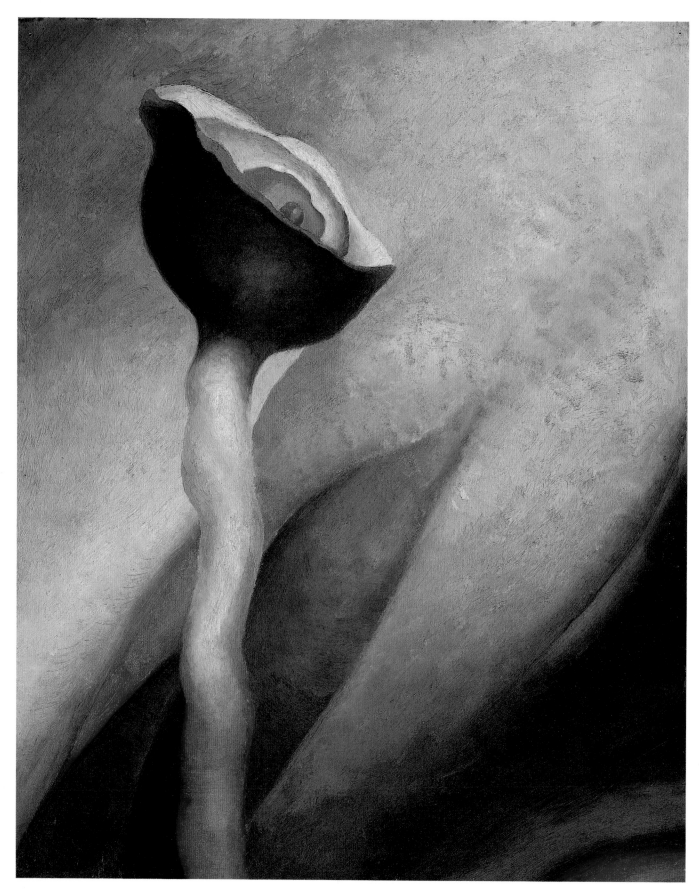

Series I, No. 2

Red Canna

c. 1920. Watercolor on paper, 19⅜ x 13″
Yale University Art Gallery, New Haven.
Gift of George Hopper Fitch and Mrs. Fitch

*Early in her Lake George sojourns,
O'Keeffe was attracted to the colorful
canna lilies that bloomed profusely in late
summer and inspired a series of watercol-
ors and oils.*

Other early works were painted in watercolor from nature, among them a group of canna lilies begun in 1919. These floral studies progress from rather literal depictions to freer designs which summarize the canna's billowy petals and intense colors in quick, loose strokes brushed on the pristine sheet without benefit of preliminary drawing. In technique and effect *Red Canna* (c. 1920), one

Series I, No. 2

1918. Oil on canvas, 17½ x 21″
Private Collection.
Copyright © The Georgia O'Keeffe Foundation

of her most bravura watercolors, is similar to the loosely brushed nudes of two years earlier, sharing a fluid dexterity and calligraphic grace; in lieu of the sparkling structure that her contemporary and friend, Charles Demuth, brought to his floral watercolors, O'Keeffe placed priority upon the liquidity of the medium and the gestural tracing of the rounded brush across the paper.

Translating such images into the less tractable, more opaque medium of oil posed different challenges for the artist. A group of zinnia subjects suggests the varied approaches. Her initial efforts were rather literal, conventionally composed arrangements of life-sized blossoms viewed against plain white grounds. The complex crowns of the zinnia posed a challenge for O'Keeffe; in some paintings, she treated the blossom as a generalized blur of whites and lavenders, while on another occasion, she approximated the multipetaled effect by daubing on the pigment with a palette knife. Finally, realizing that such feathery blooms were perhaps better suited to the flickering stroke of the Impressionist, she abandoned the zinnia and the experimental techniques associated with it; in its stead, she gravitated to more sculptural floral forms.

As her self-assurance grew, O'Keeffe's style and vantage on her subjects changed. Paralleling the work of many photographers in the 1920s, she began to focus closely on her motifs, separating the flowers from their natural environs to examine their forms and colors at close hand. Her oils of the 1920s were, however, more faithful to the appearance of her floral subjects, but they never lapsed into botanical illustration, their formal concerns for color and design always remaining paramount. In *Canna—Red and Orange* (c. 1922; page 80) she dived, beelike, into her subject to extract a decorative pattern which paradoxically delves into the deep recesses of the blossom while insistently respecting the flatness of the canvas. The bold colors of the composition—intense reds and oranges complemented by pinks and a dissonant patch of acid green—recall the daring combinations of saturated hue previously used in her invented abstractions, but now drawn from observation of the natural world.

Two years later, the canna again provided the subject for one of the novel compositions by which O'Keeffe secured her position among the first rank of American modernists. With *Red Canna* (c. 1924; page 72) she continued the tendency to distill abstract patterns from natural sources, but now vastly enlarging the fragment of the blossom to fill the thirty-six-inch canvas. The enlargement of motif coincided with her Big Trees and magnified leaves, also begun in 1924, and, like the latter, her large flowers were drawn from close-up study of natural forms. The restrained brushwork is typical of O'Keeffe's handling of oils, creating peculiarly smoothed shapes and subtle spatial ambiguities in her graded passages from intense tones to pearly whites. As the shapes swell and taper across the plane, they pulse with color and energy, suggesting the artist's continuing fascination with themes of natural vitality, translated to the microcosm of the blossom. Despite the apparent dissimilarity in subject, the floral enlargements provided an analogue to the forces of nature O'Keeffe had previously examined and are thematically related to her abstractions, her Texas skyscapes, and her Lake George panoramas.

O'Keeffe's floral subjects caught the attention of collectors and critics who responded with alacrity. Their discussions of the work were often colored by the popularized tenets of Sigmund Freud, which by the 1920s were widespread in America. In a cultural atmosphere initially titillated and gradually transformed by his theories, art and its critical reception—like many other aspects of modern life—were invariably and indelibly colored by Freudian considerations. Psychoanalytic theory had been introduced to America early in the century by Dr. A. A. Brill, a Brooklyn psychiatrist who had studied in Vienna with Freud and translated several of his key texts. Brill was a friend of Mabel Dodge, the socialite-author whose salons provided a focal point for the modern spirits in prewar New York, and through her he met Stieglitz and became an occasional participant in his avant-garde circle. The enthusiasm for Freudian theory was not, however, long confined to specialists, but quickly seized the imagination of an entire generation.

Within the Stieglitz circle, indeed among American artists in general, O'Keeffe's prominent position was novel and the exception for the time; hence, it was no surprise that discussions of the artist's work, from her debut at 291 onward, almost without exception took note of her sex. From the outset, Stieglitz offered encouragement for this interpretive approach, as in his legendary appraisal, "At last, a woman on paper!" In countless discussions and letters, he underscored gender as one of the special attributes of O'Keeffe's sensibility, an emphasis which was not surprisingly stressed by her champions as well as her detractors, and often in fevered tones.

Marsden Hartley wrote an early appraisal of O'Keeffe, acclaiming her as "one of the exceptional girls of the world" whose paintings are "probably as living and shameless private documents as exist." He viewed her work as informed by her life—"Georgia O'Keeffe has had her feet scorched in the laval effusiveness of terrible experience"—and by her sex. "With Georgia O'Keeffe," he proclaimed, "one...sees the world of a woman turned inside out." In 1922 Paul Rosenfeld, who, like Hartley, was one of Stieglitz's intimates, rhapsodized over O'Keeffe's expression "through the terms of woman's body. For, there is no stroke laid by her brush, whatever it is she may paint, that is not curiously, arrestingly female in quality." He even discovered passages in the paintings that "appear licked on with the point of the tongue, so vibrant and lyrical are they." He concluded that "essence of very womanhood permeates her pictures."

Following Hartley's and Rosenfeld's example and fueled by O'Keeffe's first large retrospective exhibition of one hundred works in 1923 at the Anderson Galleries in New York, a chorus of bodily referents ensued. Painter-critic Alexander Brook, for instance, seemed troubled by the lack of "arm's length that is usual between the artist and the picture; these things of hers seem to be painted with her very body." Herbert Seligmann, another Stieglitz protégé, wrote that in O'Keeffe's art "all things and shapes [are] related to the body, to its identity become conscious." Even Edward Alden Jewell, the eminent critic for the *New York Times*, became enthralled by "the breathing of the Mighty Mother" which he sensed throughout her work.

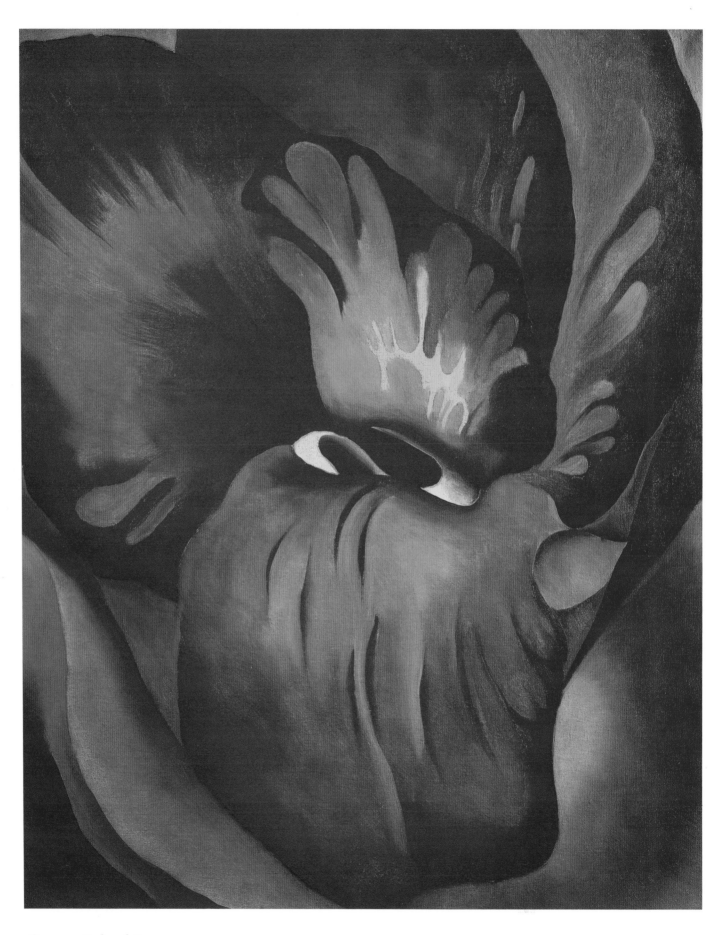

Canna—Red and Orange

Such commentary, exploring the erotic themes ostensibly disguised within her subjects, made the search for sexual symbols in her paintings a favorite pastime for many in the 1920s. When the artist steadfastly refused to credit others' sexual readings of her blossoms, it only seemed to fuel their interest. Though delighting at the acclaim, O'Keeffe cringed at the tone of the remarks. In light of her reactions, Stieglitz's reprinting of Hartley's text as the catalogue preface for the 1923 exhibition might appear at best calculated, at worst callous. In retrospect, the sympathetic critic Helen Read lamented Hartley's "pernicious suggestion...that these pictures were veiled records of her emotional life," an interpretation which colored much subsequent discussion of O'Keeffe's work.

Despite her distaste for the tone of Hartley's laudatory remarks, O'Keeffe's sufferance of its reprinting may suggest her willful separation of public persona and private self. Such a schism she also effected in permitting the exhibition of Stieglitz's portraits of her. "When I look over the photographs Stieglitz took of me," she later wrote, "...I wonder who that person is." O'Keeffe's distancing of herself from "the person in the photographs" might suggest that she prized the aesthetic value of a work—be it his photographs, or her paintings—over its purported subjective content; paradoxically, it also implies that, for her, art might be a vehicle for profoundly personal communication, for expression which could confound the probing speculation of outsiders. She admitted that his photographs made her feel "as if in my one life I have lived many lives," and in their exhibition, O'Keeffe was complexly perceived in multiple roles, at once artist and actress, maker, model, and Muse.

In a sympathetic review of her 1923 exhibition, Henry McBride predicted that O'Keeffe "is what they probably will be calling in a few years a B.F., since all of her inhibitions seem to have been removed before the Freudian recommendations were preached upon this side of the Atlantic." If O'Keeffe's images were B.F., however, the response to them was decidedly A.F. The feverish notice in the press—as well, of course, as the memorable paintings—attracted unusual interest among New York gallery-goers. In 1926 throngs flocked to Stieglitz's new showcase—the aptly named Intimate Gallery—for an O'Keeffe exhibition which was so popular he extended it for a fortnight. "Psychiatrists have been sending their patients up to see O'Keeffe's canvases," the *New Yorker* reported waggishly. "If we are to believe the evidence [the gallery] is littered with mental crutches, eye bandages and slings for souls. They limp to the shrine of Saint Georgia and they fly away on the wings of the libido."

The Freudian interpretations of her flowers and other images climaxed in the commentary of Louis Kalonyme, a one-time Stieglitz satellite whose rhetorical excesses may have cost him his place in that privileged circle. In 1926 and again the next year, he wrote admiringly of O'Keeffe, "our only woman painter whose art is a natural flower of life." In 1928, in a commentary on her Intimate Gallery exhibition, his ecstasies peaked in a discussion of her "sexual distinction." Generally Kalonyme admired her work as "direct and affirmative, free of introspective agonies, devoid of the feminine cringe and giggle." Yet he persisted in explaining her flowers, particularly the popular calla lily images featured in the

Canna—Red and Orange

c. 1922. Oil on canvas, 20 x 16"
Private Collection

O'Keeffe's distinctive color sense was noted by many commentators; for instance, critic Paul Rosenfeld in 1922 praised the "oblique, close, tart harmonies [that] are found throughout her work; to them are due much of its curious, biting, pungent savor."

1928 show, as symbols of something other than what they appear to be—"just as a pair of luscious buttocks were, to put it mildly, a symbol to Renoir, and a pair of furtive breasts were a symbol to the eagle-eyed Constantin Guys." Kalonyme concluded that hers was "a shamelessly joyous avowal of what it is to be a woman in love.... She reveals woman as an elementary being, closer to the earth than man, suffering pain with passionate ecstasy, enjoying love with beyond good and evil delight."

Whatever the nature of O'Keeffe's private delights, she was frustrated by the distracting Freudian babble centered on her works, particularly the floral subjects, commentary that diverted attention from the sophisticated formal challenges she was addressing. On one occasion she sought to end this favorite pursuit of male critics by commissioning an appreciative essay from a woman, little anticipating the results. In prose as fervid as that of any of the men, Mabel Dodge Luhan wrote that "the art of Georgia O'Keeffe is unconscious...the production of a sleep-walker" that made Luhan feel "indelicate." She described the artist (somewhat incoherently) as "externalis[ing] the frustration of her true being out on to canvases which, receiving her out-pouring sexual juices, lost while in the sleep of Unconscious Art, permit her to walk this earth with the cleansed, purgated look of fulfilled life!" Luhan dismissed the paintings as a "catharsis...no more significant than the other deposited accretions and excrements of our organisms" and perfectly suited to the Intimate Gallery, which she venomously likened to "other 'comfort stations' of our civilized communities." It is no surprise that Luhan's "appreciation" remained unpublished.

It was left to the influential critic Henry McBride, a long-time partisan of the artist, to try to quell some of the emotional fervor. In reviewing O'Keeffe's 1927 show for the *New York Sun*, he praised the works' intellectual and formal brilliance but downplayed their symbolic interpretation. The column earned a note of warm appreciation from O'Keeffe who was "particularly amused and pleased to have the emotional faucet turned off—no matter what other one you turn. It is grand—." McBride's acclaim was repeated the following year when, like many others, he singled out her flower subjects but, unlike most, eschewed efforts to decode their mysteries. "These and similar paintings, content those who respond to the painter's touch and to her clarity of color—and mean just what the spectator is able to get from them and nothing more. To overload them with Freudian implication is not particularly necessary."

In his review, McBride noted that O'Keeffe "seems to be unflustered by talk, to be unaware of much of the talk, and to pursue her way in calmness toward the ideal she clearly indicated for herself at the beginning of her career." Only much later did O'Keeffe show that her calm unawareness was a studied response to the critical and public interest that swirled around the artist and her flowers. In her preface to a 1939 exhibition, she acknowledged that "everyone has many associations with a flower—the idea of flowers." As attractions of her floral subject she cited its softness and its perfume, in short its sensual—as distinct from sexual—aspects, regretting only that because of its relative smallness people had not time to notice its charms. "So I said to myself—I'll paint what I

see—what the flower is to me but I'll paint it big and they will be surprised into taking time to look at it—I will make even busy New Yorkers take time to see what I see of flowers." That she succeeded in making them stop and see is obvious; but O'Keeffe sharply denied what Kalonyme, Luhan, and others found there. "I made you take time to look at what I saw and when you took time to really notice my flower you hung all your own associations with flowers on my flower and you write about my flower as if I think and see what you think and see of the flower—and I don't."

O'Keeffe's studies of the calla lily, which had transported Louis Kalonyme, are among the artist's most familiar subjects and doubtless rank among the most multivalent blossoms of modern times. She was familiar with the numerous depictions of the lily previously made by her colleague Marsden Hartley and with the eroticism that some critics discovered in those; troubled by similar interpretations of her own floral studies, O'Keeffe determined to try a calla "to see if I could understand what it was all about." Her early experiments with Hartley's blossom, dating from 1923, such as *Calla Lily in a Tall Glass, No. 1*, generally treat single blooms placed in long-necked containers or profiled against a monochromatic ground. The isolation of the flower and the dramatic contrast of white spathe with dark background were remarkably similar to late nineteenth-century examples by various Victorian still-life specialists. The formal elegance and simplicity of her design owed more, however, to modernism's reductive vision, paralleling—albeit fortuitously—the spare drawings that Piet Mondrian periodically made of the flower.

The precision with which O'Keeffe drew and brushed the calla in the 1920s marked a move away from the painterly effects of the zinnias to tighter, simpler floral forms. The waxy blossom offered the same type of clear outline and organic shape that later attracted O'Keeffe to profiles of adobes, sun-bleached bones, and water-smoothed stones. In the callas, O'Keeffe discovered the ideal combination of organic subject and formalist design that was to motivate her throughout her career.

For some, her white lilies evoked recollections of late Victorian sentiments attached to flowers. "Gift books," in vogue in the nineteenth century, ascribed to different species particular attributes, and the showy calla was variously acclaimed as the embodiment of beauty, purity, and "pure and hallowed dreams," which made it an appropriate floral accompaniment for portraits of many mid-century matrons. It was this tradition that led Miguel Covarrubias to draw a caricature of O'Keeffe as "Our Lady of the Lily," and Stieglitz to refer to her callas—perhaps with tongue firmly in cheek—as "the Immaculate Conception."

But the calla was a versatile blossom, as Katharine Hepburn famously recited in *Stage Door* (1937): "The callas are in bloom again. Such a strange flower, suitable to any occasion. I carried them on my wedding day. Now I place them here in memory of something that has died." Its attributes made the flower suitable for purposes funereal as well as feminine. Early botanists believed that the species was dangerously poisonous, contributing to its associations with mor-

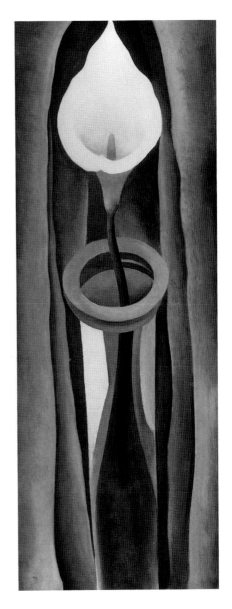

Calla Lily in a Tall Glass, No. 1

1923. Oil on board, 32 x 11½"
Gerald Peters Art Gallery, Santa Fe.
Copyright © The Georgia O'Keeffe Foundation

O'Keeffe first painted the calla lily in 1923, drawn to the subject by paintings by her friend Marsden Hartley and the discussion that they excited. Over the next several years she produced numerous studies of the flower, which in turn generated more fevered commentary than his ever had.

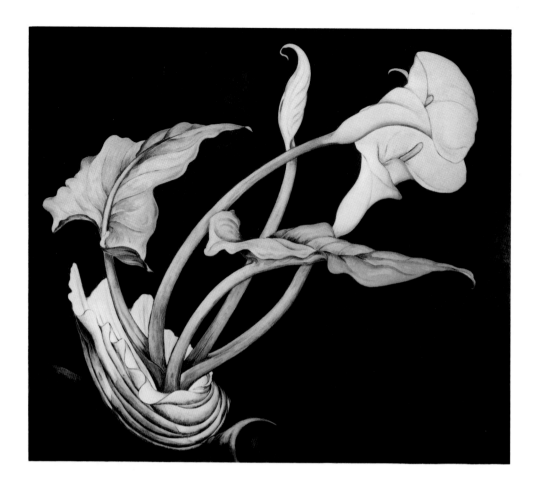

Charles Demuth, *Calla Lilies*
(Bert Savoy)

1926. Oil on composition board, 42⅛ x 48″
The Carl Van Vechten Gallery of Fine Arts,
Fisk University, Nashville.
Alfred Stieglitz Collection

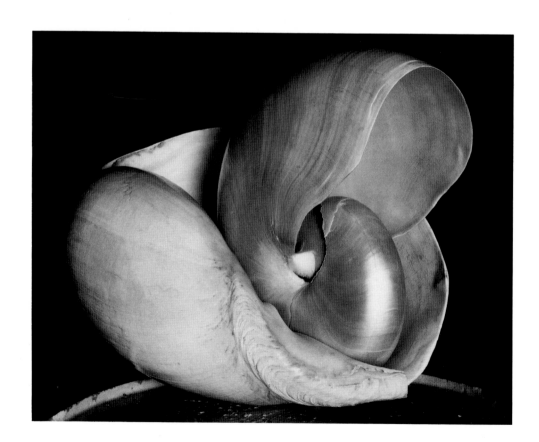

Edward Weston, *Shells*

1927. Silver print, 7⅝ x 9½″
© 1981 Center for Creative Photography,
Arizona Board of Regents, Tucson

tality. The calla's color also had foreboding implications, and in the 1880s American readers were warned that "to dream of white flowers has been supposed to prognosticate death." Throughout the nineteenth century the calla enjoyed popularity as a mourning flower; when Queen Victoria finally passed away in 1901, the royal corpse was strewn with white blossoms and crowned with a halo of calla lilies.

The androgynous form of the calla blossom added to its complex symbolic tradition. While its roundness and dramatic concavity bolstered associations with the female form—an association not lost on O'Keeffe's numerous commentators—the prominent stamen could also be viewed as a masculine symbol, an allusion exploited by numerous advertisers and illustrators of the fin de siècle. The lily's identity with both genders added yet another dimension to this versatile flower, making it an apt symbol of homosexuality, most notably in parodies of Oscar Wilde, whose homoerotic repute had resulted in celebrated litigation in 1895.

The overtly sexual symbolism of the lily was exploited by several important modernists, particularly in the decade after World War I. Salvador Dali featured the bloom in *The Great Masturbator* (1929; Private Collection), a hallucinatory anthology of sexual imagery which initiated a remarkable series of works detailing with unprecedented frankness a staggering array of erotic preoccupations. Marc Chagall's less blatant but equally visionary amatory themes of the 1920s several times featured lovers united with bouquets of giant callas. In America, in addition to Hartley, Charles Demuth also made repeated use of the subject, most compellingly in his oil painting *Calla Lilies (Bert Savoy)* (1926). Perhaps the least well known of Demuth's "homages," this image depends for its very meaning upon the sexual interpretation of the blossom. When first exhibited at Stieglitz's Intimate Gallery in 1926, the painting made Henry McBride wonder "just what it is that makes the Calla so esteemed these days, other than the fact that it was considered vulgar a generation ago." With circumspection the critic passed along the rumor "that this Bronzino-like portrait of a particularly robust Calla was intended by the artist as a tribute to the memory of a strange, erratic figure in the theatrical world who recently passed, as they say, to his reward." As such, Demuth's memorial lily played a rather different role from those which bedecked the dead Victoria a generation earlier. What McBride did not report was that the "strange, erratic figure" memorialized in this composition was the female impersonator Bert Savoy, part of the vaudevillian team of Savoy and Brennan. To symbolize the bisexual persona of the dead Savoy, the funereal, androgynous calla was ideally suited. Demuth's planting of his lily in the orifice of an elaborate sea shell, from which the "robust Calla" springs, further complicated and enriched the symbolic schema of his homage.

In 1926, O'Keeffe moved from the simple profiled portraits of the calla to the striking designs discovered in enlargements of the flower's interior; her *Yellow Calla* (overleaf) extracts from the blossom a decorative design of great complexity. The deep recesses of the calla, surrounded by broad, flat spathe, provided in miniature the same dichotomy between near and far, deep and flat,

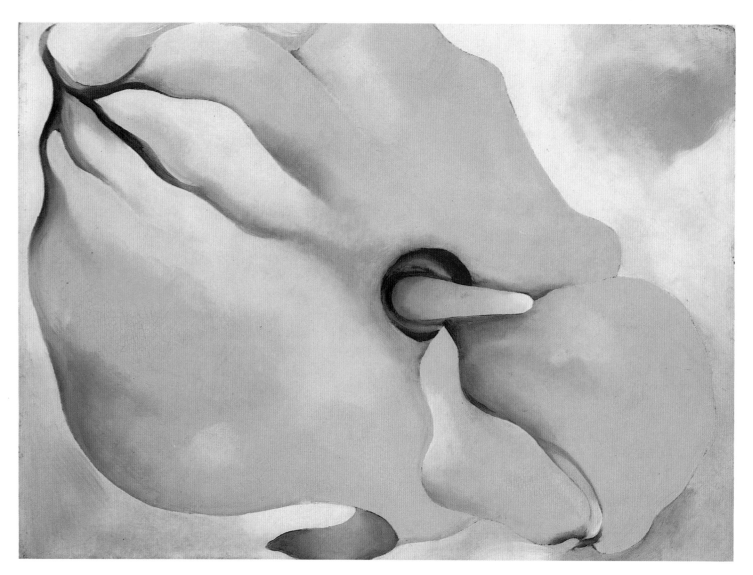

Yellow Calla

1926. Oil on fiberboard, 9⅜ x 12¾″
National Museum of American Art,
Smithsonian Institution, Washington, D.C.
Gift of the Woodward Foundation

*Calla subjects figured prominently in her
work of 1926, including intimate explo-
rations of the flower's interior.*

Two Calla Lilies on Pink

1928. Oil on canvas, 40 x 30″
Philadelphia Museum of Art. The Alfred
Stieglitz Collection, Bequest of Georgia O'Keeffe

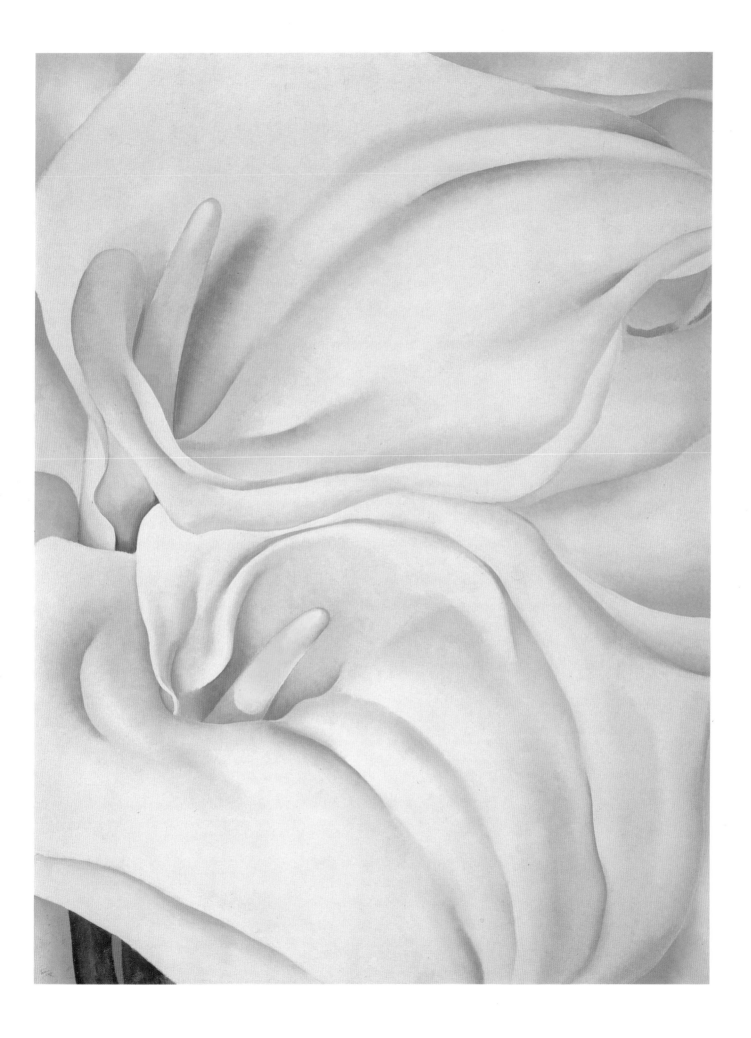

that later charged her Southwestern landscape and bone paintings. To dive into the recesses of the subject and yet to make the whole adhere to the flat plane of the canvas was a pictorial challenge in which the artist repeatedly delighted. The formal and decorative concerns evinced in O'Keeffe's calla lilies were at the base of her aesthetic as it evolved in the 1920s, and so too was the preoccupation with natural subjects and organic principles which she indulged in her floral enlargements.

O'Keeffe's close study of her subjects in the 1920s paralleled the explorations of photographers, as has been often noted. Stieglitz, Strand, and others were similarly using the camera's close-focus capacity to extract abstract patterns from a variety of subjects both natural and man-made. In 1927, just as O'Keeffe was plumbing the depths of the calla, the iris, and other blossoms, Edward Weston was turning his camera toward still-life compositions of another natural form, the graceful spiral of the chambered nautilus. His striking designs of the shells' round and smooth surfaces (page 84) were, in their natural inspiration and visual effect, similar to O'Keeffe's flowers; and, like her still lifes, his photographs elicited varied interpretations, including the sexual. Tina Modotti related to Weston the excitement that the shell pictures caused among their colleagues in Mexico; one photograph "made everybody, including myself, think of the sexual act—it is hard to describe it." The shell pictures affected Modotti profoundly: "They disturbed me not only mentally, but physically— there is something so pure and at the same time so perverse about them—they contain both the innocence of natural things and the morbidity of a sophisticated, distorted mind." The shells, boldly depicted with such formal simplicity, made her think "of lilies and embryos at the same time—they are mystical and erotic." It is just such ambiguities that complicate and enrich the reading of O'Keeffe's lilies.

Other blossoms favored by the artist were similarly rich in associations, not simply limited to the interpretations in traditional lexicons of the "language of flowers," and they also reward extended contemplation. Her famous irises were an important preoccupation for many years; she favored the black iris, which she could only find at certain New York florists for about two weeks each spring. The enlargements and abstractions derived from the flower have often been explained in gynecological terms, almost clinical in their precision. Such explications, once the province of Freudian critics, have more recently been repeated in feminist interpretations of the flower. Linda Nochlin, for example, read *Black Iris III* (1926; overleaf) as a "morphological metaphor" for female genitalia, insisting that the connection is "immediate," "concrete," and "that the two meanings are almost interchangeable." In this merger of botany and anatomy, Nochlin found reflection of "the unity of the feminine and the natural order," a concept which enjoyed great vogue early in this century.

Anatomical interpretations of the iris are bolstered when it is likened to one of the most heated portraits of the artist by Alfred Steiglitz, made early in their relationship in 1918. Approaching his subject closely, just as she did her flower, Stieglitz focused on O'Keeffe's nude torso. The round breasts, dark pubes, and

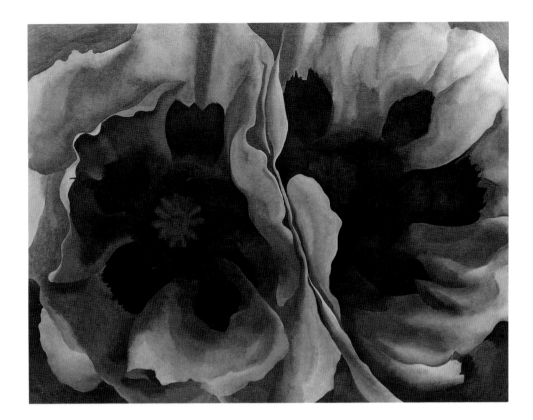

Oriental Poppies

1928. Oil on canvas, 30 x 40⅛"
Collection, University Art Museum,
University of Minnesota, Minneapolis

O'Keeffe strove for an overall composition, balanced in every direction. So successful was she in this case that the painting for years was presented in a vertical orientation, which was not her original intent.

splayed thighs in his photograph are echoed in the curvature of upper petals, the flower's black beard, and the falls or lower petals which extend beyond the margin of the composition of her painting. In the realm of erotica there are ample precursors and parallels to Stieglitz's photograph, but few with the elevated aspirations of his portrait; still, the sexual charge in the work is unmistakable. The French painter Gustave Courbet once titled a similar image *The Origin of the World*, a designation rich in associations which would have appealed to the Symbolist spirit of Stieglitz, O'Keeffe, and their contemporaries.

The iris is a familiar image in Western art, frequently used in Christian iconography; its swordlike leaves were especially employed as a symbol for Mary's suffering, a pictorial metaphor which might also have been familiar to O'Keeffe from her Catholic upbringing and her parochial schooling. The plant was also prominent in the art and horticulture of the Orient. The subject and its handling recall O'Keeffe's influential mentor, Arthur Wesley Dow, who often cited Oriental precedent and illustrated his book *Composition* with floral designs, including the iris. Dow particularly prized the Japanese, who "knew no division into Representative and Decorative; they thought of painting as the art of two dimensions, the art of rhythm and harmony, in which modelling and nature-imitation are subordinate," just as they are in O'Keeffe's singular compositions. O'Keeffe's paintings even evoke associations with the Iris of ancient mythology, messenger of the Greek gods and, perhaps more important to a modern colorist, the personification of the rainbow. Not least among the iris's metaphoric potential is its reference to the structure of the eye, implying allusions to the

artist's vision. Plutarch, playing on associations with both rainbow myth and ophthalmology, referred to the iris as "the eye of heaven," a reference which O'Keeffe would doubtless have appreciated.

O'Keeffe's equally familiar red poppies, the subject of numerous paintings in the late 1920s, are similarly freighted with associations. Fields of poppies, as painted by Claude Monet from the 1870s onward, led to a blossoming of color in his work; these floral subjects were exhibited often in New York and elsewhere from the 1880s onward, securing his prominent position with our artists and collectors. Monet's shimmering masses of scarlet, albeit very different from O'Keeffe's magnified red blooms, rescued the poppy from the realm of herbal illustration and helped to establish its popularity in American art and gardens at the turn of the century, just as O'Keeffe was beginning her schoolgirl exercises in still-life painting. The flower also enjoyed great popularity with Oriental artists and their western imitators, and like the iris it was often used as illustration in Dow's teaching.

During the belle époque, graphic artists often used the poppy to symbolize death, sleep, and dreams, an allusion to its evanescent beauty or to the narcotic properties of certain of the species. In the late nineteenth century, use and abuse of opium, derived from one Asian variety of the plant, was widespread in this country and abroad and led to a distinctive culture which reached into some bohemian circles. On a more prosaic level, the poppy seed had wide culinary use, especially among communities of northern and eastern European heritage and possibly by O'Keeffe's Hungarian-American mother; the flower would have been commonly found in Wisconsin kitchen gardens and its seeds in baked goods. During the 1910s, the plant's traditional associations with mortality were forcefully renewed by John McCrae's poem "In Flanders Fields," with its famous refrain, "In Flanders fields the poppies blow/Between the crosses, row on row," an image of World War I which likely struck a responsive chord in the pacifist O'Keeffe. Her choice of the poppy as a subject for her art in the mid-1920s even suggests parallels with the American Legion Auxiliary's adoption of the flower as its symbol in 1922, which quickly led to its appearance on many patriotic lapels each Memorial Day.

To read O'Keeffe's flowers, as Louis Kalonyme did the callas, simply as "portraits of feminine states of feeling and mind," is to reduce them to one-dimensional erotic Rorschach tests. O'Keeffe was certainly familiar with the traditional associations clustered about her subjects. As a self-conscious modernist, she was aware as well of the more novel interpretations given to the blossoms. As a formalist, she was also attuned to the artistic possibilities that close study of flowers afforded. Her achievement rests in creating memorable images which layer form and disparate meaning in rich and complex patterns.

Black Iris III

1926. Oil on canvas, 36 x 29⅞"
The Metropolitan Museum of Art, New York.
The Alfred Stieglitz Collection, 1949

Among the most familiar of all O'Keeffe's works, Black Iris III *has generated critical references to subjects as diverse as photographic focus, Japanese design, and gynecology. Its hold on the imagination and the memory results from a careful balance of these disparate evocations and its artful composition.*

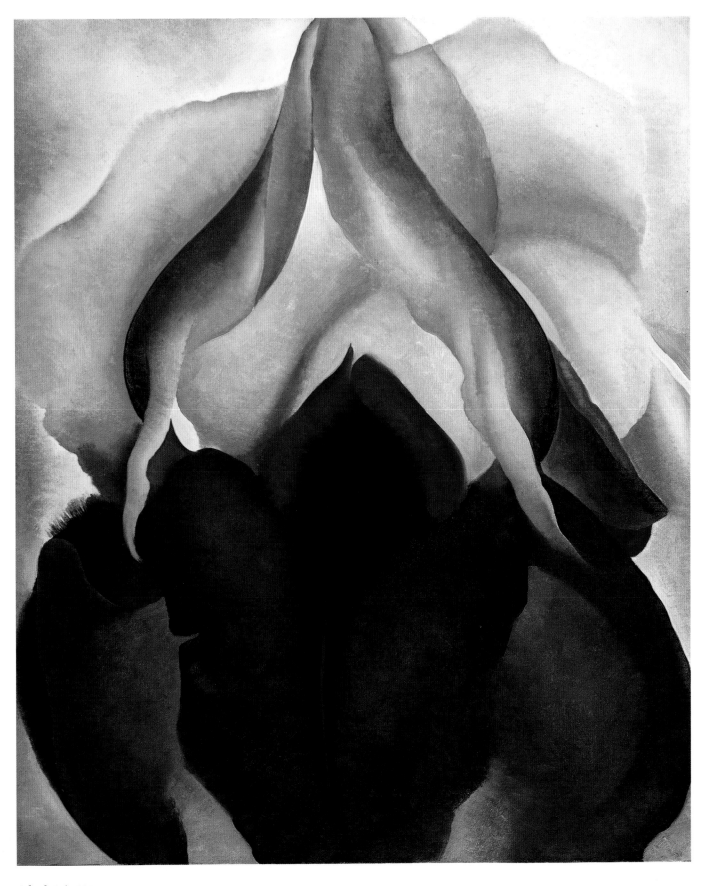

Black Iris III

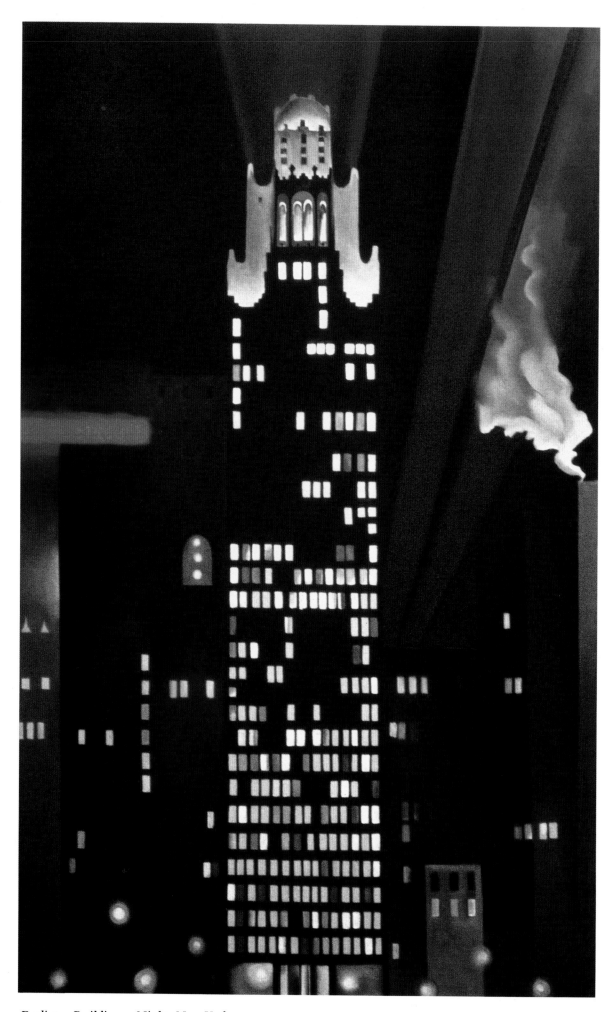

Radiator Building—Night, New York

VI. City

STIEGLITZ'S ORBIT BETWEEN MANHATTAN AND LAKE GEORGE created long stretches in the metropolis where O'Keeffe was away from her primary inspiration in nature. In their early years together, O'Keeffe during these urban spells painted her now-familiar abstractions and still lifes, as well as interiors of her studio-apartment. Architectural subjects, as Lisa Messinger has astutely observed, were often among O'Keeffe's first responses to a new environment, as when she changed addresses in her early years or traveled later in life. Such was the case when she painted *Fifty-ninth Street Studio* (1919; location unknown) shortly after her arrival in New York City.

The studio interior was a familiar subject for painters, a form of self-portraiture reflected in the creative environs of the artist. O'Keeffe would surely have been familiar with this tradition, to which her mentor William Merritt Chase had made such singular contributions. However, in contrast to the paintings of his sumptuously decorated studio, which revealed much about both the artist and his time, O'Keeffe's studio design is spare and seemingly impersonal. Instead of revealing herself through the detailing of things in her environment, she explores formal problems—patterned lights and darks, evoking shadowed recesses on a flat plane—in a design of nearly abstract simplicity.

Yet even this ascetic studio interior, apparently devoid of incident and detail, reveals something of the maker. The architectural forms are irregular, pulsing with vitality, and evoke comparisons with the abstract apertures of the pink-and-blue *Music* paintings (also of 1919), whose pale tonalities the studio interior shares. The darkened room with glowing window glimpsed through the pulsing jamb is the bedroom of the small apartment, the sanctum that Stieglitz and O'Keeffe shared shortly after her move to New York. The motif was, in short, of the most intimate importance to the artist.

Although architectural interiors never figured prominently in her work, the formal problems suggested in the 1919 studio view remained a preoccupation. About 1925, when O'Keeffe and Stieglitz, then newly wed, were occupying a studio on Fifty-eighth Street, she painted a similar design (which she subsequently destroyed) inspired by the bathroom, itself an unusual subject for an artist, which doubled as Stieglitz's darkroom, his creative precinct. If depiction of the studio interior is understood as an essay on creativity, O'Keeffe in her bathroom view effectively compounded the tradition with a painting of a studio-within-a-studio.

The Manhattan interiors were summarized ultimately in several austere compositions of 1929, abstract designs in red and black inspired by architecture.

Radiator Building—Night, New York

1927. Oil on canvas, 48 x 30"
The Carl Van Vechten Gallery of Fine Arts,
Fisk University, Nashville.
Alfred Stieglitz Collection

In a whimsical touch, the artist altered the lettering of the neon, substituting "Stieglitz" for the actual "Scientific American" sign, and literally put her husband's name up in lights, dominating the city skyline as he dominated her artistic landscape.

93

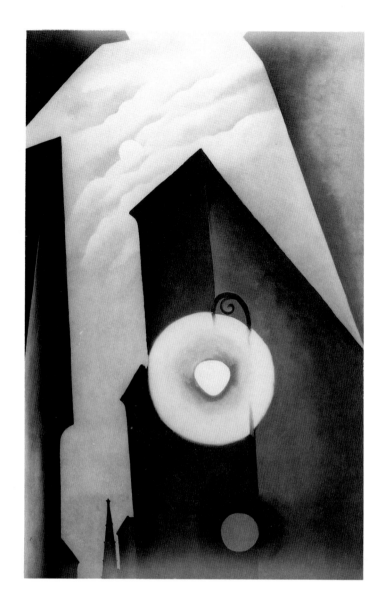

New York with Moon

1925. Oil on canvas, 48 x 30"
Thyssen-Bornemisza Collection, Lugano,
Switzerland

O'Keeffe was excited by the size and complexity of the quintessential American metropolis. During winters in Manhattan, she was removed from her primary inspiration in nature, and instead turned to the rapidly changing face of the American city.

But increasingly, as New York's skyline grew to dizzying new heights, O'Keeffe's attention was drawn outdoors to the city as subject. Her fascination with urban views increased when, late in 1925, she and Stieglitz moved into the new Shelton Hotel at Lexington Avenue and Forty-ninth Street. The hotel was the first set-back skyscraper in New York, and from their twenty-eighth-floor apartment O'Keeffe enjoyed spectacularly spacious views out and over the city. "I had never lived up so high before and was so excited that I began talking about trying to paint New York," she recalled. "Of course, I was told that it was an impossible idea—even the men hadn't done too well with it."

O'Keeffe was undaunted by the discouragement of "the men" who viewed New York as their terrain, and quickly turned to the subject. The painter was eager to display her new work and sought to include her first Manhattan view, *New York with Moon* (1925), in Stieglitz's "Seven Americans" exhibition at the Anderson Galleries that March. However, as she could vividly recall decades later, "The men decided they didn't want me to paint New York. They wouldn't let me [hang it]. They told me to 'leave New York to the men.' I was furious!"

Stieglitz's exclusion of the canvas might also have been dictated by pragmatic concerns; O'Keeffe's large flowers were being introduced in the same show, and he cannily calculated that the city view might distract attention from them. The artist, however, was not easily deterred, and she insisted on including the canvas in her solo show at Stieglitz's new Intimate Gallery the following February. Years later, she still savored her triumph when "it sold on the very first day of the show: the very first picture sold. From then on they let me paint New York."

New York with Moon is composed from a pedestrian's perspective, the vantage point O'Keeffe favored in her early Manhattan views (despite the fact she was living high above her subject). The artist frames the night sky with angles and cornices of brick and brownstone, developing a format—cosmic distances contained by hard forms—which served her well over many years. Decades later, the problem of painting the Grand Canyon from the river's edge suggested a similar composition to her, and she again employed the framed glimpse of sky yet with significantly different effect. In the Canyon Country series, O'Keeffe celebrates unspoiled landscape, not the man-made world. The desert, not the urban arena with its rusts and soot, provides the palette; the design is illuminated naturally, rather than by artificial streetlights which outshine the moon. The canyons of the later work are Grand rather than concrete, nature's, not man's.

The inspiration discovered in nature made the artist at best ambivalent about the metropolis. The ominous scale and dark tonalities of *City Night* (1926; overleaf) exaggerate the stark forms and disquieting mood of the city nocturne initially explored the preceding year. Nature, suggested by the tiny moon, has been almost banished from this urban vista of blank monoliths. The hard drawing and clean application of paint—attributes (in a very different guise) of her plant studies as well—create immaculate surfaces which have often been cited as evidence of O'Keeffe's kinship with such Precisionist artists as Charles Sheeler and Charles Demuth. Yet, while she briefly shared in that movement's fascination with machined forms and urban geometries, her city subjects differ by virtue of their decorative effects; and, in lieu of the Precisionist's celebration of the modern metropolis, O'Keeffe introduces a note of austerity, anxiety, even menace, to her Manhattan views.

The urban nocturnes inspired some of O'Keeffe's most severe abstractions, such as *Black, White and Blue* (1930; overleaf). The painting's hard edges and limited tones repeat the forms and colors of *City Night*, clearly denoting it as a design of urban inspiration. The black arc and white dagger that rise from the lower left echo the general composition of O'Keeffe's 1919 abstraction *Orange and Red Streak*. In the later design, however, the blood-red horizon of the Texas-inspired abstraction has been replaced by a blue-black stripe which suggests the verticality and the steely, sooty tones of the city; the upward sweep of the orange streak is lyrical, evoking western space and sound, whereas the sharper edged, brittle forms of the urban design imply an unnatural, man-made environment.

Manhattan nights did not always prompt such severe reactions from the artist. On occasion, her approach was more decorative, as in *Radiator Building—Night, New York* (1927; page 92) in which the Art Deco beacon dissolved into a

Overleaf, left:
City Night

1926. Oil on canvas, 48 x 30"
The Minneapolis Institute of Arts

O'Keeffe realized that "one can't paint New York as it is, but rather as it is felt, nor can one be an American by going about saying one is an American. It is necessary to feel America, live America, love America, then work." For four years, beginning in 1925, she worked at capturing the feeling of Manhattan.

Overleaf, right:
Black, White and Blue

1930. Oil on canvas, 48 x 30"
Collection of Barney A. Ebsworth

The hard forms and restricted colors of O'Keeffe's abstractions of about 1930 echo those of her city nocturnes, betraying their origins in the urban environment.

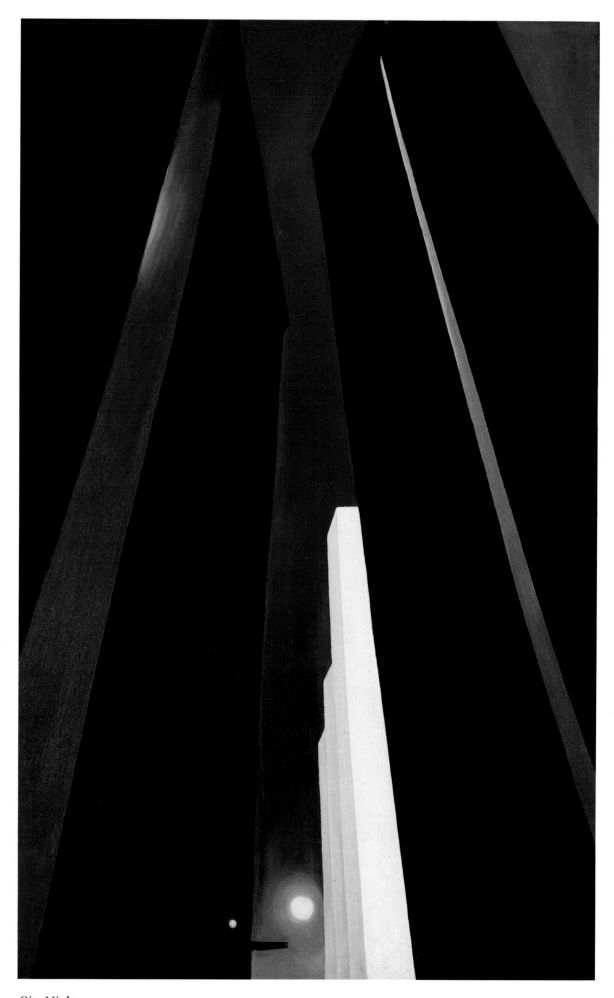

City Night

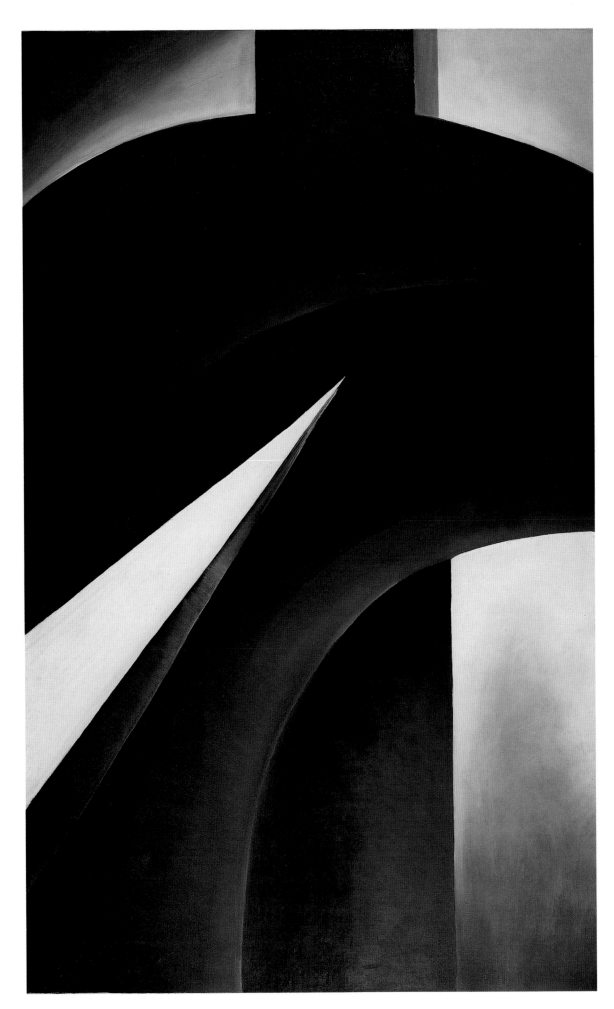

Black, White and Blue

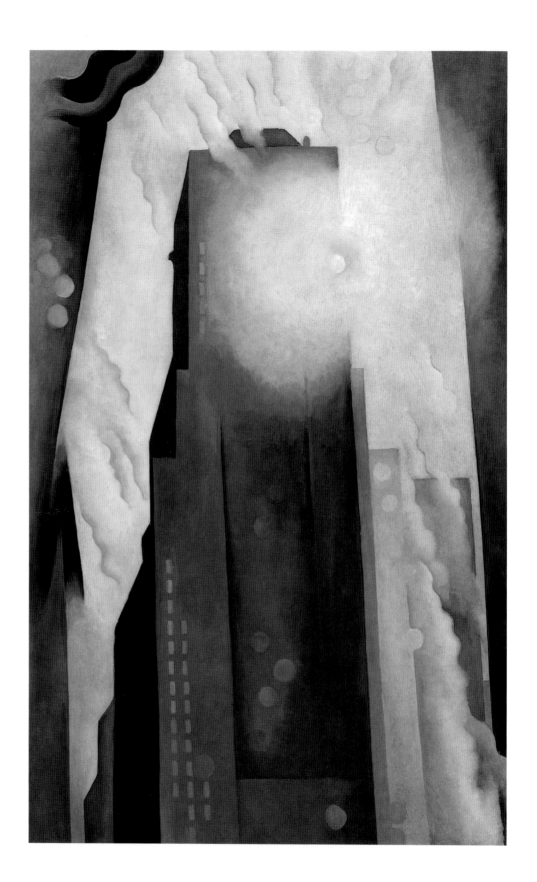

The Shelton with Sunspots

1926. Oil on canvas, 48½ x 30¼"
The Art Institute of Chicago

dazzling pattern of white blocks against the black, flanked by bright areas of blue smoke and red signage. The effect of electric lights in the night had previously captivated numerous painters and photographers. Some responded with dynamic abstractions filled with urban energy and some with images of mystery

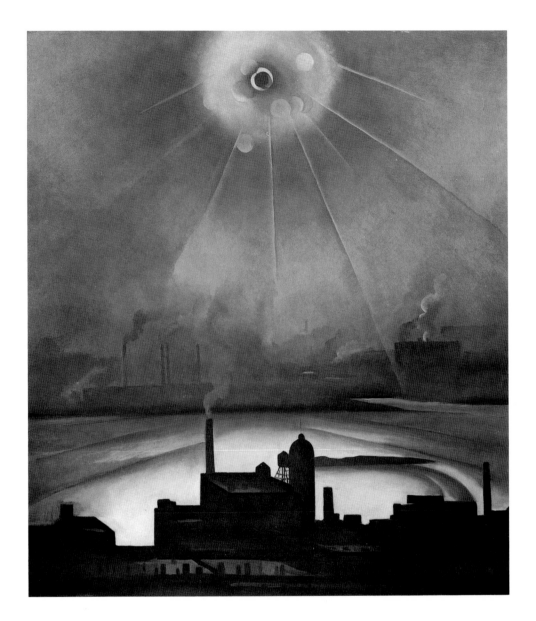

East River from the Shelton

1927–28. Oil on canvas, 25 x 22"
New Jersey State Museum Collection, Trenton.
Purchased by the Association for the Arts
of the New Jersey State Museum with
a Gift from Mary Lea Johnson

After moving into an upper-story apartment at the new Shelton Hotel in 1925, O'Keeffe's perspective on the city changed from a pedestrian's vantage to a bird's-eye view.

and romance; yet others discovered nearly abstract patterns in the darkness punctuated by the light. Alfred Stieglitz, for instance, often turned his camera upon the structures seen from his gallery window, extracting designs not evident by the clear light of noon. In her *Radiator Building—Night, New York*, O'Keeffe whimsically replaced the corporate marquee with "Alfred Stieglitz," putting her husband's name in lights and honoring his position in the American art capital.

Such lightheartedness with urban subjects was, however, the exception rather than the rule, as in the late 1920s, the mood of her New York subjects changed subtly but significantly. In 1926, she painted *The Shelton with Sunspots*, a design she attributed to a serendipitous glimpse of the sun "biting" the tower and leaving an afterimage in the retina of spots over building and sky. The effect is one that photographers often encountered in the camera lens; O'Keeffe might have been disposed to exploit it due to her familiarity with Stieglitz's photographic studies of the sky being made at the same time. This curious solar motif might also have been suggested by John Marin's earlier watercolor *Sun-*

spots (1920; Metropolitan Museum of Art, New York), an unusual subject which captures the impression of similar sparkling retinal patterns over a seascape. Yet, however fortuitous her discovery of the motif, O'Keeffe's use of it suggests an interest in more than the momentary, optical impression. In *The Shelton with Sunspots*, she reasserts the power of nature in the unnatural city.

Not only views of the Shelton, but those from it provide a telling indicator of her changing attitudes toward the city. Ensconced high above the city, she had an unrivaled view of the East River and the borough of Brooklyn, a vista that prompted a series of views in oil and pastel. Most of these are emphatically horizontal, suggesting the laterally expansive view from her aerie, and nearly monochromatic in tone, their dominant grays only occasionally punctuated by roofs of rust or ocher. In *East River from the Shelton* (1927–28; page 99), however, she made a significant departure in the format and created the most effective image of the group. By reorienting her view vertically to include the skies above the Brooklyn shore, her view captures the sun (and its sunspots) as well as the city. The sun's colorful blaze and its lines of force beaming downward on Manhattan ignite the river in waves of carmine, suggesting the supremacy of nature's power even in the bustling metropolis.

In the late 1920s O'Keeffe, the daughter of Sun Prairie, came increasingly to feel out of sync with her and Stieglitz's urban haunts. Another view of the East River from her apartment, also titled *East River from the Shelton* (1928), provides a barometer of her mood. The city outside the window is gray and pale, while indoors appears the only color; contained in the pink glass bowl is a spray of foliage with two perfect leaves. The greenery amidst the city's grayness suggests O'Keeffe's continuing fascination with natural subjects, even in colorless Manhattan. In that environ, the fragile spray seems as out of place as the artist herself had come to feel. Genuine surprise and discomfort were still evident many years later when she recalled the spring day in the late 1920s when her urban isolation was made clear to her. After a long winter in the city, she happened to walk into Central Park one day and "I suddenly realized that it was the first time in months that I'd had the earth beneath my feet. All that cement and those buildings—that's no way to live, without the grass beneath your feet and the sky above you."

O'Keeffe's epiphany found echoes elsewhere in her generation. Malcolm Cowley spent the 1920s in Paris, among the American expatriates who comprised Hemingway's "Lost Generation." He recalled that "in Europe we were learning to regard the dragon of American industry as a picturesque and even noble monster; but our friends at home had not the advantage of perspective; for them the dragon blotted out the sky; they looked up and all they could see was the scales of its belly, freshly painted and enameled with Duco. They dreamed of escaping into older lands which the dragon hadn't yet invaded—while we, in older lands, were already dreaming of a voyage home."

With the onset of the Depression, most of the Lost Generation found the way home to American shores. And, in the summer of 1929, months after completing her poignant pastel *East River from the Shelton*, O'Keeffe found her way to older lands, and to a new perspective on both art and life.

East River from the Shelton

1928. Pastel on paper-covered board, 21½ x 27¾″
Collection of Juan Hamilton.
Copyright © 1987 Juan Hamilton

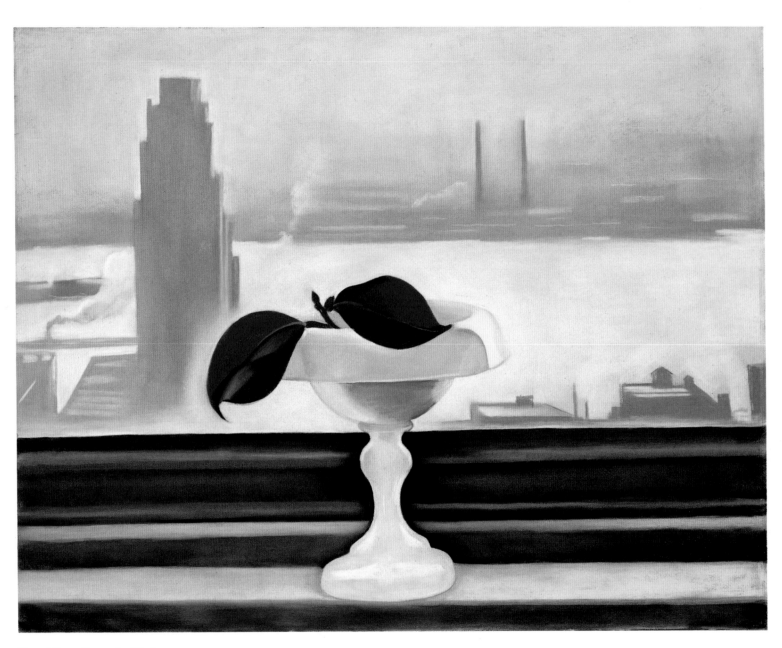

East River from the Shelton

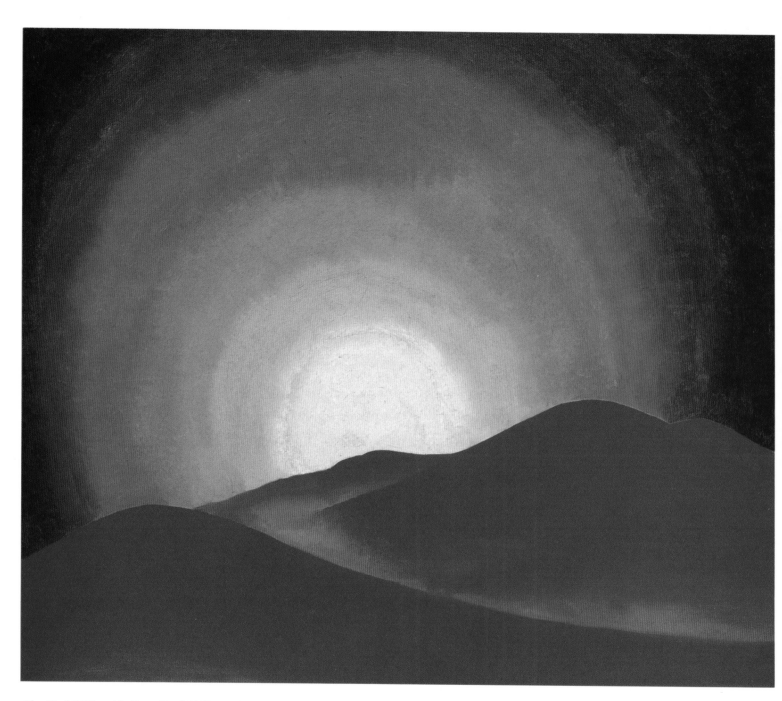

The Red Hills with Sun (Red Hills, Lake George)

VII. Desert

"AN ANNUAL EXHIBITION IS A SEVERE TEST upon any artist's powers, and, as a rule, is not to be recommended, for it implies that something new in the artist's experience has been recorded, and it is not every year that presents such new experiences." After that cautionary preface, Henry McBride proceeded to congratulate Georgia O'Keeffe on her 1928 showing at Stieglitz's Intimate Gallery in which "she comes nearer to [the ideal] than ever before." In a gathering unusually rich in varied types—leaf and floral studies, urban architecture, landscapes, and abstractions—the *New York Sun*'s esteemed critic discovered several distinctive motifs "that haunt Miss O'Keeffe." First among these was *The Red Hills with Sun* (1927), a treatment of natural form and solar force which McBride called the finest possible statement of her "terrific theme."

Despite its creation in New York, *The Red Hills with Sun* seemed oddly out of place amidst other works of the period; the saturated color was unmatched among her Lake George views, even in the most fiery autumnal scenes, and the glowing vitality of nature's subject seemed at odds with the darker abstractions in the exhibition. The pulsing celestial orb and throbbing land forms took their inspiration not from Lake George nor Manhattan, but from O'Keeffe's Texas years. This painted recollection of western skies and vacant spaces suggested that region's tenacious hold on O'Keeffe's imagination, and the West offered a consoling subject when the hordes of summer visitors or claustrophobia of city winters were most aggravating. The image of sun and molten hills seemed "complete" to McBride, and he forecast that "it probably, in consequence, is the last of that series."

In retrospect, *The Red Hills with Sun* stands Janus-like, looking both backward to O'Keeffe's Texas years, yet forward to the Southwestern subjects that were shortly to follow. Its focus upon nature's forms and forces is recalled in such works as *Hills and Mesa to the West* (1945), suggesting that, rather than concluding a series, the earlier canvas heralded a return to enduring themes.

A year after the debut of *The Red Hills with Sun*, the confinement of New York led O'Keeffe away from the city and back to the western precincts that had shaped her vision. With Paul Strand's wife, Rebecca, she set off for New Mexico in April 1929, lured by the colorful reputation of that most ancient of American quarters. Her brief acquaintance with New Mexico in 1917, en route to a Colorado holiday, had made a memorable impression; as she later observed, "If you ever go to New Mexico, it will itch you for the rest of your life."

O'Keeffe's "itch" was reinforced by the painting excursions of various artists in the years following World War I, a period during which New York "discov-

The Red Hills with Sun (Red Hills, Lake George)

1927. Oil on canvas, 27 x 32"
© The Phillips Collection, Washington, D.C.

Nearly a decade after leaving Texas, the memory of western skies and spaces continued to charge O'Keeffe's imagination.

ered" the Southwest. Among the first modernists to visit was her colleague Marsden Hartley, who worked there in the summers of 1918 and 1919; among Hartley's associates in the Stieglitz circle, O'Keeffe alone had had first-hand experience with the remarkable scenery that inspired his paintings and pastels, works which doubtless rekindled her fond memories of the place. In the 1920s the artistic traffic on the new trail to Santa Fe increased. Some, like Andrew Dasburg, found inspiring subjects and new direction there; others, like Stuart Davis and Edward Hopper, seemed largely immune to the region's charms. Among the numerous pilgrims, however, Georgia O'Keeffe was the most profoundly affected by the region. Her numerous landscapes and other Southwestern subjects created over the next four decades suggest the lasting inspiration she discovered in that special place.

While the brilliant color and suave technique of later works, such as *Hills and Mesa to the West,* evince the artist's familiarity with and mastery of her environs, the landscape could unsettle the first-time visitor. Several of her canvases from the first summer suggest O'Keeffe's struggle to come to terms with the scene. The rugged landscape, the brilliant, bleaching sunlight, and the awesome scale of northern New Mexico's desert country were the undoing of many painters, visitors and residents alike. Stuart Davis, for instance, dismissed New Mexico as "a place for an ethnologist, not an artist," complaining of the abundant and dramatic scenery that "you always have to look at it."

In her initial efforts with the local scene, O'Keeffe responded not as an ethnologist, but more as a tourist. Just as at Lake George she had early discovered the barn subjects, so too in New Mexico did O'Keeffe initially concentrate on man's monuments, choices that suggest the difficulty that she, like Davis and so many others, had with the scale of the landscape. Mabel Dodge Luhan, doyenne of the Taos art colony and hostess to O'Keeffe and Strand during the summer of 1929, described the artist's initial reactions to the region and "the extraordinary picture of her making whoopee!" Luhan envied the newcomer's "freshened vision," which was turned upon many of the sites that attracted visitors to the area, then and now. Among the products of O'Keeffe's 1929 summer were views of the ancient Taos Indian pueblo; of the adobes, especially the buttressed apse of the church at Ranchos de Taos; and of the ritualistic crosses of the Penitente sect, which she silhouetted against desert hills and sky.

The pueblo was a requisite stop for any tourist, and for many painters a familiar motif. The ancient structure and the colorful ceremonies of its residents had figured in works since painters first established a colony in Taos at the turn of the century. O'Keeffe's version of the pueblo, however, emphasized neither the Indians nor their rituals; instead, the pueblo seems as vacant as the empty streets of New York she had painted but a year earlier. Its irregular forms are captured in a painted souvenir of place, but one which smacks more of the tourist's postcard than a subject deeply felt.

With the church at Ranchos de Taos, O'Keeffe encountered another familiar theme. Many Anglo artists visiting in New Mexico were attracted by Hispanic subjects, and strove to capture something of the spiritual character of the region.

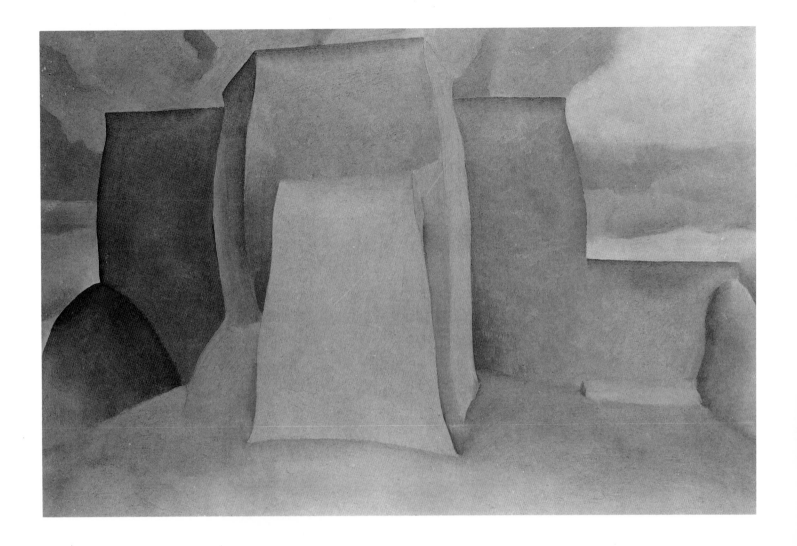

Their motifs—views of churches, still lifes incorporating religious imagery, depictions of ritual, or portraits of the pious peasants—seemed less concerned with conventional Catholic liturgy and ritual than with the close identification of Hispanic culture with the land. In the Anglo depictions there is often a wedding of church and nature, evoking a primeval spirituality at times even tinged with paganism.

O'Keeffe recognized the Ranchos church as one of the most beautiful Spanish structures in the country, and acknowledged that "most artists who spend any time in Taos have to paint it." Few, however, did so with her distinction. In a series of canvases painted during the summers of 1929 and 1930, she examined the sculptural forms of the buttressed church rising organically from the ground of which it was made and profiled against the sky. In her colors, forms, and lighting, O'Keeffe unites the Ranchos church to sky and land, a union of structure and setting that grew more pronounced over the two summers spent on the subject. In the initial examples, a shadow line separates the buttressed walls from the plane of dirt on which they sit. With *Ranchos Church* (1930), the ultimate canvas from the series, the pictorial equation is most forcefully made.

Ranchos Church

1930. Oil on canvas, 24 x 36"
The Metropolitan Museum of Art, New York.
The Alfred Stieglitz Collection, 1961

Unlike Manhattan's skyscrapers, the adobe structures were traditionally human in scale; built by hand, of natural materials, they were marked by undulant lines and swelling planes suggestive of nature's process, rather than the hard geometries of the city. In O'Keeffe's series of the Ranchos church, organic forms stress the union of man-made structure and natural environs. This historic church near Taos has perhaps been more often photographed and painted than any other American structure.

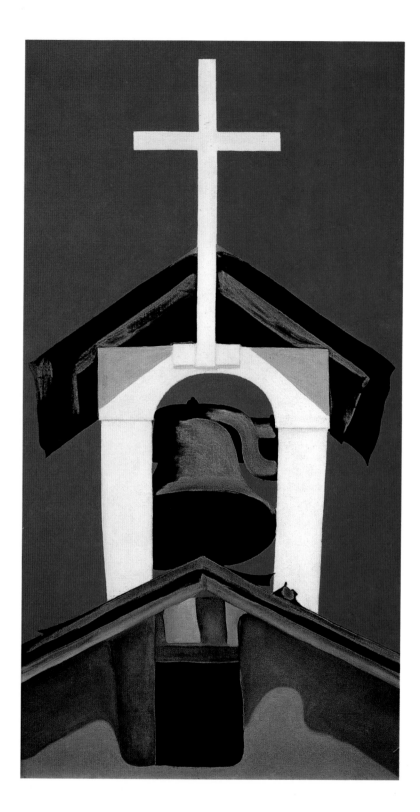

Bell/Cross, Ranchos Church

1930. Oil on canvas, 30 x 16″
Private Collection.
Photo courtesy Gerald Peters Gallery,
Santa Fe, New Mexico

Gable, white belfry, and cross are dramatically isolated against the blue in another expression through fragmentation. The combination of crisp flat planes of architecture with sinuous shadow lines echoes the patterns of geometric and organic form found in O'Keeffe's cross paintings from the preceding year, as well as in her early abstractions.

In it, the hard shadows that had divided building from ground have been diminished, making the flow from earthen floor to adobe walls almost imperceptible; above, the curves of buttress intersect with the cleavage between clouds, tying the church in the foreground to the limitless space of the heavens.

This bonding of near and far, specific and infinite, was even more pronounced in *A Fragment of the Taos Church* (1929; Private Collection), in which a

single buttress against the sky stands for the whole church, signifying the whole region. By isolating a fragment of the structure, the artist sought "to create an equivalent for what I felt about what I was looking at—not copy it." Earlier, O'Keeffe's distinctive vision had microcosmically examined flowers and shells, and during her initial New Mexican summers it was turned on similar subjects in the desert; but with the fragment of the Ranchos church, the glance that isolates and simplifies was applied to a more imposing subject. She used such "details," isolated from yet emblematic of a larger subject, "because it seemed to make my statement as well as or better than the whole could." O'Keeffe allowed that "I was quite pleased with the fragment of the Ranchos Church," so much so that she repeated an architectural detail the following summer in *Bell/Cross, Ranchos Church* (1930).

It is, however, crosses, not churches, that have become most emblematic of both the artist and the region. *Black Cross, New Mexico* (1929; overleaf), which silhouettes a fragment of the cross against gray hills sweeping to the distant crimson horizon, was the boldest of four canvases on the theme that resulted from her first summer in New Mexico. Unlike most Anglo painters who were attracted by the crosses of the Penitente sect, O'Keeffe did not emphasize the often gruesome drama of their Crucifixion reenactments; neither did she stress the religious implications of her subject, despite her own Catholic upbringing, although she hinted at her feelings regarding her family faith when she likened the crosses, so common in the northern desert country, to "a thin dark veil of the Catholic Church spread over the New Mexican landscape."

Initially, viewers and critics interpreted the subject in conventional Christian terms. Henry McBride, for instance, described the ethereal *Gray Cross with Blue* (1929; overleaf) as "'the St. Francis of Assisi' in pale blues and turquoise, for those who . . . attempt to live on the spiritual heights." In contrast, he labeled the somber truncated cruciform design as the "'Parsifal!' cross," and warned that it was an image "not for the mind but for the 'subconscious.'" He concluded, with characteristic humor, that "a gallery is no place for it. It ought to be viewed in church." For O'Keeffe, however, it was the formal drama of the crosses punctuating the landscape that captured her imagination. The angular fragment of the black cross, cropped and closely viewed against the eroded hills extending into the distance, created a pairing of man-made and natural forms—a combination similar to that employed in the Ranchos church series—that evoked the special character of the desert and served as a potent symbol of place. "Any one who doesn't feel the crosses simply doesn't get that country," she explained to McBride in 1930. Decades later she reiterated, "For me, painting the crosses was a way of painting the country."

While the country might be symbolized indirectly by an adobe structure or a Penitente cross, tackling it directly was a greater challenge. Among the nineteen canvases from her first Taos summer, which were exhibited in New York in February 1930, only two were traditional landscape vistas, both depicting the low sand hills near Alcalde whose soft gray forms provide the geological counterpart to the Ranchos church's profile. As with the church, the hill in *Soft Gray,*

Overleaf, left:
Black Cross, New Mexico

1929. Oil on canvas, 39 x 30⅜"
The Art Institute of Chicago.
The Art Institute Purchase Fund

O'Keeffe likened the heavy crosses of the Penitente sect that dotted the desert to "a thin dark veil of the Catholic Church spread over the New Mexico landscape. . . . For me, painting the crosses was a way of painting the country."

Overleaf, right:
Gray Cross with Blue

1929. Oil on canvas, 36 x 24"
Courtesy The Albuquerque Museum.
Purchase 1983/1985 G.O. Bonds, Albuquerque Museum Foundation, Ovenwest Corporation, Frederick R. Weisman Foundation

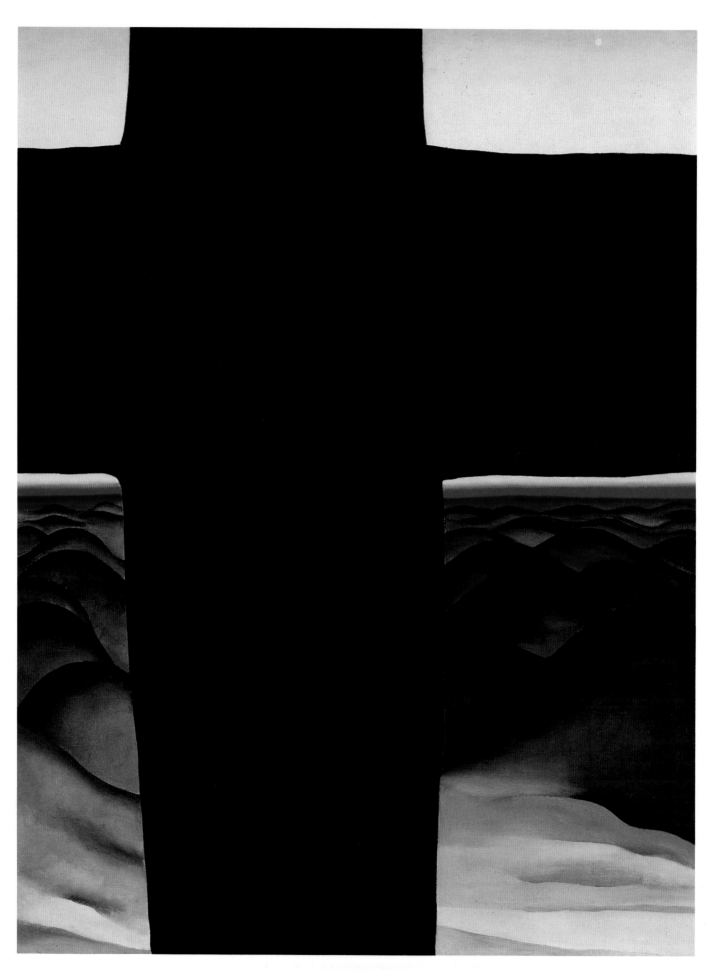

Black Cross, New Mexico

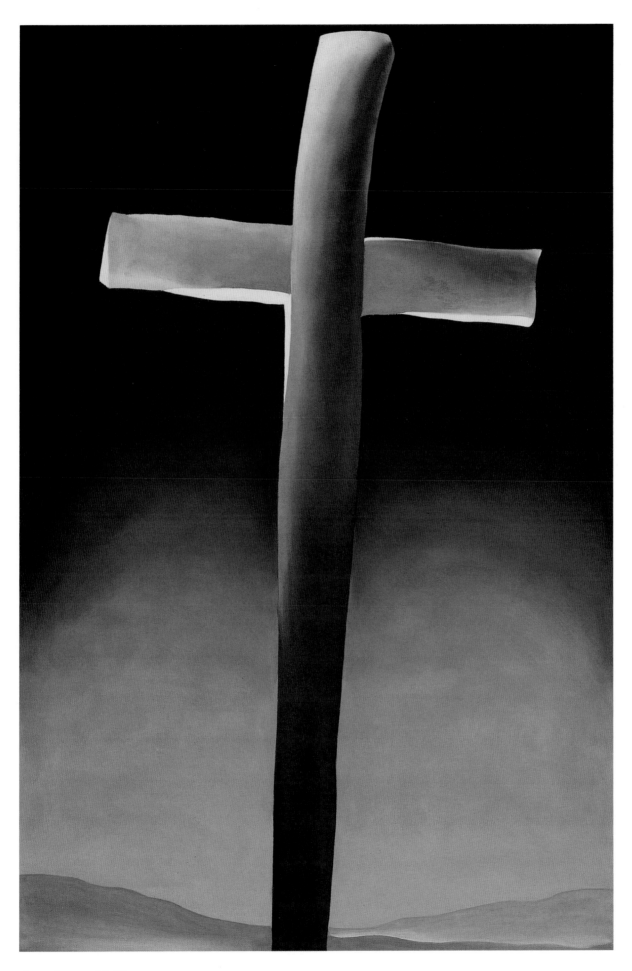

Gray Cross with Blue

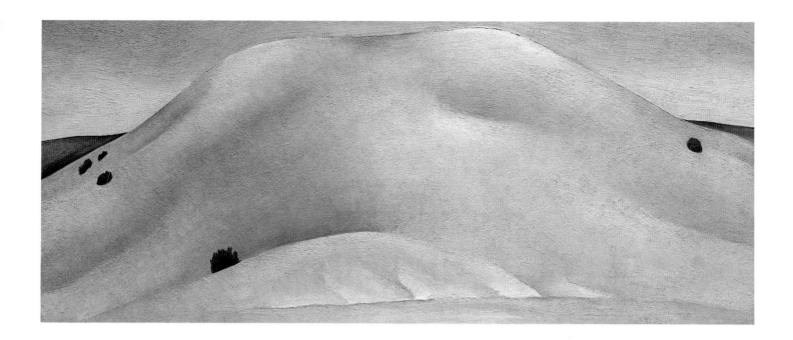

Soft Gray, Alcalde Hill (Near Alcalde, New Mexico)

1929–30. Oil on canvas, 10⅛ x 24⅛″
Hirshhorn Museum and Sculpture Garden,
Smithsonian Institution, Washington, D.C.
Gift of Joseph H. Hirshhorn, 1972

During her first extended visit to New Mexico, O'Keeffe discovered the sandy hills near Alcalde, south of Taos in the Rio Grande valley, and returned there to spend the summers of 1930 and 1931. By isolating the low rise and centering it in her canvas, O'Keeffe gave the land form a monumentality beyond its actual dimensions.

View from My Studio, New Mexico

1930. Oil on canvas, 20 x 36″
Private Collection

From her quarters in Alcalde, O'Keeffe could survey the expanse toward the Black Mesa and the mountains in the distance. In this part of the state, the landscape is more colorful than on the higher plateau at Taos, and O'Keeffe responded with brighter, more varied hues.

Alcalde Hill (Near Alcalde, New Mexico) (1929–30) is composed of the same soil and monochrome as the ground from which it rises; and, like the building, the land form rises to crowd the upper margin of the canvas, its smooth contours profiled against the blue and effectively blocking the challenging sweep of space.

At Alcalde, O'Keeffe could escape the forced camaraderie of the Taos art colony and work alone in the landscape of the Rio Grande valley. The scene inspired her from her first encounter in 1929, when she painted the bald sand hills; she was also drawn to the more distant mesa and mountains, but confessed that her initial efforts with that vista failed. The color and particularly the scale of the place were overwhelming, and the prospect across the desert valley could not be reduced to a simple, elegant profile of a sand hill.

The challenge of the site only enhanced its allure, however, and after her first summer, O'Keeffe returned often to the region to tackle the subject anew. In 1930, from rented quarters at a guest ranch in Alcalde, she painted several versions of the *View from My Studio, New Mexico*, designs of the mesa and the distant mountains toward Abiquiu that summarized the country's forms and color with new authority. These colorful landscapes provide a striking alternative to the stark, urban geometries viewed from her Shelton studio a few years earlier, suggesting the brilliant New Mexican light's invigorating impact on her color sense; they also contrast dramatically with the pale hillsides painted at Alcalde the previous summer, greatly intensifying the color and multiplying the complexity in the landscape subject. These strata of color—green floor plane topped by orange hillside, black and lavender mesa and distant blue peaks— suggest the variety in the geological subject; their arrangement in colored bands, reminiscent of the more abstract Pink and Green Mountains series that she painted in Colorado in 1917, indicates one solution to the challenge of recording the distance.

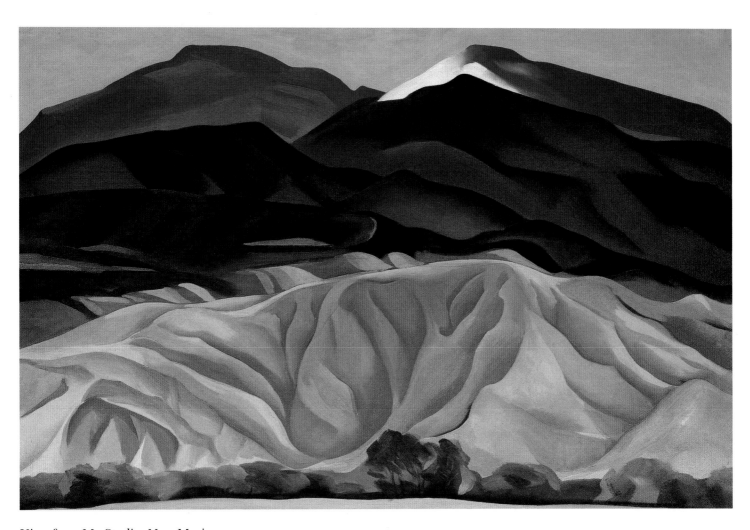

View from My Studio, New Mexico

The Mountain, New Mexico

1931. Oil on canvas, 30 x 36"
Collection of Whitney Museum of American Art,
New York. Purchase

The unusually loose stroke suggests the artist's struggle to come to terms with the novel scale and expanse of northern New Mexico's high country. In 1939, O'Keeffe complained that "a red hill doesn't touch everyone's heart as it touches mine and I suppose there is no reason why it should.... You have no association with those hills—our waste land—I think our most beautiful country. You must not have seen it, so you want me always to paint flowers."

Gray Hill Forms

1936. Oil on canvas, 20 x 30"
Courtesy of the University of New Mexico Art
Museum, Albuquerque.
From the Estate of Georgia O'Keeffe.
Copyright © 1976 The Georgia O'Keeffe
Foundation

Whether as a single form of building or hillside profiled against the sky, or as a more complicated subject arrayed in colorful bands, these early New Mexican subjects were frontally viewed and depicted from ground level. From the studio she first occupied in Taos in 1929, O'Keeffe looked out across fields of alfalfa and miles of sage to "a most perfect mountain," a prospect which, she reported jubilantly, "makes me feel like flying." Her painting of the view, however, remained conventionally earthbound and repeated a formula used at Lake George, dividing the canvas bilaterally into foliated foreground and generalized peaks in the distance; however, without the reflective surface of water to bridge the distance, the foreground and background seem oddly discontinuous. In the vast spaces and clear air of the desert country, the transition from near to far was a challenge to any painter; but it did not take O'Keeffe long to discover other, less pedestrian perspectives on the country.

The vistas that made her feel like flying soon inspired an airborne view as the artist took imaginative flight above the vacant acres. In *The Mountain, New Mexico* (1931) the land form pushes toward the top margin of the canvas and nearly eliminates the horizon, the result of being viewed from overhead. The intense red pigment, which flows like lava down the canvas, is applied with a loose stroke that differs from the burnished surfaces more customary in O'Keeffe's work. While not common, such gesturalism did periodically appear in her canvases, generally in preliminary treatments of a subject, suggesting either the sketchiness of a first impression or the newcomer's unfamiliarity with a subject. As she returned to favorite motifs, however, the refined surface generally reasserted itself, marking her familiarity with a subject. Such was the case with the eroded red hills of northern New Mexico, especially in the country around the Ghost Ranch north of Abiquiu, where she summered from 1934 onward (and where she later bought her first home). Within a few years, these eroded subjects were depicted as smooth humps which rise and couple across the canvas.

As O'Keeffe refined her imaginative bird's-eye view of the desert country, she simultaneously explored the landscape from the terrestrial plane. The eroded hills in *Gray Hill Forms* (1936) are arrayed like a landscape frieze across the horizontal canvas. The high red and yellow cliffs behind her Ghost Ranch home and the white escarpment across the Chama valley from Abiquiu were similarly treated in a series of canvases begun in the late 1930s. At first, the new subjects were handled with an atypical brushiness, but in time Abiquiu's white cliffs or the rust and ocher forms at Ghost Ranch were painted with greater restraint. In *The White Place in Shadow* (1940; overleaf), for instance, she treats the chalky wall with lean pigments handled with short strokes, capturing the dessicated effect of her desert subject. As with previous studies of building and blossom, she here focuses upon a detail, capturing a fragment of her subject and closely exploring its concavities and convexities. While representational, the image is also imbued with an abstract compositional sense, the dark wedge that splits the white ground appearing as the reversal of the white form intruding into a dark field in *Black, White and Blue* from more than a decade earlier.

The White Place in Shadow (From the White Place)

1940. Oil on canvas, 30 x 24″
© The Phillips Collection, Washington, D.C.

O'Keeffe had favorite landscape sites which she dubbed with familiar names and repeatedly painted. The "White Place" refers to canyon cliffs cut into unusually pale sedimentary rock across the Chama River from her home in Abiquiu.

Black Place IV

1944. Oil on canvas, 30 x 36″
Collection of Mr. and Mrs. R. Crosby Kemper

The "Black Place" first drew O'Keeffe's attention in the mid-1930s, and she repeated its colorful forms for nearly fifteen years, working both from observation and, later, from memory.

The tendency to create abstract patterns in the landscape increased in the 1940s, as the artist's familiarity with and dedication to the region increased. As she had previously done in Texas, she was now thinking of the New Mexican landscape as "mine," even to the point of discovering and naming frequent painting sites: the "White Place," for example, or "My Backyard" (the red cliffs of Ghost Ranch), or her favorite, the "Black Place." She discovered this declivity in the landscape early in her New Mexico sojourns and often returned to the site, about one hundred and fifty miles northwest of Ghost Ranch, on the Jicarilla Apache reservation. Her early paintings of the Black Place were rather straightforward descriptions of the rise to a high horizon, a geological oddity of low gray hills crowned with black and banded with pink. In a famous simile O'Keeffe likened the gray hills to "a mile of elephants . . . all about the same size with almost

Black Place IV

Black Hills with Cedar, New Mexico

1941. Oil on canvas, 16 x 30"
Hirshhorn Museum and Sculpture Garden,
Smithsonian Institution, Washington, D.C.
The Joseph H. Hirshhorn Bequest, 1981

Hills and Mesa to the West

1945. Oil on canvas, 19 x 36"
Private Collection

Solar motifs appeared recurrently throughout O'Keeffe's career, capturing nature's primal force in various ways.

white sand at their feet," and such paintings of the mid-1930s as *Gray Hill Forms* capture the pachydermous forms of the motif. By 1941, however, in *Black Hills with Cedar, New Mexico*, she was emphasizing the hollow between the humps, designing a landscape with references which seem less elephantine than human, particularly feminine. Twin hills rise breastlike above a fertile cleavage, evoking Mother Earth, the drought-ravaged subject of famous Dust Bowl images by Alexandre Hogue and others.

The bodily analogy was consistent with the artist's interest in nature's structure and process, pictorial and imaginative concerns which had motivated her from the outset. And, just as in the examinations of leaves and flowers, with familiarity came increased liberties as the artist manipulated her landscape subject. In subsequent treatments of the hills, it was the dark valley between the smooth rises that became increasingly important in her designs. Throughout the 1940s she returned to the subject more than a dozen times, rendering its eroded contours in pastels and in an ambitious series of oils. Common to the works of that decade is an elevated vantage point, which blocks the horizon and focuses attention upon the patterns made by V-shaped configurations of intersecting colored bands. In some treatments, the rounded forms of the rhymed hills flanking the valley dominate the composition; in others, pictorial interest centers on the angular slash of stream in the valley, bisecting the composition like a bolt of lightning. The early Black Place paintings stressed the grayness of the motif, for example, capturing the effects of a dismal morning there after a rain, which the artist remembered as "gray sage, gray wet sand underfoot, gray hills, big gloomy-looking clouds, a very pale moon." On other occasions, O'Keeffe would invent new hues with which to describe the site; this was especially true late in the decade, when she was painting the Black Place from memory rather than observation. In the final treatments, the rounded hills nearly disappear, leaving only a gray ground across which flow dark ribbons of pink.

In simplifying her image and reducing its elements to a minimum, O'Keeffe repeated a compositional progression which had characterized her work from the beginning. As familiarity with her subject—whether a Texas sunrise, New Mexico's Black Place, or some purely abstract form—grew, she wrested from it increasingly simple and spare designs, ultimately "possessing" a motif through its distillation to barest essentials, and then moving on to new pictorial challenges. Such was the sequence of Black Place paintings.

While that specific subject was exhausted by the late 1940s, the desert environs never ceased to stimulate O'Keeffe's imagination. In *Hills and Mesa to the West* (1945), the setting sun ignites both hill and heavens; the striking image continued the solar imagery of the 1910s and 1920s and suggests the renewed importance that sky would come to play in her later New Mexican views. While the Black Place had been viewed from above, eliminating the sky to concentrate on the suggestive patterns within the land, the artist was not negligent of the vast spaces overhead. In New Mexico where, she said, "one seems to have more sky than earth in one's world," her attention was inevitably drawn above, recapturing some of the effects that had motivated her finest early abstractions.

Cow's Skull—Red, White and Blue

VIII. Bone

I N FEBRUARY 1938, *Life* magazine devoted several pages to "Georgia O'Keeffe Turns Dead Bones to Live Art," illustrated with color reproductions of four paintings and photographs of the artist. In one, taken on her penthouse roof in New York, O'Keeffe cradles the broken jaw of a bleached steer's skull. While the text acclaims O'Keeffe's "flair for collecting ordinary objects and turning them into extraordinary compositions," it also warns: "She looks upon skulls not in terms of death but in terms of their fine composition." In juxtaposing hand and bone, the pose stresses the painter's manual craft, evident in the finely brushed paintings of skeletal subjects that she initiated in 1930, and emphasizes the formal appeal of the object whose hard, clean outline and bleached whiteness provided inspiration akin to that of, for instance, a calla lily or pale leaf.

O'Keeffe was attracted by the bleached animal skeletons that littered the New Mexican landscape. "When I found the beautiful white bones on the desert," she explained in "About Painting Desert Bones," which she wrote for her 1944 exhibition at Stieglitz's gallery, "I picked them up and took them home," just as she had previously gathered shells and rocks and pieces of wood. For her, these curious souvenirs expressed "the wideness and wonder of the world as I live in it." Barrels of bones were shipped East where, long before the "Santa Fe look" became a decorator's cliché, O'Keeffe embellished her spare apartment at the Shelton and the Lake George summer home with sun-bleached reminders of the American Southwest. Yet as mementos of "wideness and wonder"—symbols of something more than place—O'Keeffe's paintings of skeletal subjects were susceptible to interpretation on many levels, a quality they shared with her charged images of fruit and flower, building and landscape, as well as abstract compositions.

"About Painting Desert Bones" provides an exegesis which at once clarifies and obscures the issues raised by the subjects. This stratagem of revealing while deflecting was characteristic of O'Keeffe and others of the Stieglitz circle and reflects a deep ambivalence about exposing their private and rarefied visual discourse, suggesting their debt to the traditions of obliquity developed at the turn of the century. She explained, for instance, that the compositions based on pelvic sockets derived from childhood habits of eating around the raisin in a cookie or the hole in a doughnut, a well-rehearsed account which could (and did) deflect interest from other, more complicated readings. Likewise, her explanation of the bones as souvenirs of her Southwestern summers was intended

Cow's Skull—Red, White and Blue

1931. Oil on canvas, 39⅞ x 35⅞"
The Metropolitan Museum of Art, New York.
The Alfred Stieglitz Collection, 1952

O'Keeffe shipped barrels of bleached bones to New York as souvenirs of the New Mexican desert. There they decorated her home and provided the subjects for novel still-life compositions.

119

By the 1930s, interest in O'Keeffe had spread beyond the art world, and she had become a celebrity. In 1939, the New York World's Fair Tomorrow Committee named her one of the twelve most outstanding women of the preceding fifty years.

GEORGIA O'KEEFFE TURNS DEAD BONES TO LIVE ART

The horse's skull and pink rose pictured in color on the opposite page may strike some people as strangely curious art. Yet because it was painted by Georgia O'Keeffe, whom they consider a master of design and color, American experts, collectors and connoisseurs will vehemently assure the doubters that it is a thing of real beauty and rare worth.

O'Keeffe's magnificent sense of composition and subtle gradations of color on such ordinarily simple subjects as leaves and bones have made her the best-known woman painter in America today. As such she commands her price. At an art sale O'Keeffe's *Horse's Head with Pink Rose* would bring approximately $5,000. A collector once paid $25,000 for a series of five small O'Keeffe lilies. Elizabeth Arden, the beautician, commissioned O'Keeffe to paint a flower piece for $10,000 last year. Art Critic Lewis Mumford has called her "the most original painter in America today." The Whitney Museum, The Museum of Modern Art, the Brooklyn Museum, the Detroit Institute of Arts, the Cleveland Museum of Art, and the Phillips Memorial Gallery in Washington, D. C. are proud to hang her paintings in their permanent collections. The color reproductions on the following pages include several from a portfolio of twelve O'Keeffes which Knight Publishers issued in November at $50 per copy.

Georgia O'Keeffe was born in 1887 in Sun Prairie, Wis. Her father was Irish, her mother Hungarian. She grew up in Virginia, attended art school in Chicago and New York, gave up painting in 1906 to spend the next ten years working for advertising agencies and teaching art. Her first show occurred in New York in 1916. Since then her talent for painting flowers with great sexy involutions and her flair for collecting ordinary objects and turning them into extraordinary compositions have made her famous.

IN NEW MEXICO O'KEEFFE GETS MATERIAL FOR A STILL LIFE BY LUGGING HOME A COW'S SKELETON

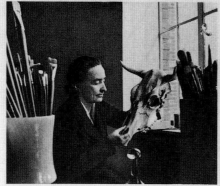

As long as there is light, O'Keeffe paints steadily all day. Here she pastes back a piece of the fragile skull which has broken off. Her best friends call her O'Keeffe, not Georgia.

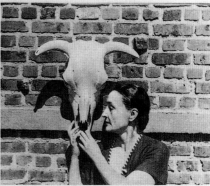

On her penthouse roof in New York O'Keeffe keeps this steer's skull bleached in the sun. She looks upon skulls not in terms of death but in terms of their fine composition.

to counter the critics' interpretations on other, perhaps more revealing levels; paradoxically, it may have fueled rather than frustrated such speculation.

At their first exhibition in Stieglitz's gallery in the winter of 1931–32, O'Keeffe's still lifes of weathered skulls elicited various reactions, including praise for their formal strength. The reviewer for *Art News* was typical; acknowledging that the artist's annual exhibitions were generally "studded with stiff pictorial problems," the writer assumed that O'Keeffe "saw these ghostly relics merely as elegant shapes." In *Cow's Skull—Red, White and Blue* (1931; page 118), the best-known of the early skull pictures, the simple silhouette of brow and

horns against the dark background is drawn with remarkable assuredness and simplicity. The flat pattern of the skull's upper third, as simple and flat as a Matisse cut-out, contrasts formally with the lower jaw, whose fractured and shadowed recesses O'Keeffe explored with painstaking detail. The play of depth against flatness is one in which she had previously delighted, as for instance in her bee's-eye views of flowers whose petals adhere to the flat plane of the canvas. Yet, the appeal of the striking skeletal paintings depends upon more than their formal brilliance. The subject was inescapably evocative, as O'Keeffe herself acknowledged in calling the bones "my symbols of the desert." In the bleached bones she paradoxically discovered a compelling vitality. "To me they are strangely more living than the animals walking around—hair, eyes and all with their tails twitching. The bones seem to cut sharply to the center of something that is keenly alive on the desert even tho' it is vast and empty and untouchable—and knows no kindness with all its beauty."

In selecting the subject, O'Keeffe was drawing upon an iconography with a long and rich tradition, and one not limited to desert depictions. The mystical import of skulls was recognized by many cultures, including the native tribes of the American West; for instance, among Karl Bodmer's watercolors document-ing that part of the country in the 1830s is *Magic Pile Erected by the Assiniboin Indians* (Joslyn Art Museum, Omaha), recording a talisman of stones and bone which captivated the explorer-artist, symbolizing for him both race and place. As emblems of a specific landscape and locale, the skeletons of dead animals were also used by nineteenth-century Romantic painters to evoke desert desolation, from the American interior to the Sahara. Closer to O'Keeffe's time and place, the steer's skull had appeared in the logo and advertisements for the Ghost Ranch, with which she became acquainted early in her New Mexican years; the motif also figured prominently in the work of several of her contemporaries, such as the Texas painters Alexandre Hogue, Jerry Bywater, and Otis Dozier, all of whom employed skeletal imagery in Dust Bowl landscapes of the 1930s.

In contrast to their compositions, however, O'Keeffe initially treated her bones as still-life subjects isolated from their natural surroundings. By severing the skull from its setting, the artist at once simplified her form and image, yet complicated its symbolic resonance. With *Cow's Skull—Red, White and Blue*, the summa of the series, she expanded the Southwestern symbol to a larger role as national icon.

When she painted it in 1931, there was much discussion in art and literary circles about the "American scene." Beginning in the 1920s, even as many of their countrymen joined the expatriate migration to Europe, and continuing into the next decade, many other creative Americans were discovering new con-fidence and inspiration in native subjects. Their attitudes and aesthetics differed greatly—from Upton Sinclair's satires on small-town mid-America to the com-memorations of American place composed by Aaron Copland or Virgil Thomp-son, from Edward Hopper's or Charles Burchfield's moody evocations of the drab metropolis to Hogue's grim Dust Bowl images or Thomas Hart Benton's celebration of agrarian myth. Yet, however varied in style or technique, such

Horse's Skull with Pink Rose

1931. Oil on canvas, 40 x 30″
Private Collection.
Copyright © The Georgia O'Keeffe Foundation

Artificial flowers, used to decorate Hispanic graves in New Mexico, were added to the skulls, a provocative combination which generated surmise regarding her "surrealist" intentions. The juxtaposition was originally a serendipitous accident, but O'Keeffe decided that "the rose in the eye looked pretty fine" and repeated the motif several times over.

Horse's Skull on Blue

1930. Oil on canvas, 30 x 16″
Art Museum, Arizona State University, Tempe.
Gift of Oliver B. James

Like the flowers or leaves that she had previously painted, the bone subjects indicate O'Keeffe's continuing reliance upon nature's forms for inspiration.

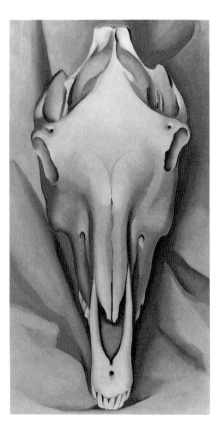

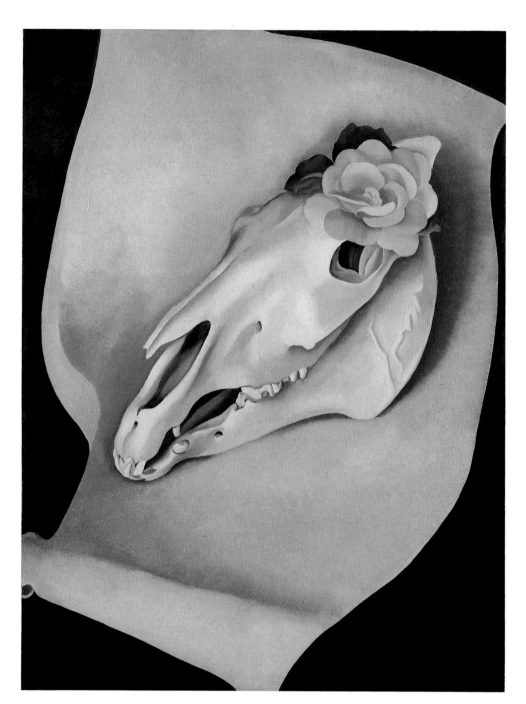

artists were united in discovering inspiration—as Alfred Kazin famously titled his book on the growth of an American literature—"on native grounds."

Georgia O'Keeffe was intimately acquainted with an American scene which for many of her contemporaries existed only in the imagination, and she knew that it encompassed more than the clichéed image of "a dilapidated house with a broken-down buckboard out front and a horse that looked like a skeleton." The ideas that propelled these artists—many of them Eastern "city men" who, she claimed, "would have been living in Europe if it had been possible"—to her appeared "pretty ridiculous. . . . The people who talk about the American scene

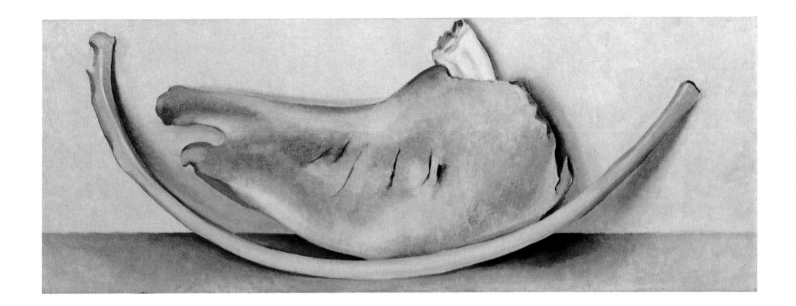

Rib and Jawbone

1935. Oil on canvas, 9 x 24″
The Brooklyn Museum, New York.
Bequest of Georgia O'Keeffe

don't know anything about it." The discussion of art's native grounds peaked in the 1930s, just as O'Keeffe was creating her skeletal evocations of the New Mexican scene. Provoked by the vociferous discussions about writing "the Great American Novel—the Great American Play—the Great American Poetry," O'Keeffe determined to make "an American painting. They will not think it great," she admitted, "with the red stripes down the sides—Red, White, and Blue—but they will notice." It was, she later admitted, "my joke on the American scene."

Like the 1931 example on its striped background, most of the skulls were viewed frontally and symmetrically placed within the vertical canvases. While some were depicted against flat, dark grounds, O'Keeffe commonly placed the subject on a fabric whose folds offered compositional interest and variety. The *Horse's Skull on Blue* (1930), one of the earliest skeletal paintings, is also among the simplest and most redolent of tradition; the creased fabric ground evokes memories of Cézanne's late still-life compositions, as does the skull (albeit human, not equine) that figured so importantly in his *vanitas* compositions. In subsequent treatments, O'Keeffe occasionally experimented with various placements of the skull. In *Mule's Skull with Turkey Feather* (1936; Private Collection), for instance, the fractured skull rests atop a horizontal plane and is examined from the side; in *Horse's Skull with Pink Rose* (1931) it is situated obliquely and silhouetted against a stylized scroll of fabric.

More startling than changes in position is the introduction of other objects into these skeletal studies. The turkey feather, like the bleached bone, is a natural object retrieved from the landscape and recycled in the studio, providing a comparable symbol of the region; that it came from an indigenous bird which at least one Founding Father would have preferred as a symbol of the nation only increased its symbolic aptness for this "American scene" still life. The pink rose, however, stuck in a bony eye socket, seemed to present a different message

altogether, one which initially confounded critics and public alike. The artist later explained the inspiration simply: She recalled that she had been looking through a collection of artificial flowers one day "when someone came to the kitchen door. As I went to answer the door, I stuck a pink rose in the eye socket of a horse's skull. And when I came back the rose in the eye looked pretty fine, so I thought I would just go on with that." As she proceeded with the skull-and-flower series, she reverted to the frontal views of her first skeletal still lifes, finally simplifying pose and palette to the minimal in *Cow's Skull with Calico Roses* (1931; Art Institute of Chicago). The cruciform pattern of skull against black stripe is similar to that of the red-white-and-blue example, a design which, reinforced by the stark contrasts of black and white, endows the image with tragic potential. This sobriety, however, is paradoxically offset by the jaunty blossoms, just as the colorful, patriotic banner mitigates the serious tone of *Cow's Skull—Red, White and Blue*. In both cases, the still life vacillates between wittiness and weightiness, and in the shifting perception lies its power and its claim to memory.

Despite its accidental origins, the inclusion of the flowers might also be considered symbolic of the American Southwest, where Hispanic graves were customarily decorated with artificial blossoms; however, to most eastern viewers, unfamiliar with New Mexican *camposantos* and funerary traditions, the flower appeared incongruous, even surreal, and provided the occasion for much comment and interpretation. Critics saw the combination of objects as evidence of O'Keeffe's "perverse humor," and even her long-time supporter, Henry McBride, wondered about her ruminating on the skull "with the perversity of a Hamlet." So compelling were the images that one writer later remembered O'Keeffe at this juncture as "a rather terrifying young woman bent on grim research into the mysteries of death in the desert."

To appreciate the skull imagery, one must understand that O'Keeffe, like many of her audience, was the product of the feverish climate at the century's turn. Recollections of fin-de-siècle subjects and attitudes in later life, conscious or otherwise, are not surprising, either in the artist's work or the perceptions of her contemporaries. Both were touched by the age's habits of symbolic presentation and tinged by its preoccupations, which were often morbid.

A gravure of *Isle of the Dead* (1880) by Arnold Boecklin, one of the icons of Symbolist painting, hung for years in Stieglitz's family home and helped to shape his early penchant for Symbolist art; in his later years, he showed an equivalent interest in allusion and visual metaphor that might be traced to this youthful enthusiasm. In one of the most famous of his portraits, Stieglitz immortalized both O'Keeffe's hands and her skeletal subject, as the artist caressed the hard surfaces of a horse's skull. Stieglitz "makes such a strong visual connection between the artist and the bone," as Lisa Messinger has observed, "that it suggests a reading of the picture more symbolic than simply that of a study of an artist and her subject matter." The photograph echoes O'Keeffe's interpretations of the skeletal as emblem of the desert's dual nature, at once vital and cruel, implying a comparable dualism in Stieglitz's "analogy between O'Keeffe and the bone she touches—both beautiful but unapproachable."

O'Keeffe's caress of the horse's dead head evokes memories of earlier women enthralled with decapitation, like Keats's Isabella who kept her lover's head in a pot of basil, the poetic inspiration for a painting by John White Alexander that enjoyed exceptional popularity in the 1890s. Depictions of the large sorority of femmes fatales abounded at the turn of the century, and provide an unexpected—and perhaps unintended, but nevertheless piquant—precedent for another photograph, which appeared in the 1938 *Life* article. That portrait (by Ansel Adams) of the artist gathering souvenirs in the desert presents O'Keeffe hefting her trophy like some Southwestern Salome bearing the head of a bovine Baptist.

Conditioned by the aesthetic and temperamental concerns of their youth, the generation of artists that matured in the first decades of this century often engaged in such symbolic and suggestive references. It seems then no surprise that among her contemporaries who interpreted O'Keeffe—in print, as well as in photographs—many should discover in the painter and the paintings such complex meaning and significance, and rarely more so than in the bone pictures.

While the skull—in human terms, the traditional locus of intellect and imagination—was the most familiar and memorable of her early bone subjects, O'Keeffe also experimented with various other skeletal parts as she sought to come to terms with her desert souvenirs, both formally and symbolically. Jawbones figure prominently in several designs of the decade, inspiring at least one writer to speculate on their source in Biblical legend. Rather than the jawbone of an ass, however, one might as readily look to that latter-day Samson, Alfred Stieglitz, whose efforts to free America from the Philistines relied upon his "jawboning," the incessant conversation and voluble defense of his principles and his artists that left such an impression on Georgia O'Keeffe. Design was as significant as metaphor for O'Keeffe, and her reiterations of the jawbone suggest a fascination with its formal possibilities. Sometimes the jawbone was combined with other desert souvenirs. For instance, O'Keeffe contrasted its whiteness and its toothy serrations with the rounded forms of colorful stones or the dark lobes of fungus. In *Rib and Jawbone* (1935; page 123) she rhymed the round arc of the mandible and the graceful curve of rib in a suavely elegant still life, whose closely unified tones of silver suggest the bravura of a monochrome by a Whistler, or a Malevich.

In format, the bone paintings varied greatly, suggesting O'Keeffe's experimental approach to the novel motifs. Many were verticals, of varying proportions, the largest (like *Cow's Skull—Red, White and Blue*) measuring forty by thirty-six inches, a dimension familiar from other series. Less common were the horizontal arrangements; but when the composition begged such she would adapt her familiar practice to the circumstances, nowhere more notably than in the elongated panel of *Rib and Jawbone*. Its proportions approach 1:3, an eccentric format which she used only occasionally, albeit dramatically. The vertical *Deer Horns* (1938) approximates that extension, compressing the forms in a flamboyant play of horn against blue ground. The curious tension between flat-

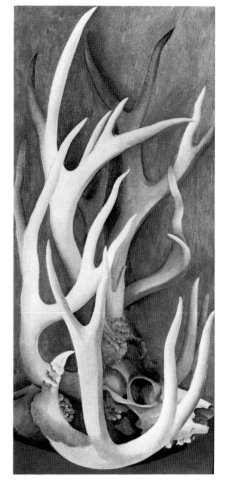

Deer Horns

1938. Oil on canvas, 36 x 16"
Private Collection

The flamboyant antlers, compressed within their narrow space, permitted O'Keeffe to explore formal contrasts, playing off the detailed volumes at the base with the flat pattern of the horn's tips. She often employed such juxtapositions of two- and three-dimensional shapes, especially in still-life subjects.

ness and depth that animated her *Cow's Skull—Red, White and Blue* as well as many of the floral paintings is evident again in this design, at once combining detailed recesses (such as the eye sockets) with the two-dimensional patterns of the antler tips.

This formal inventiveness, evident in the tension between round and planar passages, distinguishes O'Keeffe's still life from earlier works of similar theme. When the French court painter J.-B. Oudry, for example, painted antlers, it was to produce a document recording royal prowess in the hunt and the odd configuration of the king's horny souvenir. Likewise, trompe-l'oeil compositions of antlers and hunter's paraphernalia by American painters at the turn of the century, for instance, Alexander Pope, evoked the pleasures of the sporting life. In short, pictorial precedent dealt with the hunter more than the hunted, and with document more than design, by contrast illuminating the novelty and power of O'Keeffe's vision.

In 1935—after a period of personal and professional stress during which she was absent from New Mexico and nearly abandoned her art—O'Keeffe returned to the Southwest. She was rejuvenated by the dramatic landscape of the high desert country, and it showed in her canvases from that summer's sojourn. *Ram's Head with Hollyhock* (1935) announced the new freedom and inspiration; the design continues the formal play and the interest in evocative combinations of subjects first tackled in the early 1930s, but now handled with unprecedented assuredness. The enigmatic juxtaposition of skeletal, floral, and landscape images—a virtual catalogue of the subjects that had earlier garnered her acclaim—provoked new interest in O'Keeffe's work, especially after the fallow period that had immediately preceded their introduction in January 1936. For the exhibition at Stieglitz's gallery, Marsden Hartley, whose prefatory comments had occasioned such discomfort at O'Keeffe's showing in 1921, was re-enlisted to prepare "A Second Outline in Portraiture." Amidst the exhibition's Southwestern flowers, Ghost Ranch landscapes, and emblematic still lifes of bone and feather, Hartley singled out the mysterious ram's head hovering above the desert. It seemed to him "a transfiguration—as if the bone, divested of its physical usages—had suddenly learned of its own esoteric significance, had discovered the meaning of its own integration through the processes of disintegration, ascending to the sphere of its own reality, in the presence of skies that are not troubled, being accustomed to superior spectacles—and of hills that are ready to receive." He concluded that this "transmigration of bone" shared with the earlier skeletal subjects "the spirit of death," and announced the newest phase of the artist's development "portray[ing] the journey of her own inner states of being." In his biographical interpretation, Hartley discovered not despair, but joy and affirmation. O'Keeffe having "known the meaning of death of late and having returned with valiance to the meaning of life," approached the work and the world with new confidence. Ultimately, Hartley saw the *Ram's Head with Hollyhock* as moving beyond the "personalisms" that had characterized her earlier production. "There is the new image living its own life irrespective almost of the person who performed it."

Jean-Baptiste Oudry,
Bizarre Antlers of a Stag Taken by the King, July 3, 1741

1741. Oil on canvas, 45¼ x 27¼"
Musée National du Château de Fontainebleau,
France

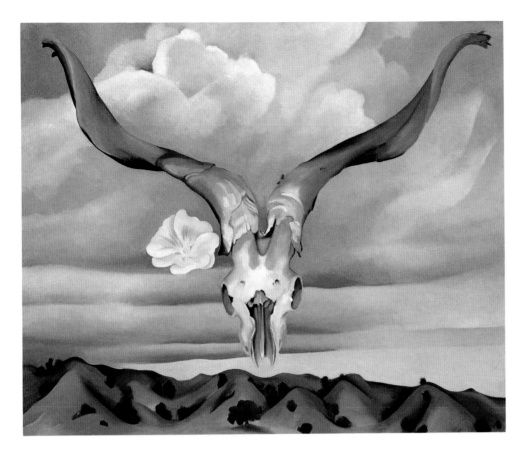

Ram's Head with Hollyhock

1935. Oil on canvas, 30 x 36"
Collection of Edith A. and Milton Lowenthal

By releasing the bones from gravity's strictures and placing them illogically above the landscape, O'Keeffe further confounded her critics and audience; some of them were troubled by the apparent celebration of death.

If the hallucinatory image assumed its own vitality for Hartley, it did likewise for the reviewers, who were puzzled and captivated by the painting. Almost without exception, critics singled out the ram's head for comment, favorable or otherwise. Henry McBride, usually O'Keeffe's partisan, praised the symbolic still lifes—horseshoes, feathers, and bones—but was challenged by "that apotheosis of a ram's head...suspended miraculously in the skies.... What does she mean?" he wondered. "The bleached skull with the rampant horns is beautiful. Is death, then, beautiful?" Royal Cortissoz worried that, with this curious image, O'Keeffe "seems to be deviating into the cul-de-sac of surrealism" from which she was rescued only by her technical finesse, painting the subject "so beautifully that the oddity of the composition passes virtually unnoticed." Lewis Mumford also recognized the picture as "the epitome of the whole show...a piece of consummate craftsmanship...[which] possesses that mysterious force, that hold upon the hidden soul, which distinguishes important communication from the casual reports of the eye." Like Cortissoz, he found O'Keeffe's "juxtapositions no less unexpected than those of the Surréalistes," but Mumford drew an important distinction between their irrational subjects and O'Keeffe's objects, combined in a composition that "makes them seen inevitable and natural, grave and beautiful."

The critical response to the ram's skull was echoed in interpretations of similarly haunting combinations from the following year, as O'Keeffe twice again painted major compositions based upon a skull. In *Deer's Skull with Pedernal*

(1936; Museum of Fine Arts, Boston), the bone is positioned on a black vertical, akin to that used in earlier still lifes, but now used to represent an actual weathered limb in the out-of-doors. The arcs of elaborate antlers, sun-struck and shadowed, echo the branching limbs of the cedar on which the skull is hung, creating a design which reminded some viewers of a Crucifixion. More than any conventional Christian symbol, however, the head mounted in front of the landscape evokes not Calvary, but the Ghost Ranch country, and specifically the view from the artist's (future) home toward her beloved Pedernal peak.

If *Deer's Skull with Pedernal* is an evocation of place, its companion of 1936, *Summer Days* (overleaf), is an equally poetic summation of time or season. The same skeletal model is this time paired with desert blossoms of late summer and suspended above the red hills of northern New Mexico. Although lacking a specific landmark such as the Pedernal, the red hills nevertheless provide a strong indicator of region, of the terrain that inspired so many of O'Keeffe's most powerful landscapes. Being unfamiliar to most Americans, however, the eroded red landscape failed to arouse the same interest as, for instance, her magnified flowers. "A flower touches almost everyone's heart," she once admitted. "A red hill doesn't touch everyone's heart as it touches mine and I suppose there is no reason why it should.... You have no associations with those hills—our waste land—I think our most beautiful country—You may not have seen it, so you want me always to paint flowers." In pairing the skull and the familiar blossoms above the exotic landscape vista, O'Keeffe managed in effect to have it both ways, creating an evocation of time—summer heat and shimmering mirages—and of unfamiliar yet haunting desert landscape.

In that eroded landscape—rather than hovering above it—she placed several of her desert skeletons in the coming years. *Mule's Skull with Pink Poinsettias* (1937; Private Collection) combines the skull resting on reddish earth with the exotic blossoms which are more evocative of (Christmas) time than (desert) place. In 1942 and again the following year, O'Keeffe repeated the placement of bones on the land; even more remarkable than the position, however, is the choice of the skulls, which are human. Unique within O'Keeffe's work, *It Was a Man and a Pot* (1942; E. B. Crocker Art Gallery, Sacramento, California) and *Head with Broken Pot* (1943; Private Collection) are more likely products of time and circumstance than of region, reflecting the horrors of war—a preoccupation for every American in that bleak year.

The most effective composition of bones *in* the landscape appeared in 1941, with *Red Hills and Bones*; the large canvas is also among her most ambitious evocations of the arid country of which she was by then an owner, having purchased the house at Ghost Ranch the preceding year. In 1939, O'Keeffe had written of the bones as "strangely more living than the animals walking around," and in the 1941 painting her response is given visual form. The bleached vertebrae in the foreground arch naturally, establishing a rhythm that is repeated in the red humps of hills stretching upward to the margin of the canvas. The scalar relationships between the foreground bones and the background hills is ambiguous; the closely viewed skeletal parts dominate the foreground, but nothing

Red Hills and Bones

1941. Oil on canvas, 30 x 40"
Philadelphia Museum of Art.
The Alfred Stieglitz Collection

mediates between the bony "here" and the distant "there." In short, the middle ground seems to have dropped out of O'Keeffe's composition, just as it had in the heads hovering above the desert horizons of a few years earlier.

This striking spatial ambiguity, which appeared as well in numerous Southwestern scenes by other painters of the period, was most dramatically expressed in *From the Faraway Nearby* (1937; overleaf). The vast scale of the desert region had been the undoing of more than a few artist-visitors. John Marin, O'Keeffe's colleague in the Stieglitz circle, also visited New Mexico in 1929 and 1930, and was impressed by "the country [that] is so damn big—so that if you succeed in expressing a little—one ought to be satisfied and proceed to pat oneself." His solution to resolving the conundrum, to "expressing a little," was to fracture his vistas with Cubist diagonals which bridge the distance by eliminating the middle ground, effectively merging near and far.

The highly charged contrast of here and there, closely viewed foreground details and hugely distant horizons, which typified the New Mexican views of Marin, O'Keeffe, and others was not a mere optical illusion. The large scale, bright light, and clear air of the region permitted one to see for the proverbial "forever," and the juxtaposition of faraway and nearby was an integral aspect of desert vision. It was a response which affected more than visual artists; for instance, the author D. H. Lawrence, visiting Taos as Mabel Dodge Luhan's guest several years before O'Keeffe and Marin, was like them captivated by the scene and used it as the setting for some of his most memorable tales.

In *St. Mawr* (1925), D. H. Lawrence described a "New England woman"—like O'Keeffe, an outsider—who faced the dramatic realities of life in northern

Summer Days

1936. Oil on canvas, 36¼ x 30³⁄₁₆″
Collection of Calvin Klein
Promised gift to the Whitney Museum
of American Art, New York

Bleached bones and summer blossoms hover above the desert landscape in a powerful evocation of season and place.

From the Faraway Nearby

1937. Oil on canvas, 36 x 40⅛"
The Metropolitan Museum of Art, New York.
The Alfred Stieglitz Collection, 1959

New Mexico. In a moving evocation of place, he offered a literary parallel to the dual vision of the desert painters. "But even a woman cannot live only into the distance, the beyond," he wrote.

Willy-nilly, she finds herself juxtaposed to the near things, . . . and willy-nilly, she is caught up into the fight with the immediate object. The New England woman had fought to make the nearness as perfect as the distance: for the distance was absolute beauty. She had been confident of success. She had felt quite assured, when the water came running out of her bright brass taps, the wild water of the hills caught, trickled into the narrow iron pipes, and led tamely to her sink, to jump out over her sink, into her sink, into her wash basin, at her service. There! she said. I have tamed the waters of the mountain to my service. So she had, for the moment.

At the same time, . . . while she revelled in the beauty of the luminous world that wheeled around and below her, the gray-rat-like spirit of the inner mountains was attacking her from behind. . . . The underlying rat-dirt, the everlasting bristling tussle of the wild life, with the tangle and the bones strewing. Bones of horses struck by lightning, bones of dead cattle, skulls of goats with little horns: bleached, unburied bones. The cruel electricity of the mountains. And then, most mysterious but worst of all, the animosity of the spirit of the place: like some serpent-bird forever attacking man.

Georgia O'Keeffe and the New England woman shared the struggle with the near and the far. It was in these vast spaces that the painter most prominently identified with New Mexico found the inspiration for her most memorable images. *From the Faraway Nearby* combines the "absolute beauty" of the distance with the "tangle and the bones strewing," as deer horns reach down to embrace and uplift the distant curve of hill. Forsaking any middle ground, the close and the infinite are locked together—the detailed skull and distant vista, united only in the kiss of horn and hill.

The painting of antlers above red hills enchants and haunts with a special spirit of place, one which has affected many viewers since its first presentation at Stieglitz's gallery in December 1937. Reviewers praised it as capturing "the very essence of the desert." In recent years, when rock star Cyndi Lauper wanted "a rootsy song," she turned to O'Keeffe's celebration of place and with her collaborator composed "The Faraway Nearby."

O'Keeffe included the impressive canvas in her major retrospective exhibition at the Art Institute of Chicago in 1943, but listed under the title *Deer's Horns Near Cameron.* The title's reference to an Arizona locale suggests that the painting was a souvenir of her camping trip to the West with photographer Ansel Adams and other friends in July 1937. (The area around Cameron, Arizona, had inspired her famous *Black Cross* nearly a decade earlier—despite its subsequent New Mexican titling—and she might understandably have felt a special tie to the region.) Although initially inspired by a specific terrain and personal experience, the painting came to have emblematic status for the artist, eventually winning the name by which she alluded to her love of the vast country: "the faraway." On this and other occasions, O'Keeffe moved beyond a pictorial essay

on desert vision to create an icon of a special American precinct—the nation's exotic, the faraway nearby.

During his visit to O'Keeffe's Ghost Ranch country in 1937, Ansel Adams wrote excitedly to Alfred Stieglitz of his delight in the "magical" countryside. "The skies and land are so enormous and the detail so precise and exquisite," he exclaimed, "that wherever you are, you are isolated in a glowing world between the macro and the micro—where everything is sidewise under you and over you, and the clocks stopped long ago." O'Keeffe's formal plays with near and far, with macro and micro, suggest the possibility of other pairings: the tangible and the infinite, mortality and immortality, the personal and the universal. In depicting the vast spaces of the Southwest, O'Keeffe and Adams discovered a metaphor whose romantic possibilities charged their artistic imaginations.

After *From the Faraway Nearby*, little remained to be done with the skulls. Skeletal imagery, however, remained important to O'Keeffe, with fascination newly drawn to the curving planes and cavities of the pelvis bones, beginning about 1943. As with the airborne skulls and antlers of the 1930s, her early pelvis bones similarly hovered above low horizons. The mysterious impression of *Pelvis with the Moon* (1943) results partly from the nocturnal effects, but more from the unfamiliarity of the bony subject, which is not as readily recognizable as an animal or human skull. As with the deer horns that only brushed the pink hills below them, so too the pelvis barely touches the landscape; its shapes unfurl across the silvery night sky, linking the moon in the canvas's upper reaches with the Pedernal at the bottom.

For the skull and horns of her earlier skeletal subjects, critics and viewers had at least a tradition of *vanitas* compositions and funerary symbolism on which to rely as they sought—however mistakenly—to come to terms with the subject. With the empty pelvises, however, there was less by way of iconographic precedent, and reviewers were left to struggle with the ambiguous white forms in the desert landscape. Some faulted the paintings for their loss of precise design— the pelvic bones were not viewed frontally and centered—and for their "fuzziness of idea (or its communication)." Others found morbid preoccupations clearly communicated by the bleached bones, but in so doing they neglected the artist's own advice that "there is no such thing as death—only change—." It was curator Daniel Catton Rich who was most eloquent in appraising the new pictures, in which he discovered a "fresh emotion...no longer concerned with death or after-death." The new paintings concentrated upon the sculptural forms closely viewed against sky and land, effecting a merger of macro and micro whose novel inventiveness stirred Rich. "Bone and sky and mountain are welded," he concluded, "into a luminous affirmation....Once again transformation has triumphed over observation."

O'Keeffe's exhibition at Stieglitz's gallery in January 1944, which inspired Rich's praise, was notable for the introduction of the pelvises, as well as her cottonwood subjects and the first Black Place painting. This remarkably productive and inventive period may have been stimulated in part by the preparation of her large retrospective exhibition at the Art Institute of Chicago in 1943, a ven-

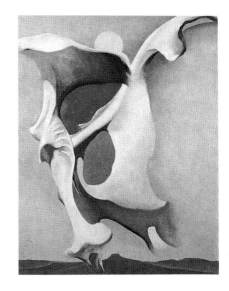

Pelvis with the Moon

1943. Oil on canvas, 30 x 24"
Collection of the Norton Gallery of Art,
West Palm Beach, Florida

In the 1940s, pelvic bones replaced skulls as the artist's favored skeletal motif. Initially they were combined with the landscape, floating above low horizons; later, O'Keeffe isolated a fragment of the bone—the pelvic socket—to represent the whole.

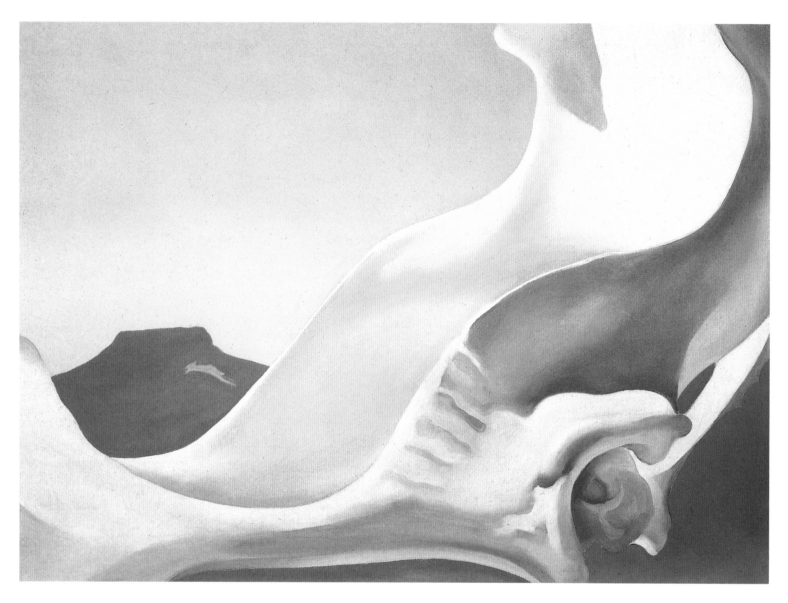

Pelvis with Pedernal

1943. Oil on canvas, 16 x 22″
Munson-Williams-Proctor Institute Museum of Art,
Utica, New York

In 1944, O'Keeffe explained that "for years in the country the pelvis bones lay about the house indoors and out seen and not seen as such things can be—seen in many different ways. I do not remember picking up the first one but I remember from when I first noticed them always knowing I would one day be painting them."

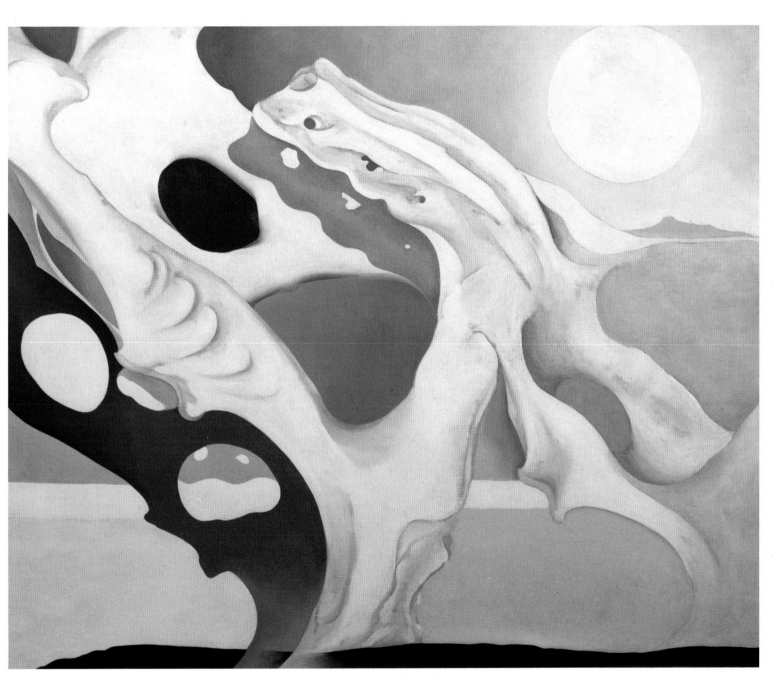

Pelvis with Shadows and the Moon

1943. Oil on canvas, 40 x 48¾″
Private Collection

ture for which Rich served as curator and which called upon O'Keeffe to review a quarter-century of her work. Growing out of that experience, Rich sensed her renewed interest in the spare elegance of Oriental art and concluded that she was "determined to make something which in cleanness of line and simplicity of vision is totally American, but never in any narrow sense." The faithful Henry McBride likewise detected a change in her direction, and a renewed emphasis on composition; he concluded that "the pelvis is a subterfuge and that Miss O'Keeffe's real pleasure consisted in going all out for decoration with only a minimum of facts about life and death."

In using the pelvises to create something "totally American," something more decorative which inescapably bespoke its distinctive region, O'Keeffe reversed the relationship of skeleton to setting. Whereas the skulls had sat inertly in (or over) the landscape, some of the pelvises relate to their settings in more complicated ways. While *Pelvis with the Moon* presents a subject which is static like the skulls, other bones actively reshaped and redefined the land; in *Pelvis with Pedernal* (1943; page 134), for instance, a fragment of bone isolates the hallowed peak from the rest of the landscape, seemingly lifting it into the blue overhead.

In her *Pelvis with Shadows and the Moon* (1943; page 135) O'Keeffe made even more dramatic transformations in the figure-ground (or bone-land) relationship. In this most ambitious and complicated of her "pelvic landscapes," the bone breaks up and rearranges the desert space into discontinuous landscape vistas. Where the hard skeleton intersects the dark horizon at the bottom of the composition, it dematerializes into transparent passages; elsewhere, the bony extension of pelvis tapers into a ground plane on which rests a dislocated Pedernal. The design is illuminated by a full moon in the upper distance which illogically casts its light as if from outside the picture, lending the composition a dreamlike quality.

The blue shadowed passages of the pelvis bone echo the tint of New Mexican skies, reflecting the artist's environment. O'Keeffe explained that she was "most interested in the holes in the bones—what I saw through them—particularly the blue from holding them up in the sun against the sky." In several sockets in *Pelvis with Shadows and the Moon*, the blue dominates; in others, however, the blue-white contrast is reversed, resulting in a decorative play of positive and negative forms which complicates a logical reading of either. A white band running smoothly across the design is momentarily disturbed in its passage by the bottom socket; this capacity of the orifice to activate its surroundings had been anticipated in two canvases entitled *Fishhook from Hawaii*, the products of a 1939 sojourn in the islands. In the pelvic subject, however, the form that results is irregular, undulant rather than prismatic, and suggests O'Keeffe's stylization of the traditional Chinese yin-yang symbol.

The formal plays within the composition of *Pelvis with Shadows and the Moon* suggest that the painting might have possessed for its maker some extraordinary import; in its description of the land, it certainly departed from topography, and its significance might likewise have surpassed decorative plays of form and color. In 1947, following the death of her husband (who likely would have discouraged the charity), O'Keeffe chose this canvas to give to her friend Frank Lloyd

Fishhook from Hawaii, No. 1

1939. Oil on canvas, 18 x 14"
The Brooklyn Museum, New York
Bequest of Georgia O'Keeffe

Wright. O'Keeffe had felt a special kinship with the esteemed architect and philosopher from their first meeting. (Apparently, the sentiment was reciprocal; in the 1930s, Wright tried to lure O'Keeffe and Stieglitz to his creative community at Taliesin, enticing them with the offer of a home of his design, a recruitment effort which was ultimately unsuccessful.) O'Keeffe and Wright were both products of the benign Wisconsin countryside, and their art was inspired by natural form and process. They also shared an interest in Oriental art and philosophy, considerations which might have shaped O'Keeffe's pelvic design. Hence, for this man, whom she called "one of my favorite people of our time," O'Keeffe selected the haunting evocation of her favorite precinct as "a small gesture of appreciation for something I feel about you."

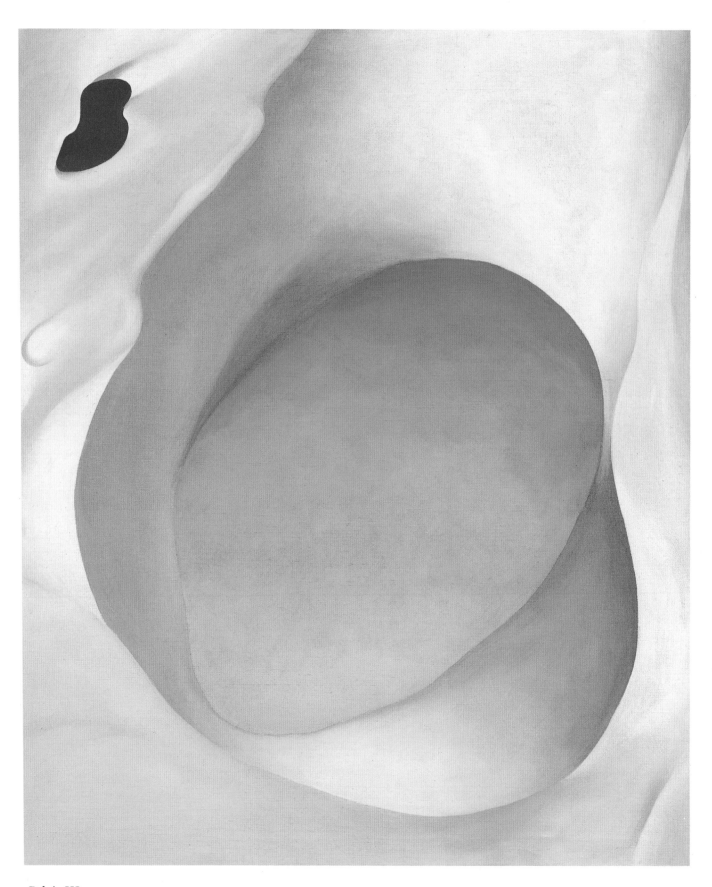

Pelvis III

1944. Oil on canvas, 48 x 40″
Collection of Calvin Klein

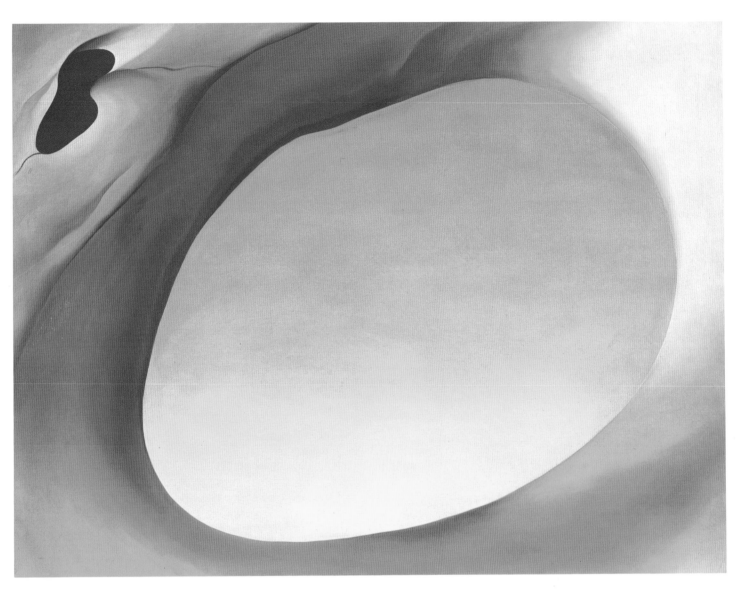

Pelvis Series—Red with Yellow

1945. Oil on canvas, 36 x 48"
Private Collection

The pelvic holes were initially isolated against the expanse of blue sky that surmounted everything in the desert. In this example, however, O'Keeffe departs from observed reality to create the colorful and dramatic culmination to the series.

The pelvic subject continued to interest O'Keeffe in her 1944 visit to New Mexico, from which resulted another imposing group of images. However, instead of using the bone to frame and activate the land, she now simplified her compositions dramatically, reducing the elements only to bony socket and blue sky. Tightly focusing upon her subject, O'Keeffe managed a skeletal equivalent to *The White Place in Shadow*—framing the blue empyrean within hard borders of pure white. The complex patterns of solid and void, receding and advancing, presented challenges akin to those discovered in the depths of white blossoms or the details of desert adobes.

By severing the subject from its landscape context and emphasizing its formal aspects, O'Keeffe neutralized the more morbid interpretations of her motif. This did not, however, quell speculation on her subjects' meanings, speculation which often returned to the personal. Were the empty pelvises O'Keeffe's lamentations on childlessness? Or menopause? Did their bleached and weathered forms suggest a concern for the drying up of her creativity? Were they prompted by concerns for her husband's failing health? Or an awareness of her own mortality? More universally, did the choice and treatment of subject express the painter's reaction to the sorrows and calamities of the time? O'Keeffe steadfastly refused to respond to the interpretative speculation that invaded her well developed sense of privacy, and answers to the more autobiographical references will probably never be known. Nevertheless, the choice of motifs as symbolically freighted as dead bones—pelvises or skulls—recalls her earlier inclination to floral studies and other iconographically complex subjects. By the mid-1940s, after exhibiting regularly in New York for three decades, critical habits of interpretation, of "decoding" her designs, were well ingrained, despite her protestations. The images resonated with symbolic echoes: Questions of regional reference, allusions to bodily parts and functions, metaphors of life and of death—all are hinted in her motifs. Simultaneously, her bone pictures begged formal explication as well, for instance, of the subtle technique that sometimes gave the blue void the appearance of a convex solid, sometimes the hard edge of a flat pattern. Their artistry and power comes from O'Keeffe's skillful selection and treatment which hold the multivalent images in balance.

Late in life, she alluded to the voids that had become such a familiar part of her formal invention: "I like empty spaces," she explained. "Holes can be very expressive." On another occasion, in explaining the pelvis subjects, particularly the holes in the bones, she hinted at their symbolic value: "They were most wonderful against the Blue—that Blue that will always be there as it is now after all man's destruction is finished." The pelvic series was initiated in 1943, in the bleak nadir of World War II, when "man's destruction" reached unprecedented levels. From her earliest watercolors, the blue—Kandinsky's spiritual hue—had held unusual interest for her; many years later, the enduring blue still held promise for the pacifist O'Keeffe, and her series of sockets against the sky could be read as a paean for peace.

The serene blue-and-white pelvises, which O'Keeffe continued to paint through 1944 in such works as *Pelvis III* (page 138), were succeeded the follow-

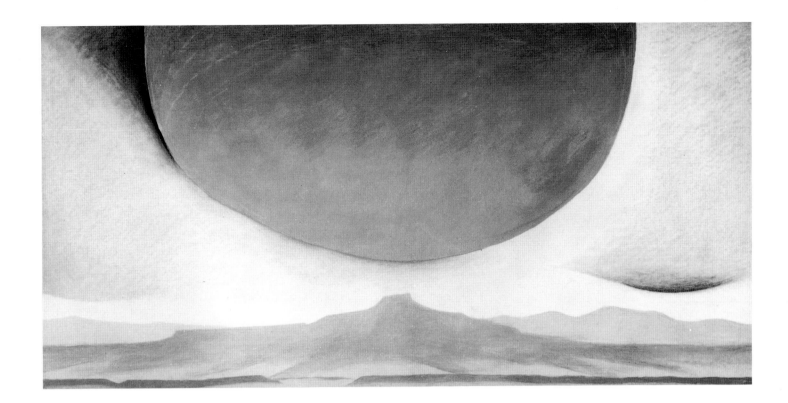

ing summer—that explosive season of Hiroshima and Nagasaki—by a more apocalyptic vision, the incendiary *Pelvis Series—Red with Yellow* (page 139) that culminated the series. While O'Keeffe would occasionally return to the bones in later years—just as she made reprises of flowers, abstractions, and other favored motifs—the pelvis's hold on her, both literally and imaginatively, waned after 1945. A late pelvis picture like *Pedernal—From Ranch No. 1* (1956; Minneapolis Institute of Arts) echoes some of the hues of the 1945 example, but in the enframement of the sacred peak, one senses a more pacific inspiration than in precursors of wartime origin. By that date, the intensity of expression had waned, but the pelvic device had lost none of its formal power.

It is the lasting impact of that compositional influence that ultimately makes the series of the 1940s so crucial. The artist's vision of her world had been shaped by the bones, both literally and metaphorically, and the pelvic patterns persisted even when the skeleton itself was dropped. The imposing pastel *Pedernal* (1945), for instance, presents the long desert horizon surmounted by an aperture in the sky suggestive of the pelvis hole. The reddish arcs that rise to contain the cosmos are repeated in simpler but more naturalistic form in another pivotal canvas of 1945, *Red Hills and Sky* (Private Collection).

The preoccupation with aerial spaces in the 1940s prefigured O'Keeffe's move in the next decade to airborne perspectives on landscape motifs. The pelvic compositions—close, tangible frames surrounding infinite recess—might even anticipate the cosmic concerns of contemporary artists in the land, such as James Turrell, whose sensibilities were prefigured by Georgia O'Keeffe. As we move uncertainly toward a new millennium and a life post-nature, her values and her achievement seem yet significant.

Pedernal

1945. Pastel on paper, 21⅜ x 43¼"
Collection of Juan Hamilton.
Copyright © 1987 Juan Hamilton

The circular pattern of the orifice continued to interest the artist, even without the pelvic frame. "I like empty spaces," she once explained. "Holes can be very expressive."

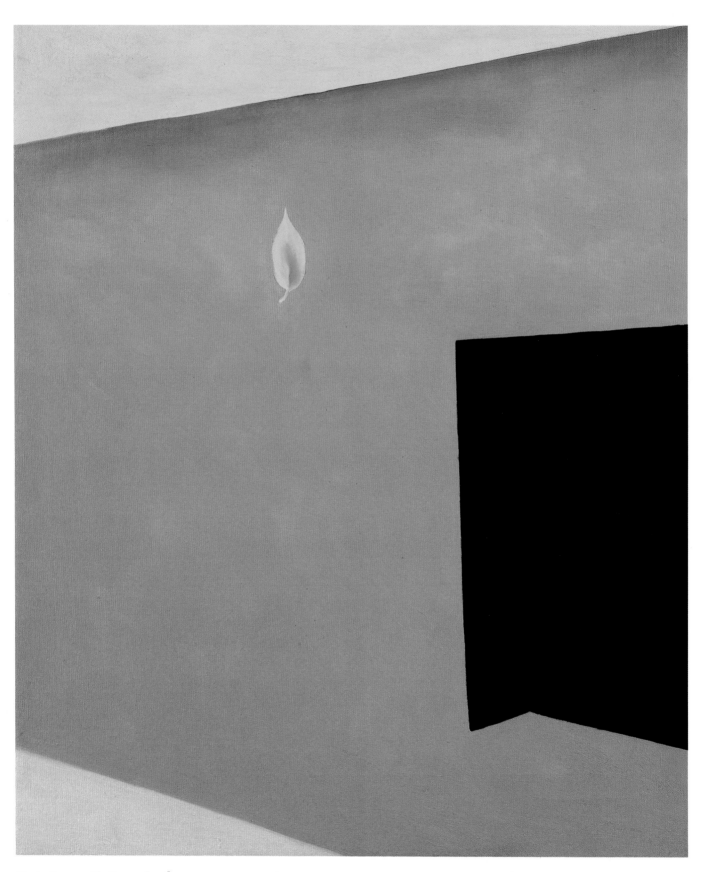

Patio Door with Green Leaf

IX. Sky

"THESE DAYS," WROTE CRITIC BARBARA ROSE IN 1970, "it is fashionable to believe that we have already an accurate picture of the quality art of the 1960s. The idea that any important work is unknown to us seems out of the question. Yet there exists a body of work done during the decade of the 1960s, almost unknown to the general art public, which I believe will endure when the media favorites of today have long faded. I am speaking of the recent paintings of Georgia O'Keeffe which rounded out her recent Whitney Museum retrospective." The praise she heaped upon O'Keeffe was echoed by other reviewers, and announced one of the most remarkable comebacks in the annals of modern art. From the 1970 Whitney show dates the beginning of the "O'Keeffe phenomenon," the artist's long and golden autumn, perhaps without precedent in our history.

Rose praised the artist's recent work for its "formal brilliance," concentrating on aesthetics rather than issues of sex or personality which had dominated many earlier appraisals. By contrast to the Freudian interpretations that prevailed in the 1920s and 1930s, the new criticism in the 1970s was as likely moved by the artist's formal inventiveness, a creative language which was nevertheless susceptible to metaphoric interpretation.

A painting like *White Patio with Red Door* (1960; overleaf) suggested its inspiration in O'Keeffe's patio at Abiquiu, a subject that she had first tackled in the mid-1940s. She claimed that this architectural feature is what made her covet the property initially, and she had portrayed the patio's adobe wall and its dark door on numerous occasions. Many of the paintings were simplified designs of the dark rectangle in the plane of the wall, sometimes reduced to abstraction; others were evocative of place or season, suggested through the inclusion of window lattice or clouds, snowflakes or spring leaves. Both as geometric pattern and as poetic allusion, the patio subject expressed the importance of place, of home.

In the late example with red door, Barbara Rose discerned O'Keeffe transcending the simplified designs inspired by indigenous architecture to produce an image at once more ambitious and ambiguous. The subtle gradations of hue in the central aperture, from red to pink, implied recession through aerial perspective; to Rose, this suggested that the red door was not the threshold to some domestic environ, but to a vast space which (as O'Keeffe once said) was "calling— as the distance has always been calling me." In short, the red door provided a glimpse into the infinite.

Through the simplest of means, O'Keeffe was able to evoke such poetic readings from viewers of the 1970s, who rediscovered in her recent work the

Patio Door with Green Leaf

1956. Oil on canvas, 36 x 30"
Private Collection.
Copyright © The Georgia O'Keeffe Foundation

The plain door in the adobe wall was a favorite feature of the Abiquiu home that O'Keeffe purchased in 1945. It quickly became the subject of a new series of canvases, exploring the pattern of the aperture from various perspectives.

143

metaphysical overtones that had captivated her earliest enthusiasts. The painting of a patio door also evinces pictorial concerns which tie it to the most sophisticated abstractions of the 1960s: a field of unified tone, suggesting a fragment of a larger expanse, and a severe reduction of elements, arrayed in a few broad planes of color. In all respects, the painting conformed well to the canons of minimalism that then preoccupied many younger artists.

White Patio with Red Door, conveying poetic meaning through minimal means, was but one of many surprises in the Whitney show. The painting heralds a "late style" in O'Keeffe's career, of the liberated and efflorescent type sometimes found by artists of advanced years, but one consistent with and logically evolving from the inventiveness she had shown from the outset. Like Monet's late water lilies, O'Keeffe's paintings of the 1960s find a new expansiveness in scale, a daring abstraction, and a simplicity and formal power remarkable even for an artist to whose work such terms might always have seemed apt.

During Stieglitz's lifetime, O'Keeffe had largely confined her travels to the familiar orbit of Lake George and the Southwest. After his death and her move from New York in 1949, she undertook travel with a new enthusiasm, and on a global scale. The experience of world travel, which belied her popular reputation as a desert recluse, provided O'Keeffe with a variety of new material. Unlike most of the painters of her generation, she had not spent a formative youthful sojourn in Paris. (Stieglitz later seemed exceptionally pleased with this omission and praised O'Keeffe for her *American* character, undefiled by European influence.) Only in 1953 did O'Keeffe finally make her pilgrimage to the great monuments of France and Spain, an experience which primarily served to confirm her contentment with her Southwestern home and life.

If she approached the famous haunts of Europe as a tourist, her subsequent journeys to less trafficked spots provided greater inspiration to the painter. Her itineraries from the mid-1950s onward show a predilection for what today would be called the Third World; years ago, she explained it as a fondness for "the dirty parts of the globe." In the spring of 1956, she spent three months in Peru where she was particularly impressed by the colors of the landscape. They were, she recalled, "almost unbelievable... marvelous purples, violent colors. And the Andes are sparkling—they freeze at night, and in the morning they glitter." Later she captured the effect in a series of painted reminiscences based upon simple pencil sketches made in her travels. A small canvas of about 1957, *Misti—a Memory*, employs an odd "Peruvian" palette of purples and blues to evoke the view of glittering Andean heights viewed from the peach-colored sea. Other excursions in the countryside yielded paintings of waterfalls, mountain peaks, and the famous Incan ruins at Macchu Picchu.

O'Keeffe's excitement over her South American trip kindled her interest in travel, which in 1959 led to an ambitious around-the-world itinerary. On the road for more than three months, she visited the Orient, India and the Middle East, and finally Italy. In approaching Italy from the Levant, O'Keeffe followed the route of Frederic Church a century earlier and, like him, found that Rome suffered for the contrast. After the ancient monuments and dramatic land-

White Patio with Red Door

1960. Oil on canvas, 48 x 84″
The Regis Collection, Minneapolis

Misti—A Memory

c. 1957. Oil on canvas, 10⅛ x 20⅛″
Private Collection.
Copyright © The Georgia O'Keeffe Foundation

In the 1950s, O'Keeffe began to travel widely, and these experiences provided new inspiration. The paintings that resulted were of a familiar type—generally landscapes—but involved innovative handling and novel motifs, such as this shimmering recollection of the Andes in Peru.

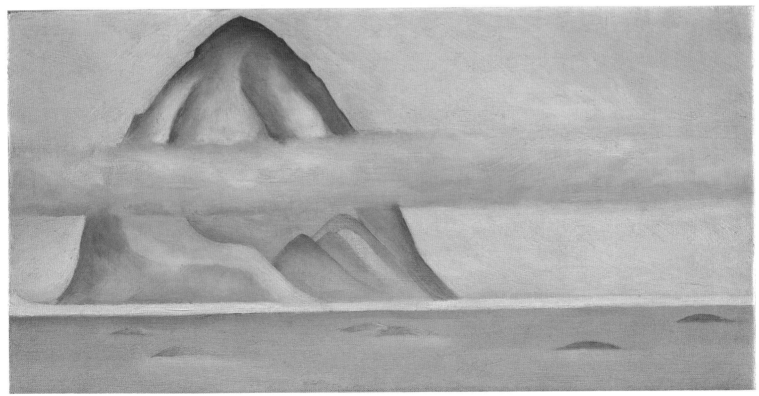

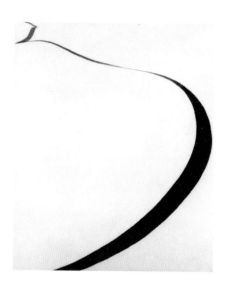

Winter Road I

1963. Oil on canvas, 22 x 18"
Private Collection.
Copyright © The Georgia O'Keeffe Foundation

From her home atop the mesa in Abiquiu, O'Keeffe enjoyed an extensive prospect across her beloved countryside. Through the glass walls of her bedroom she could view the dawn and "the road toward Española, Santa Fe, and the world." O'Keeffe treated the vista to the east over many years and in many seasons, ultimately reducing the course of the road to an elegant calligraphic stroke, nearly abstract in its simplicity. Line here maps not the highway, but an aesthetic terrain.

scapes of the Middle East, Church thought Italy "corrupt and vulgar" and he dismissed Rome as "threadbare." O'Keeffe's Roman holiday prompted a similar reaction. "There is nothing there in man's scale," she complained. "The cherubs on the walls in the Vatican—dreadful. Those big naked things. Bigger than a man. Everything in Rome was like that to me—extraordinarily vulgar. The baths, the Coliseum, the palaces—as if being huge made them good." In contrast to gargantuan Rome, she preferred the Middle East where "everything is made to man's measure. . . . There, though the palaces were large, they were made up of small units where you felt you belonged." The comparison is revealing of her preferences in tourism and in architecture as well; in New Mexico, she had crafted her own "palace," the spacious Abiquiu compound whose many small units provided, as surely as any Levantine palace, a sense of belonging amidst the vast and empty landscape.

Although Italy failed to inspire her, the Orient did, and the following year she returned to Japan, Southeast Asia (especially to see Cambodia), and the Pacific islands. The lush natural scenery of the tropics, so different from the eroded forms and rust colors of her desert home, drew her attention. *Mountains and Lake* (1961; overleaf), a landscape inspired by her travels, is remarkable for the unusual intensity of hue—verdant foliage before blue escarpment—with which she recalls the scene.

O'Keeffe had often adopted unconventional vantage points on her subjects, for instance, her familiar bee's-eye perspective of flowers. From her mesa-top studio in Abiquiu, she looked out and over the New Mexican countryside, enjoying a bird's-eye prospect which she exploited in a group of Mesa and Road to the East paintings, begun in the early 1950s. The possibilities of that elevated perspective were most dramatically realized in the masterful *Winter Road I* (1963) of a decade later, a work of Oriental simplicity in which the view is reduced to a single calligraphic stroke of brown coursing a field of white. But in that painting, the artist was still working from an earthbound perspective, a stance from which her travels ultimately released her.

In addition to new pictorial material, O'Keeffe's frequent flying in the late 1950s and 1960s also gave her a new perspective on the world. The travels took her from her mesa top, permitting physical as well as imaginative flights over the landscape. The artist projected self and viewer above her subjects, initially rivers and islands, ultimately enormous expanses of white cloud. The perspective was akin to Monet's imaginative hovering above a Giverny lily pond, with the resultant distortions of space and scale. By abandoning conventional footholds, both painters were able to concentrate upon the artful patterns hidden within their motifs and to wrest from them designs of an exceptionally high order, at once "abstract" yet referential to the world. It was that combination of abstract design with echoes of the perceived world—that is, representation, in some degree— that had from the outset distinguished O'Keeffe's vision and artistic style, and which so strongly stamped her last paintings.

During her travels, O'Keeffe was surprised to find riparian patterns even in the world's most arid areas, and from miles overhead she made pencil sketches

on small sheets of paper. These linear patterns were later enlarged in charcoal, resulting in a 1959 series of drawings which echo the patterns of abstract designs she had produced decades earlier, again indicative of formal and thematic continuities throughout her career. In turn, the drawings were parent to a series of oils, begun in 1959 and continuing into the following year, which introduce O'Keeffe's distinctive sense of color into the landscape patterns. Looking down on her river subjects, O'Keeffe remembered seeing "such incredible colors that you actually begin to believe in your dreams." Back on terra firma, at work in the studio, she felt free to employ color arbitrarily, explaining to one viewer that "after all you can see any color you want when you look out the [airplane] window."

Only One (1959; overleaf) is among the first of the painted rivers. From her perch beside the window, O'Keeffe looked down upon the flow, experiencing in exaggerated form the elevated vantage point she had used many years earlier to record the course of the Chama River across the New Mexican desert. In the more recent work, however, conceived from the higher plane with a resulting loss of detail, the landscape is reduced to pattern, a strident contrast of rust tones and deep blues. In subsequent treatments of similar motifs, such as *It Was Red and Pink* (1959; Milwaukee Art Center), she used colors lighter in tone, and in the lyrical *It Was Blue and Green* (1960; Whitney Museum of American Art, New York), she introduced a looser stroke and more curvilinear forms.

With the aerial views of rivers O'Keeffe was still relating her work to the land, which had motivated her for nearly half a century. With her next series—clouds viewed from above—the vantage point remained elevated, but her angle of vision changed from the overhead vertical perspective, which created flat patterns across the ground, to a horizontal view across space. No longer looking down on the terrain, her attention is focused outward and toward a horizon at some immeasurable distance. The resulting "airscapes" represent a culmination of many of her pictorial and thematic concerns.

In 1962, O'Keeffe painted an overhead view of a tropical isle glimpsed through a pattern of white cumulus, the first indication of her new interest. The vista over the clouds—rather than the land seen through them—quickly seized her imagination, and prompted *Sky Above White Clouds I* (1962; page 150). O'Keeffe subsequently likened the composition to the contemporaneous works of Kenneth Noland, whose horizontal bands of color formally parallel her division of the canvas into lateral zones of white and blue; but, while sharing an economy in their design, there are few other points of comparison between the two painters and their work. The younger artists of the 1960s often tended to employ minimal elements as an end in themselves; for O'Keeffe, on the other hand, the reduction of pictorial elements (sky and clouds) to two planes of color was but a further step in her continuing quest for an absolutism based on nature, a tendency which had characterized her work over most of her career. Years earlier, her fellow modernist Marsden Hartley had spoken of O'Keeffe's approach to "the borderline between finity and infinity." With her cloud pictures, O'Keeffe seems finally to have divorced herself from the finite subjects and

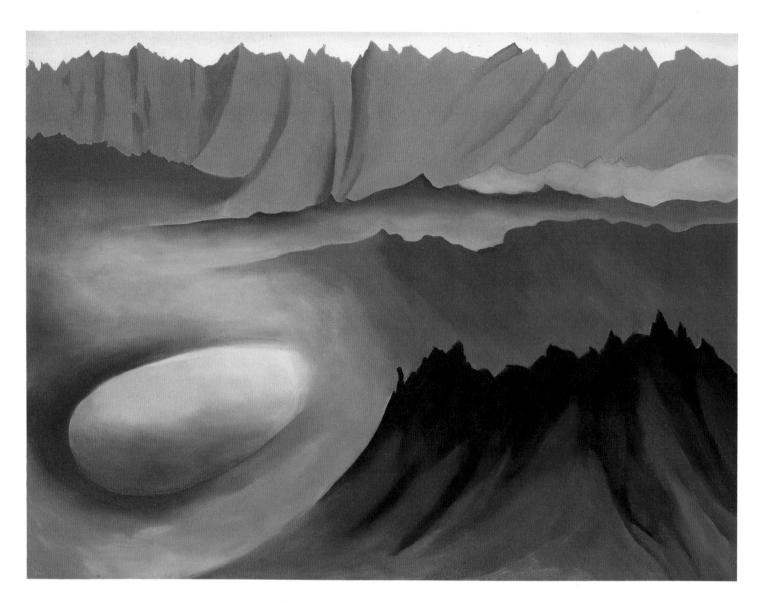

Mountains and Lake

1961. Oil on canvas, 30 x 40"
Private Collection.
Copyright © The Georgia O'Keeffe Foundation

Only One

1959. Oil on canvas, 36 x 30⅛"
National Museum of American Art,
Smithsonian Institution, Washington, D.C.
Gift of S. C. Johnson and Son, Inc.

O'Keeffe had a natural fear of flying—"I just look down the aisle and around to see who I'm going to die with"—but, once safely airborne, she enjoyed the novel view of the landscape from overhead. She was struck by the pattern of rivers against arid land, and in the late 1950s embarked upon new series of charcoal drawings and paintings inspired by such views.

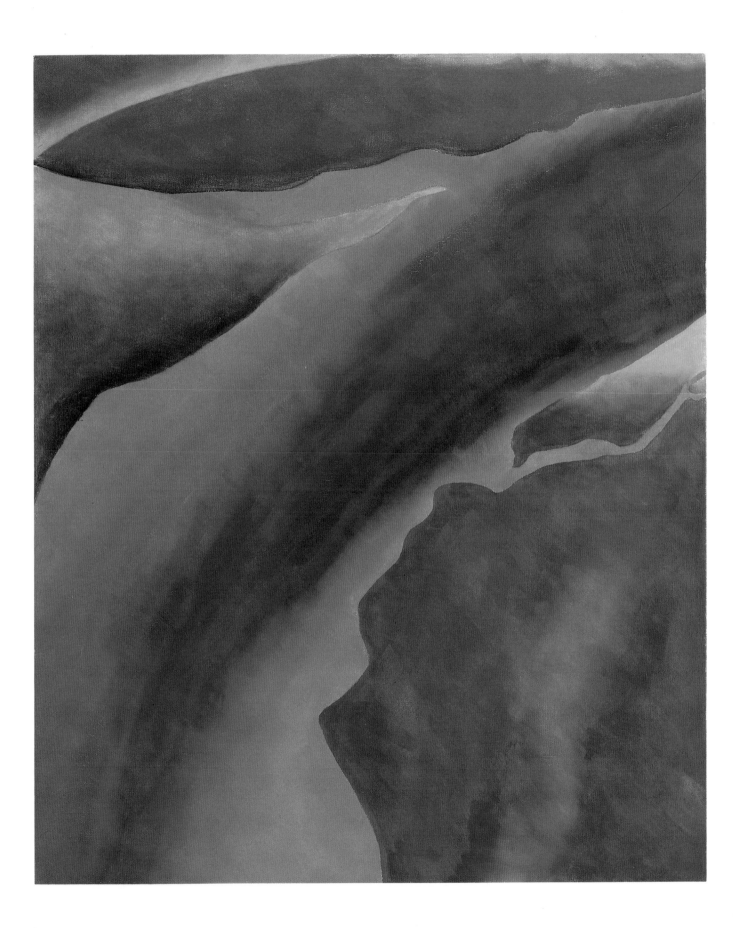

Sky Above White Clouds I

1962. Oil on canvas, 60 x 80″
National Gallery of Art, Washington, D.C.
Alfred Stieglitz Collection,
Bequest of Georgia O'Keeffe

"One day when I was flying back to New Mexico, the sky below was a most beautiful solid white. It looked so secure that I thought I could walk right out on it to the horizon if the door opened. The sky beyond was a light clear blue. It was so wonderful that I couldn't wait to be home to paint it."

concerns of this world, achieving that point toward which so many of her earlier efforts had been prologue.

The considerable size of *Sky Above White Clouds I* made the simplicity of its two-part design even more striking. The viewer is drawn into the composition where, in the absence of familiar reference points, the spaces become immeasurable. In confronting the cloudscape, one does not have the sense of looking *at* a view constructed with conventional Renaissance perspective; instead, the spectator is imaginatively projected *into* the space, floating in the infinite void. O'Keeffe once expressed an unusual wish: "I've often thought how wonderful it would be to simply stand out in space and have nothing." With her designs of sky-above-clouds, she projects herself into just such a position; absent a toe-hold in the real world, shorn of all physical attributes, the disembodied eye floats in the void.

The effect of the 1962 painting was stirring for the artist who, the following year, embarked upon a new series of four paintings entitled Sky Above Clouds. Finished within less that three years, the series gives a condensed indication of her working methods. In theme and treatment, it helps to clarify the concerns that preoccupied her in her last fruitful decade, the extension of interests of a lifetime.

Sky Above Clouds IV, the culmination of the series, was, at twenty-four feet wide, by far the largest and most ambitious painting O'Keeffe had ever produced. While its impact on viewers and critics was predictably strong, it conformed to her own tradition, extending (literally and figuratively) the habits of

seeing and creating she had practiced for more than a half century. The enormous canvas was the product of an intensive painting campaign in the summer and autumn of 1965, conducted in O'Keeffe's garage, which was temporarily put to service as a studio, the only space in her Ghost Ranch home large enough to accommodate it. The physical exertion required in its creation was exceptional for an artist of any age, but especially for one of her nearly eighty years, and O'Keeffe often recalled that aspect of the work in later references to it; equally demanding was the extension of her imagination over such vast pictorial spaces, redolent at once of dream and observation. The singular painting was completed in time for the garage's return to more functional role in the New Mexico winter, and in time for the canvas to be dispatched to Fort Worth where, in March 1966, it made its debut in a one-woman exhibition at the Amon Carter Museum, organized by O'Keeffe's long-time friend and admirer Mitchell Wilder. Four years later it reappeared in the Whitney's larger retrospective, wrapped around the cover of the exhibition catalogue and prominently installed in the museum's ground-floor gallery. (The Whitney's freight elevators and stairwell were inadequate to accommodate the canvas, hence its separation from the balance of the show on the building's upper level.) When the O'Keeffe retrospective subsequently traveled, only the Art Institute of Chicago had sufficiently spacious galleries to handle the work, and, as a result, it remained there while the balance of the exhibition toured the nation. Eventually, the mural-sized painting was acquired by the Art Institute of Chicago, in part as a bequest from the artist.

Sky Above Clouds IV, little traveled but much remarked upon, has become something of a signature image for the artist's late years. In the National Gallery of Art's O'Keeffe exhibition that opened on her one hundredth birthday in November 1987, the picture was again specially installed in a gallery devoted to her final, simplified works. As the visitor emerged from the descent of a dark, enclosed staircase to gaze out upon the wide expanse of clouds and distant horizon, the effect was perhaps not dissimilar from the airborne perspective over empty space that inspired O'Keeffe initially. The picture's cool tones dominated

Sky Above Clouds IV

1965. Oil on canvas, 8 x 24'
The Art Institute of Chicago.
Gift of Georgia O'Keeffe, restricted gift
of Paul and Gabriella Rosenbaum Foundation

The overhead views of "cloudscapes," begun in 1962, culminated in this, the largest and most ambitious canvas of O'Keeffe's career. The artist, then in her late seventies, completed it in a concentrated effort in the autumn of 1965, in time for its debut at her Fort Worth retrospective the following spring, where it astonished critics and visitors alike.

the exhibition's final gallery, providing a striking conclusion to the impressive exhibition and an apt apotheosis for the artist.

The major achievement of O'Keeffe's cloud mural was never repeated. Although she continued to paint until the early 1970s, eventually the infirmities of her advanced years dimmed her sight and in time stilled her hand. But the public fascination with the life and work of one of America's premier artists, rekindled at the Whitney retrospective of 1970, continued to flourish, achieving new prominence and attracting new audiences in the National Gallery's exhibition and its subsequent travels.

Despite the artist's growing physical frailty, she continued to exercise strong control over the perception and understanding of her career. After laying down her brushes in the 1970s, she briefly tackled modeling in clay, a creative outlet in which the touch of the hand could substitute for the keen eye upon which she had always relied; in this she was inspired by her new assistant, Juan Hamilton, himself a skilled ceramic artist. During the 1970s, again assisted by Hamilton, she also oversaw fabrication of sculptures based upon plasters of graceful curvilinear forms which she had modeled years earlier.

As significant as the extension of work into unfamiliar media was her concern for the historical record, which resulted in the exceptional publication of 1976, *Georgia O'Keeffe* by Georgia O'Keeffe. Neither conventional autobiography nor aesthetic treatise, incorporating earlier statements about her art with fragmentary recollections of her life, at once revealing yet oblique, the compendium represents a literary genre of her own invention. Its handsome large format and spare design, inspired and approved by the artist, set a new and lofty standard for book production and art reproduction, and won many kudos. The following year, coincident with her ninetieth birthday, O'Keeffe's collaboration with producer Perry Miller Adato resulted in an award-winning film profile of the artist. The book and film further fueled the public's interest in the almost legendary artist of the Southwest, as did official recognition, including honorary degrees (from Harvard, Columbia, and Brown among others), and prestigious awards and medals. Throughout her final decade, even as failing health kept her from the public eye, the artwork continued to garner attention and new enthusiasts; and, with that recognition, the artist's mystique grew as well. At her death on March 6, 1986, O'Keeffe was accorded the honor of a front-page obituary in the *New York Times*, a rare recognition for an artist, or for any American.

The long and sustained applause for O'Keeffe and her work was fueled by forces in the world around her. With her triumphant return to Manhattan in the Whitney retrospective, she quickly became the beneficiary of a new generation of scholars' interest in pioneering modernists in the United States, of whom she was the last survivor; of a resurgent feminist movement's search for Founding Mothers; and of an aging population's fascination with geriatric productivity. But, above all, the artist's reputation, rising anew, was due to her own careful cultivation of her public persona. No less than her paintings, her life was a work of art. Like the evening star, hers rose early, and it shined brightest before the dark.

Georgia O'Keeffe with sculpture, San Francisco Museum of Modern Art, 1982

Photograph by Ben Blackwell

In her final years, O'Keeffe was troubled by failing eyesight, but encouraged by her assistant, Juan Hamilton, remained active with various projects, including the casting of this large sculpture from a plaster model she had made in 1945.

Georgia O'Keeffe with sculpture,
San Francisco Museum of Modern Art, 1982

Chronology

1887	Born November 15 in Sun Prairie, Wisconsin, to Francis Calyxtus O'Keeffe and Ida (Totto) O'Keeffe; the second child and first girl in a family that grew to two sons and five daughters.
1887–1903	Lives on family's 600-acre dairy farm in Sun Prairie; educated at local grammar school, later at Sacred Heart Academy, Madison (where she received first art instruction), and Madison High School. Family moves to Williamsburg, Virginia, in 1902, after which Georgia lives with an aunt in Madison.
1903	Spring: Joins family in Williamsburg; attends Chatham Episcopal Institute, Chatham, Virginia, graduating in 1905.
1905–06	Studies at the School of The Art Institute of Chicago, where John Vanderpoel's classes are particularly inspirational.
1907–08	Studies at Art Students League, New York, with William Merritt Chase, in whose class she earns scholarship for still life; also with F. Luis Mora and Kenyon Cox. Visits exhibitions of modern art (Rodin, Matisse) at Alfred Stieglitz's Little Galleries of the Photo-Secession (known as 291 for its Fifth Avenue address).
1908	Summer: Attends Art Students League's summer school at Lake George, New York.
1908–10	Abandons painting to pursue career as commercial artist in Chicago, drawing lace and embroidery for advertisements; leaves commercial work after eyesight suffers due to measles. Returns to family, who have relocated to Charlottesville, Virginia.
1911	Spring: Substitutes for Elizabeth May Willis, her favorite early mentor, at Chatham Hall—her first teaching experience.
1912	Summer: Visits art classes at University of Virginia taught by Alon Bement, a disciple of Arthur Wesley Dow; interest in painting revived.
1912–14	Employed as art supervisor and teacher in public school in Amarillo, Texas, her introduction to the American West.
1913–16	Summers: Teaches art at University of Virginia with Alon Bement.
1914–15	Studies with Arthur Wesley Dow at Columbia Teachers College, New York. Visits exhibitions of Braque and Picasso, Marsden Hartley, and John Marin at 291.
1915–16	Teaches art at Columbia College, Columbia, South Carolina; begins series of abstract charcoal drawings.
1916	January 1: Pollitzer shows abstract drawings to Stieglitz, who retains works. Spring: Returns for more classes with Dow. May–July: Drawings exhibited (with paintings by Charles Duncan and René Lafferty) at 291—without artist's knowledge; meets Stieglitz to demand exhibition's dismantling, but he prevails. September: Returns to Texas, to head art department at West Texas State Normal College in Canyon; works there until February 1918.
1917	Stieglitz presents her first solo exhibition (through May 14), which is 291's finale. May 25–June 1: Visits New York, meeting Paul Strand and others of Stieglitz circle; Stieglitz photographs her for the first time. Summer: Travels to Colorado; en route detours through New Mexico, her first visit to the state.
1918	Spring: Recuperates from influenza in South Texas. June: Returns to New York at Stieglitz's urging, accompanied by Strand. July: Stieglitz moves into her temporary quarters and begins photographing her regularly. August: Resigns from West Texas State Normal College to pursue painting in New York. Late summer: Accompanies Stieglitz to his family's Lake George summer home, returning there annually through 1920s.
1918–29	Renews interest in oil painting, creating abstract designs, still lifes, and landscapes.
1921	February: Stieglitz's photographs of O'Keeffe publicly exhibited for first time at Anderson Galleries, New York. Marsden Hartley publishes early appreciation of her work, an essay tinged with sexual interpretations.
1923	Stieglitz presents exhibition of one hundred O'Keeffe works at Anderson Galleries, her first solo show in six years; shortly followed by presentation of 116 new Stieglitz photographs, including numerous O'Keeffe portraits.

1924	March: Simultaneous exhibition of fifty-one O'Keeffe paintings with sixty-one Stieglitz photographs at Anderson Galleries. Begins large floral paintings, as well as pictures of Big Trees and still lifes of enlarged leaves. September: Stieglitz divorced from first wife. December 11: Marries Stieglitz before justice of the peace in Cliffside Park, New Jersey, with John Marin as witness.
1925	Paints first urban subject, *New York with Moon.* March: Stieglitz's "Seven Americans" exhibition at Anderson Galleries includes O'Keeffe along with Marin, Hartley, Arthur Dove, Charles Demuth, Strand, and Stieglitz, generating considerable acclaim. November: Moves to new Shelton Hotel. December: Stieglitz opens The Intimate Gallery.
1926–29	Annual exhibitions of new work at The Intimate Gallery.
1927	June–September: Small retrospective at Brooklyn Museum (no catalogue).
1928	May: Sale of six calla lily paintings for record price ($25,000) earns new publicity. Spring: Travels to Wisconsin to visit family and childhood home.
1929	April–August: Visits New Mexico with Rebecca Strand, as guest of Mabel Dodge Luhan, initiating cycle of summers in Southwest. June: The Intimate Gallery closes. December: Included in "Paintings by Nineteen Living Americans," the second exhibition at the new Museum of Modern Art. Stieglitz opens An American Place gallery.
1930	February–March: Exhibition at An American Place includes first New Mexican subjects; presents work there nearly annually through 1950.
1930–31	First paintings of skeletal subjects.
1932	April: Receives commission to paint mural for Radio City Music Hall. Spends summer at Lake George instead of New Mexico; travels to Canada and paints barns and crosses of Gaspé country. November: Technical problems cause cessation of work on mural; abandons painting for more than a year.
1933	February–March: Hospitalized in New York for nervous exhaustion; subsequently recuperates in Bermuda and, from May onward, at Lake George.
1934	June–September: Returns to New Mexico for first time in three years; first visit to Ghost Ranch, sixteen miles north of Abiquiu, to which she returns frequently thereafter.
1936	October: Moves with Stieglitz from Shelton to penthouse apartment on East Fifty-fourth Street.
1937	July–December: At Ghost Ranch, staying in adobe house which she later buys; hostess to Ansel Adams and other friends with whom she travels in the West. Winter: Failing health forces Stieglitz to give up photography.
1938	April: Stieglitz suffers heart attack, followed by pneumonia; delays departure for New Mexico until August. May: Receives honorary doctor of fine arts degree from the College of William and Mary, her first of many such honors.
1939	February–April: Paints in Hawaii as guest of Dole Pineapple Company; later, in New York, reluctantly completes painting of a pineapple for her sponsor. April: Honored as one of twelve outstanding women of past fifty years by New York World's Fair Tomorrow Committee; painting *Sunset—Long Island* selected to represent New York State in the fair. Summers at Lake George instead of New Mexico.
1940	October: Buys house at Ghost Ranch during her six-month visit.
1941	October–November: Group show with Stieglitz, Marin, Dove, and Picasso at An American Place.
1943	January–February: First full-scale retrospective at Art Institute of Chicago, with catalogue by curator Daniel Catton Rich. Begins series of pelvis paintings.
1944	Spring: Assists in preparations for exhibition of Stieglitz's collection of modern American and European art and photography at Philadelphia Museum of Art.
1945	May–October: In New Mexico; buys abandoned house on three acres in Abiquiu, which over the next three years she remodels as a winter home.
1946	May–August: Retrospective at Museum of Modern Art, organized by James Johnson Sweeney, is first show there to honor a woman (no catalogue). June–July: In Abiquiu. July 10: Returns to stricken Stieglitz in New York; he dies July 13. Autumn: Returns to Abiquiu.
1947–49	Works in New York, settling Stieglitz's estate, preparing exhibition of his collection at Museum of Modern Art (1947; subsequently, Art Institute of Chicago, 1948), and distributing his artworks to public institutions.
1949	Spring: Moves to New Mexico permanently, dividing time between Abiquiu (winters and springs) and Ghost Ranch (summers and autumns). Elected to National Institute of Arts and Letters.

1950	October–November: Exhibition at An American Place marks gallery's closing. Edith Gregor Halpert, director of the Downtown Gallery, becomes new dealer (until 1963).
1951	February: First trip to Mexico, beginning international travels.
1952	February–March: First show at Downtown Gallery features pastels from 1915 to 1945, suggesting paucity of recent work in oil.
1953	February: Retrospective at Dallas Museum of Art. Spring: First trip to Europe (France and Spain); returns to Spain for three months the following year.
1956	Spring: Visits Peru for three months, inspiring group of coastal and Andean subjects.
1959	Travels around the world for three months, including seven weeks in India. Paintings and drawings based on overhead views of river patterns inspired by experience of flight.
1960	October–December: Retrospective at Worcester Art Museum, Massachusetts, with Daniel Catton Rich as curator and catalogue author. Autumn: Six-week trip to Japan, Taiwan, Philippines, Hong Kong, Southeast Asia, and the Pacific islands; tropical landscapes and views of islands through clouds result.
1961	Summer: First of several trips down the Colorado River, which inspire series of Canyon Country paintings.
1962	Elected to American Academy of Arts and Letters, the nation's most prestigious assembly of creative artists, filling the seat vacated by the death of e.e. cummings.
1963	Doris Bry replaces Downtown Gallery as artist's agent. Travels to Greece, Egypt, and the Near East.
1965	Paints her largest canvas, *Sky Above Clouds IV*, the ultimate in a series of "cloudscapes" viewed from overhead.
1966	March–May: Retrospective organized by Amon Carter Museum of Western Art, Fort Worth, with catalogue prepared by Mitchell A. Wilder.
1970	May: Receives National Institute of Arts and Letters's Gold Medal for Painting. October–November: Major retrospective organized by Lloyd Goodrich and Doris Bry for the Whitney Museum of American Art heralds triumphant return to New York; subsequently, show travels to Chicago and San Francisco, winning new acclaim nationally.
1971	Loss of central vision leaves only peripheral sight.
1972	Last unassisted oil painting.
1973	Autumn: Meets Juan Hamilton, a young ceramic artist working at Ghost Ranch, who becomes her assistant and constant companion, and ultimately her representative; he assists in new work with clay, making hand-built pots.
1974	January: Visits Morocco with Hamilton; over the next decade travels with him often, visiting Central America, the Caribbean, Hawaii, and cities in continental U.S. Publishes *Some Memories of Drawings*, a portfolio of reproductions with comments by the artist.
1975	Resumes painting in watercolors and, with assistance, in oils.
1976	Publishes *Georgia O'Keeffe*, a best-selling book of fine reproductions with distinctive text by the artist.
1977	January: Receives Medal of Freedom, the nation's highest civilian honor, from President Gerald Ford. Perry Miller Adato produces film portrait of the artist which is aired nationally on public television. Ninetieth birthday celebration at National Gallery of Art, Washington, D.C., generates increased public interest.
1978	Prepares catalogue introduction for exhibition "Georgia O'Keeffe: A Portrait by Alfred Stieglitz," which opens at Metropolitan Museum of Art, New York, in November.
1980	Laurie Lisle publishes *Portrait of An Artist: A Biography of Georgia O'Keeffe*, the first full-length study of her life.
1984	Moves to Santa Fe, where she lives with Juan Hamilton and his family.
1985	April: Awarded National Medal of Arts by President Ronald Reagan.
1986	March 6: Dies at St. Vincent's Hospital, Santa Fe.
1987	November: Centennial celebrated by major retrospective at National Gallery of Art, with Jack Cowart, Juan Hamilton, and Sarah Greenough as co-curators; subsequently toured to Art Institute of Chicago, Dallas Museum of Art, Metropolitan Museum of Art, New York, and Los Angeles County Museum of Art.
1989	Following distribution of designated paintings by bequest, the Georgia O'Keeffe Foundation established, to perpetuate the memory of the artist and her work.

Selected Bibliography

NOTE: The literature on Georgia O'Keeffe and her art, which was already substantial during her lifetime, has grown exponentially since her death. The items included in this bibliography represent readily accessible monographs and exhibition catalogues devoted to the artist. For readers desiring a more complete listing, those recent publications with extensive bibliographical information are indicated by an asterisk (*).

ADATO, PERRY MILLER, producer and director. *Georgia O'Keeffe*. Videotape, 59 min. Produced by WNET/THIRTEEN for Women in Art, 1977. Portrait of an Artist, no. 1; series distributed by Films, Inc./Home Vision, New York.

BRY, DORIS, AND CALLAWAY, NICHOLAS, eds. *Georgia O'Keeffe—In the West*. New York: Alfred A. Knopf, 1989.

CALLAWAY, NICHOLAS, ed. *Georgia O'Keeffe: One Hundred Flowers*. New York: Alfred A. Knopf, 1987.

CASTRO, JAN GARDEN. *The Art & Life of Georgia O'Keeffe*. New York: Crown Publishers, 1985.

*COWART, JACK; HAMILTON, JUAN; AND GREENOUGH, SARAH. *Georgia O'Keeffe: Art and Letters*. Washington, D.C.: National Gallery of Art, 1987.

GOODRICH, LLOYD, AND BRY, DORIS. *Georgia O'Keeffe*. New York: Whitney Museum of American Art, 1970.

HASKELL, BARBARA. *Georgia O'Keeffe, Works on Paper*. Santa Fe: Museum of New Mexico Press, 1985.

HOFFMAN, KATHERINE. *An Enduring Spirit: The Art of Georgia O'Keeffe*. Metuchen, N.J.: Scarecrow Press, 1984.

LISLE, LAURIE. *Portrait of an Artist: A Biography of Georgia O'Keeffe*. New York: Seaview Books, 1980; rev. ed., New York: Washington Square Press, 1987.

*LYNES, BARBARA BUHLER. *O'Keeffe, Stieglitz and the Critics, 1916-1929*. Ann Arbor: University of Michigan Press, 1989.

MESSINGER, LISA MINTZ. "Georgia O'Keeffe." *The Metropolitan Museum of Art Bulletin*, XLII:2 (Fall 1984), entire issue.

———. *Georgia O'Keeffe*. New York: Thames and Hudson, 1988.

NEWMAN, SASHA. *Georgia O'Keeffe*. Washington, D.C.: The Phillips Collection, 1985.

O'KEEFFE, GEORGIA. *Georgia O'Keeffe*. New York: Viking Press, 1976; New York: Penguin Books, 1985.

———. "Introduction." *Georgia O'Keeffe: A Portrait by Alfred Stieglitz*. New York: Metropolitan Museum of Art, 1978.

POLLITZER, ANITA. *A Woman on Paper: Georgia O'Keeffe*. New York: Simon & Schuster, 1988.

RICH, DANIEL CATTON. *Georgia O'Keeffe*. Chicago: Art Institute of Chicago, 1943.

———. *Georgia O'Keeffe—Forty Years of Her Art*. Worcester, Mass.: Worcester Art Museum, 1960.

SAVILLE, JENNIFER. *Georgia O'Keeffe: Paintings of Hawai'i*. Honolulu: Honolulu Academy of Arts, 1990.

ROBINSON, ROXANA. *Georgia O'Keeffe: A Life*. New York: Harper & Row, 1989.

WILDER, MITCHELL A., ed. *Georgia O'Keeffe*. Fort Worth: Amon Carter Museum of Western Art, 1966.

Photograph Credits

Index

All works are by O'Keeffe unless otherwise indicated.

Page numbers upon which illustrations appear are in *italic* type.

159

160